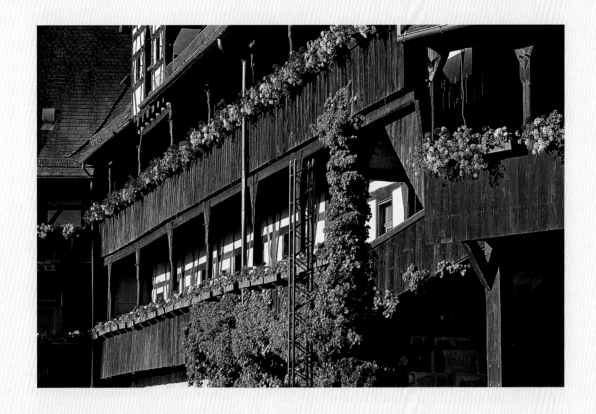

Journey through

# FRANCONIA

Photos by
Martin Siepmann

Text by
Ulrike Ratay

Stürtz

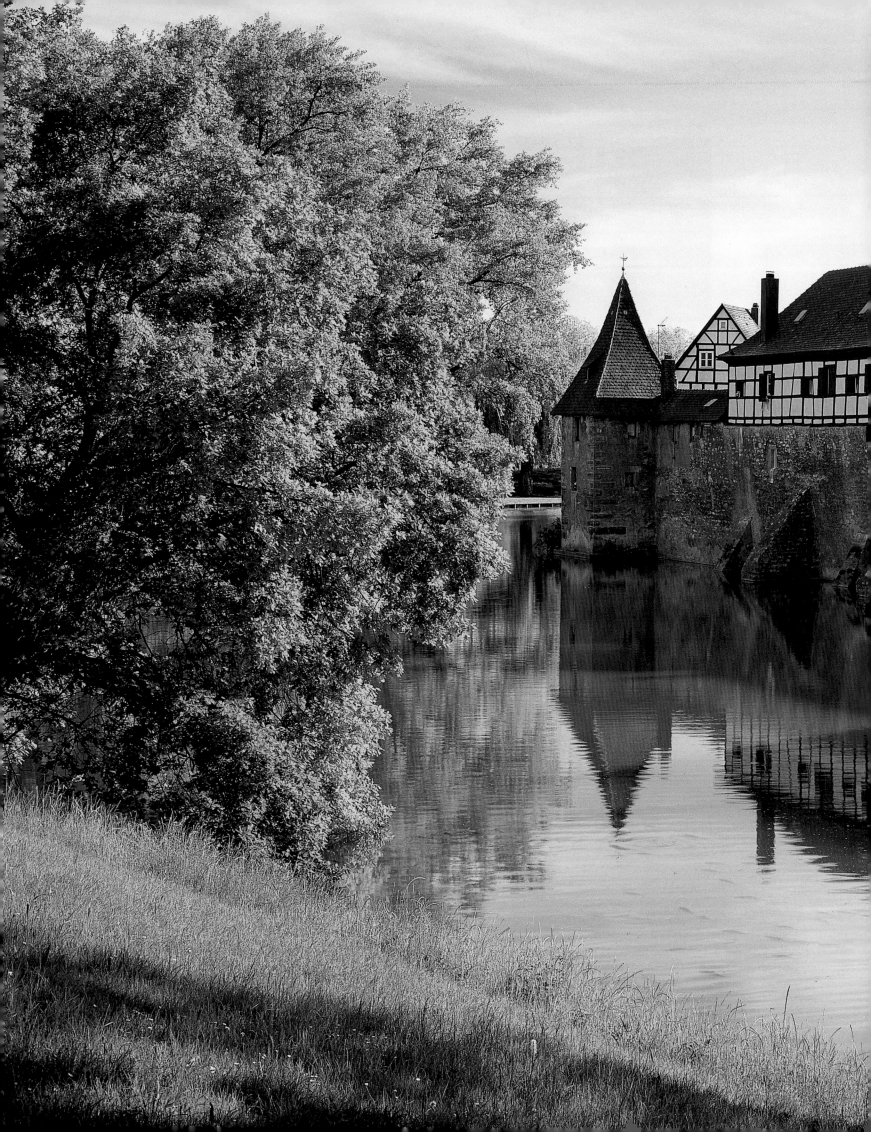

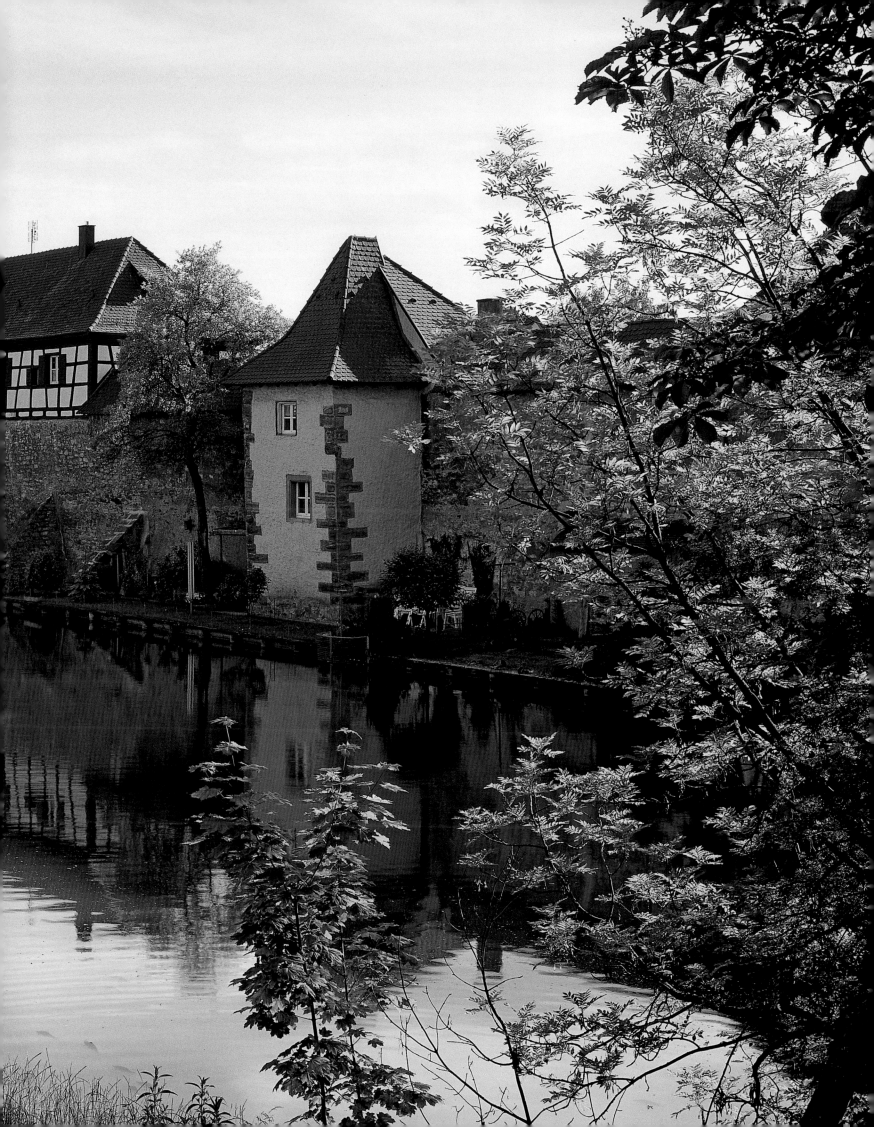

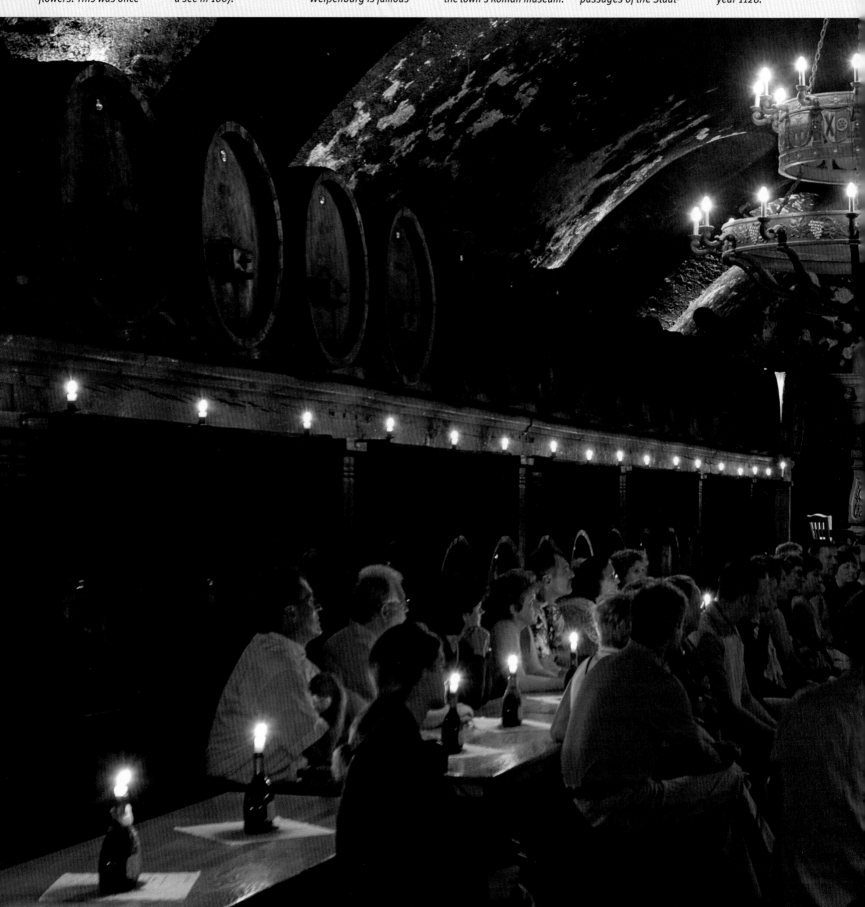

First page:
In summer the window boxes lining the courtyard of the Alte Hofhaltung in Bamberg are filled with flowers. This was once

Emperor Heinrich II's imperial palace and later the seat of the bishop when Bamberg was made a see in 1007.

Previous page:
Part of the old defences of Weißenburg in Bayern, formerly a free city of the Holy Roman Empire. Weißenburg is famous

for its Roman "treasure", buried here in the 3rd century BC and only rediscovered in 1979. The major finds are on show at the town's Roman museum.

Below:
The Residenz in Würzburg is undermined by the wine vaults and underground passages of the Staat-

licher Hofkeller. One of the largest traditional wineries in Germany, the state cellars date back to the year 1128.

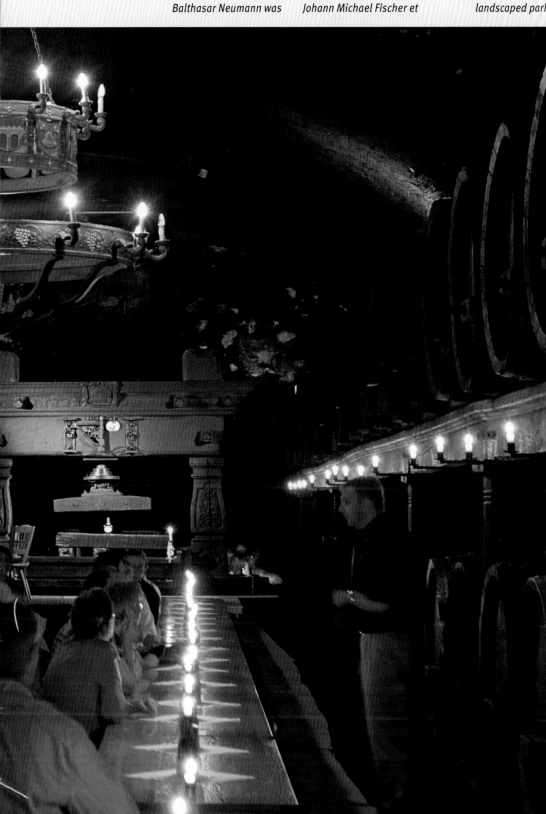

**Page 10/11:**
*Side view of the Residenz in Würzburg. The famous baroque palace by Balthasar Neumann was built between 1720 and 1744; the Hofgarten, laid out from 1756 onwards by Johann Michael Fischer et al, is a combination of symmetrical Rococo gardens and informal landscaped park.*

# Contents

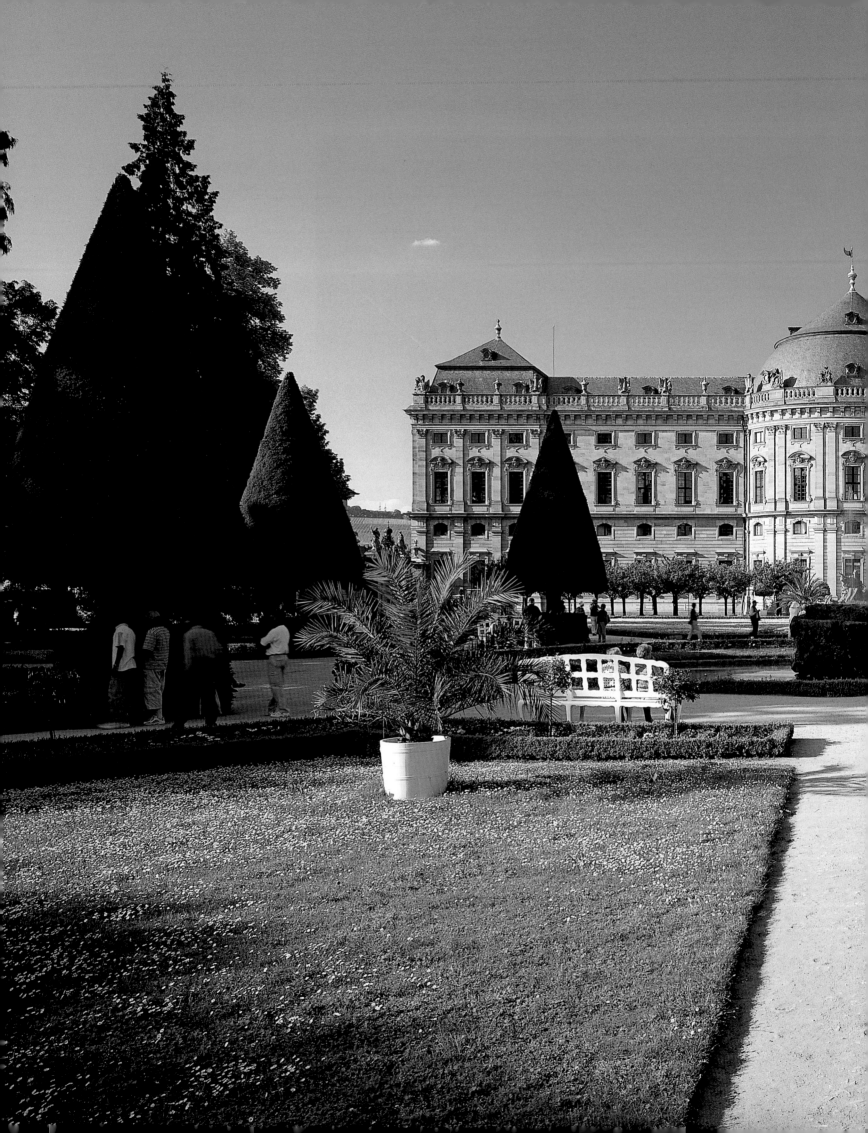

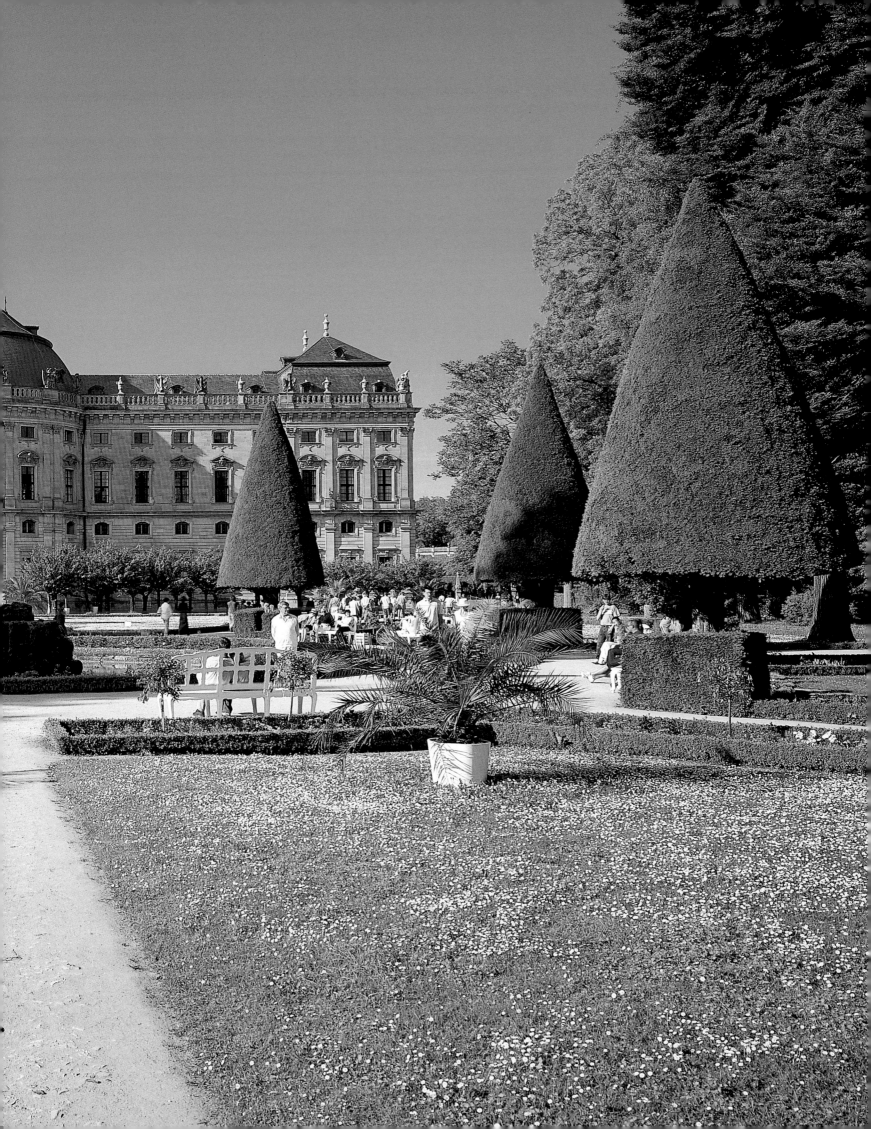

# Franconia – a land blessed

Wohlauf, die Luft geht frisch und rein,
wer lange sitzt, muss rosten;
den allersonnigsten Sonnenschein
lässt uns der Himmel kosten.
Drum reicht mir Stab und Ordenskleid
der fahrenden Scholaren,
ich will zu guter Sommerzeit
ins Land der Franken fahren!

Der Wald steht grün, die Jagd geht gut,
schwer ist das Korn geraten;
sie können auf des Maines Flut
die Schiffe kaum verladen.
Bald hebt sich auch das Herbsten an,
die Kelter harrt des Weines;
der Winzer Schutzherr Kilian
beschert uns etwas Feines.

Wallfahrer ziehen durch das Tal
mit fliegenden Standarten;
hell grüßt ihr doppelter Choral
den weiten Gottesgarten.
Wie gerne wär ich mitgewallt;
ihr Pfarr' wollt mich nicht haben!
So musst ich seitwärts durch den Wald
als räudig Schäflein traben.

Zum heil'gen Veit zu Staffelstein
komm ich emporgestiegen
Und seh die Lande um den Main
zu meinen Füßen liegen:
Von Bamberg bis zum Grabfeldgau
umrahmen Berg und Hügel
die breite, stromdurchglänzte Au –
ich wollt, mir wüchsen Flügel.

It was with great enthusiasm that Joseph Victor von Scheffel penned his ode to Franconia in the 19th century (left), waxing lyrical about its lush forest, good harvest and fine wines as he wandered its rolling hills and fertile valleys. Even the likes of Johann Wolfgang von Goethe were much taken with this part of Germany, having Maria in his drama *Götz von Berlichingen* proclaim that "Franconia is a land blessed". The region between the Spessart and the Fichtelgebirge, between the River Rhön and valley of the Altmühl is rich in scenery, ranging from the raw climes of low mountains to the positively idyllic Fränkische Schweiz or Franconian Switzerland, from the wide sweeps of the River Main to the sparkling lakes of the Fränkisches Seenland, from the dark forest of the Spessart and Steigerwald to the open fields of the Ochsenfurter Gau. The diversity of the landscape is matched by that of its cultural monuments which eloquently tell the tale of Franconia's turbulent past. Impressive houses of worship are not only found in the bishoprics of Bamberg and Würzburg; major centres of pilgrimage, such as the churches of Vierzehnheiligen and Gößweinstein, are also spectacular legacies of a people deeply rooted in religion. The old free cities of the Holy Roman Empire, such as Nuremberg and Rothenburg ob der Tauber, still effuse the civic pride which went into their making; countless castles and mansions yet smack of a thirst for representation harboured by Franconia's counts and princes. Ansbach and Bayreuth have their margravial residences; Schloss Johanissburg in Aschaffenburg is considered to be one of the finest late Renaissance palaces in Germany. The stately homes of the Schönborn dynasty stand proud in Pommersfelden and Mespelbrunn and medieval strongholds cling to the jagged peaks of the Fränkische Schweiz.

Franconia is also blessed with fertile soil and a mild climate in its more sheltered areas, such as in the valley of the River Main. Its most famous local produce is wine; asparagus, fruit and vegetables and even tobacco also thrive here. Grain and sugar beet are cultivated in the gaus. Barley is grown for beer in Unterfranken and in the west of Oberfranken and hops near Spalt and Hersbruck – both essential commodities, as the Fränkische Schweiz has the highest density of microbreweries in Germany. Below the soil there are more treasures to be had; in the Rhön and elsewhere underground springs bubble with goodness. This is where lava, pressed beneath coloured sandstone, once fought its way back to the surface, creating deep crevices in the land which gradually filled with mineral water. Its healing properties are

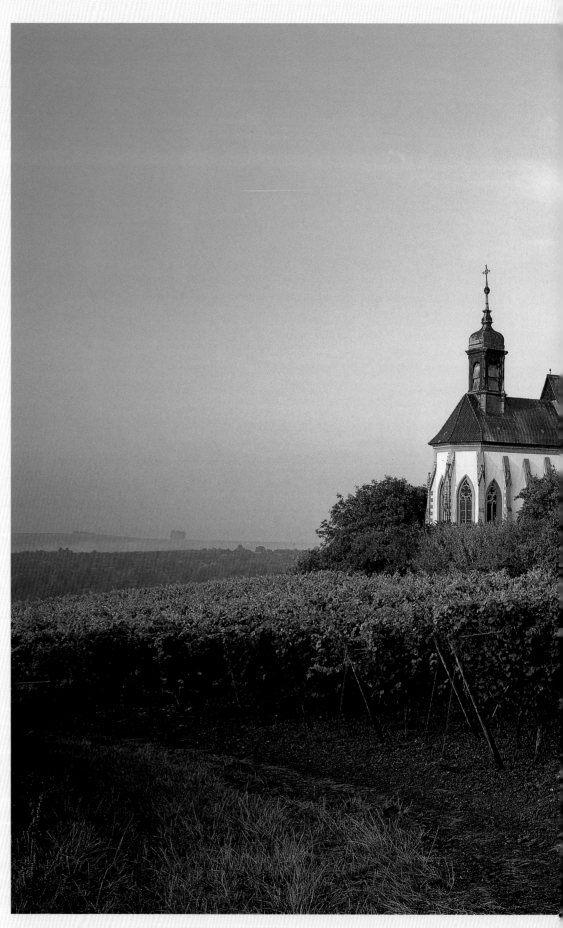

*The pilgrimage church of Maria im Weingarten outside Volkach lies at the top of a hill surrounded by vineyards. Its interior is dominated by Tilman Riemenschneider's lime-wood Madonna of the Rosary, one of his final works. The statue of Mary was stolen in 1962 and returned under very dubious circumstances.*

many. The waters of Bad Brückenau, for example, claim to alleviate rheumatic conditions, gastrointestinal complaints and women's ills; the carbonated saline springs of Bad Neustadt an der Saale soothe irritations of the gall bladder and intestines. King Ludwig I of Bavaria was a frequent visitor to the former and had his favourite architect Leo von Klenze erect a baths and pump house there in the style of the Ancient Greeks. The Rakoczy and Pandur springs in Bad Kissingen once attracted an illustrious public who included Empress Elisabeth (Sissi), Tsar Alexander II and Bismarck, their presence catapulting the health resort to world fame. Bad Bocklet was turned into a Rococo wellness paradise by the prince-bishops of Würzburg. With Bad Königshofen in the mountains of the Hassberge, the saline springs of Bad Staffelstein in the upper valley of the Main, Bad Alexandersbad, Bad Berneck, Bad Steben, Bad Rodach and Bad Windsheim the number of spa towns in Franconia almost makes up a full dozen.

### Before the Franks in Franconia

Long before the noble clientele of Franconia's spas there were the Franks. And before the Franks there were many other tribes and peoples. Mainfranken has been inhabited since the Neolithic period; until 100 BC the Celts erected forts at Schwanberg, Walberla and Staffelberg, to name but a few. They were driven out by the Romans who used the River Main as a watery frontier, having it form the northern boundary of the Roman Empire in the province of Germania. The Roman camp on Kapellenberg in Marktbreit and the excavated finds in Weißenberg are proof of Roman rule – which ended abruptly in 212 AD when the Teutons broke through the defensive Limes wall and destroyed a Roman fort near what is now Gunzenhausen. During the migration of the peoples emigrants from far and wide came and settled in Franconia. In c. 500 Alemanni and Thuringians lived here; parts of Upper Franconia had a distinctly Slavic influence. Fifty years later the tribe of the Franks, who originally came from the Middle and Lower Rhine, began a planned occupation of the area. In 689 the Franconian apostles, three Christian missionaries from Ireland named Kilian, Kolonat and Totnan, were killed for their beliefs in Würzburg; their deaths, however, did little to halt the progress of Germany's 'new' religion. The monks were murdered at the instigation of the wife of Duke Gosbert, himself a convert,

after Kilian demanded that Gosbert leave his spouse. Kilian immediately became a martyr and was later canonised, becoming permanently ingrained on the minds of the local populace when he was made patron saint of the diocese of Würzburg, founded in 742.

Under Emperor Charlemagne Francia Orientalis or East Franconia was an outpost defending the empire against the Slavs on the Upper Main and the Bavarians to the south. What remains of this period is an enormous canal project near Graben, north of Treuchtlingen, in which in 793 Charlemagne attempted to join the Fränkische Rezat River with the Altmühl and thus the Main with the Danube. At peak periods of activity up to 6,000 men are thought to have been at work on the Fossa Carolina. Yet boggy ground and more pressing engagements – such as war – soon caused the project to be abandoned. The next monarch to take up Charlemagne's ambitious idea was King Ludwig I of Bavaria, whose König-Ludwig-Kanal joined Bamberg and Kelheim in 1846. Along its 178 kilometres (110 miles) ships had to navigate no less than 100 locks in six days and cope with depths of a mere 1.6 metres (5 feet). The new railway built soon afterwards proved faster and more lucrative than Ludwig's canal and it was quickly forgotten, with parts even filled in. Today its towpaths are frequented by nothing more industrious than a few energetic hikers and cyclists. A third canal was created between the 1970s and 1992; the relatively new Rhine-Main-Danube Canal now again links Bamberg and Kelheim by water. The canal is, however, the subject of heated debate among ecologists and has yet failed to satisfy optimistic economic prognoses.

### Between worldly and religious powers

During the reign of the emperors of Saxony the duchy of East Franconia was established sometime after 930. It was never a power in its own right, however, forever a mere kingdom subjected to the rule of the emperor. In 1007 Emperor Heinrich II founded the bishopric of Bamberg and put it under the control of the pope. In 1168 Staufer Friedrich Barbarossa supported the Würzburg bishops' claim to have Franconia recognised as a duchy – a claim allegedly based on swindle, with the bishops presenting the emperor with a forged document which stated that the dukes of Würzburg had always been dukes of Franconia. Barbarossa happily confirmed their petition as the bishop of Würzburg had just married him to the 12-year-old Beatrice of Burgundy – who happened to be the sole heir to this rich stretch of land. In an attempt to curb the power of the

*The corner shop has become a rarity not only in Franconia; this one run by Frau Leutzsch still services the villagers of Hummeltal in the Fränkische Schweiz near Bayreuth. Village life is also the subject of the open-air museums in Bad Windsheim and Fladungen where old traditions are frequently demonstrated – from brewing to the baking of Christmas biscuits.*

two bishoprics, during the 11<sup>th</sup> century parts of Franconia were put under the care of imperial administrators who answered directly to the king. The mighty dynasty of the Salians also began extending their royal estates along the boundary of Franconia between the dioceses of Bamberg and Eichstätt. The tussle for imperial power was manifested in the building of the city of Nuremberg. The foundation of further towns (Rothenburg, Feuchtwangen, Ansbach, Dinkelsbühl and Schweinfurt) helped secure the might of the emperor. In the late Middle Ages both worldly and religious rulers found themselves facing serious competition from economically potent cities striving for freedom and independence.

By the beginning of the 16<sup>th</sup> century Franconia had been split into a "jumble of large, medium and small territorial sovereignties all boxed into one another with their religious and worldly, municipal and knightly rulers" which according to Hans Max von Aufseß gave it a "colourful" character manifested in "the variety of its scenery and the rich diversity of its buildings and styles".

### The Peasant War, Reformation and Counter-Reformation

In c. 1500 Emperor Maximilian I reordered his empire into ten sections, consolidating 24 separate territories in the district of Franconia which more or less matched the bounds of the present region – minus the Lower Main area between Miltenberg and Aschaffenburg, then part of the Mainz district, and Coburg and Dinkelsbühl. A period of turbulence then marked the first half of the 16<sup>th</sup> century; in 1517 Martin Luther published his 95 Theses and in 1525 the Peasant War began, during which countless castles and churches were razed to the ground. The nucleus of the uprising was in the territories of imperial city Rothenburg, with the peasants setting down their demands in the *Ochsenfurter Ordnung* (Order of Ochsenfurt). Just a short while later, in June of the same year, the rebellion was brutally quashed and one of their leaders, Florian Geyer, murdered in the Gramschatzer Wald near Würzburg. At the same time the Reformation was taking hold in Germany – both in the bishoprics and beyond. The margravates of Ansbach and Bayreuth and many castles and cities peacefully accepted the new doctrine; there were no religious images burned in Franconia. In 1530 Martin Luther was given sanctuary in the fortress at Coburg during the Diet

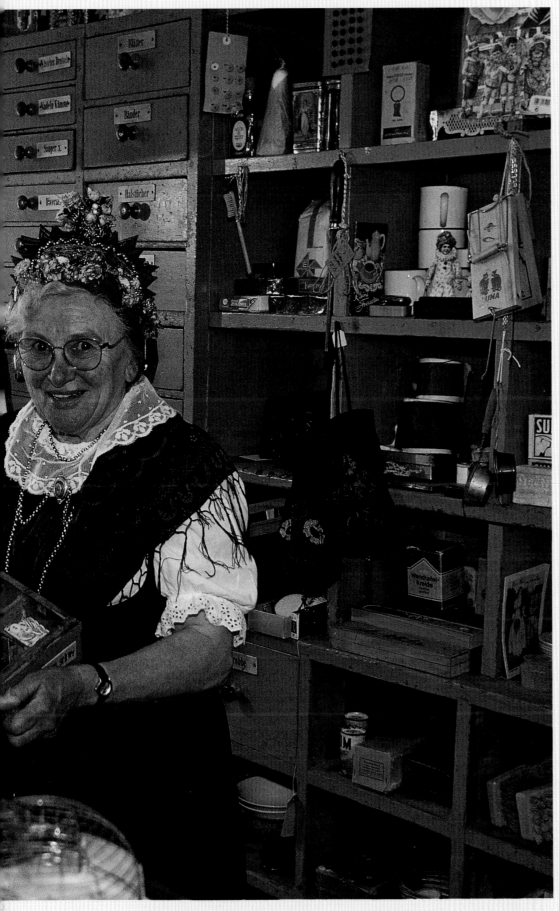

of Augsburg. Yet at the end of the 16th century the tide turned; Julius Echter von Mespelbrunn launched the Counter-Reformation and began persecuting non-conformers in monasteries and convents. Under the auspices of Philipp Adolf von Ehrenburg over 900 'witches' were condemned to death. Where Catholics and Protestants had happily existed side by side, after 1609 professed Lutherans were ordered to leave the diocese of Bamberg by Bishop Johann Gottfried von Aschhausen. The Counter-Reformation did have a less violent side, however. Art in Franconia blossomed, with Julius Echter endeavouring to disseminate his beliefs among the people through the language of architecture, initiating the construction of around 400 buildings, among them numerous churches, the university and the Juliusspital for the poor and needy of Würzburg. The many Julius steeples – massive towers with a pyramid roof – still visible on many of the village churches in the diocese bear witness to the region's return to Catholicism.

### Baroque building fever

During the Thirty Years' War Franconia was not one of the main arenas of the fighting but did suffer from plundering, famine and the bubonic plague. Following the Peace of Westphalia a Banquet of Peace was held in Nuremberg in 1649/50. The bishoprics of Würzberg and Bamberg were now Catholic and the margravates of Ansbach and Bayreuth still Lutheran, with smaller towns and villages of both persuasions often neighbours. The almost unchecked power of potentates both great and small subsequently gave rise to the construction of countless representational buildings during this period of absolutism. The Schönborn dynasty was particularly prolific in this field, rising to power with the naming of Johann Philipp as prince-bishop of Würzburg in 1642 and staying at the top for the next 150 years thanks to a complex network of brothers, cousins and nephews all 'eligible' for the post. Prince-Bishop Lothar Franz von Schönborn was particularly smitten by "building fever", claiming: "Building is the work of the Devil, for once you have started you cannot stop". This was the period which produced the royal residences in Würzburg and Bamberg, the palaces in Pommersfelden, Ansbach and Bayreuth, in Werneck, Wiesentheid, Schillingsfürst and Sanspareil and the pilgrimage churches of Maria Limbach, Gößweinstein and Vierzehnheiligen.

At the beginning of the 19th century, after existing as a unit for 300 years despite its many internal subdivisions, Franconia was wiped off

the map. The special *Reichstag* commission responsible for dividing up Napoleonic territories in Germany in 1803 and the Congress of Vienna in 1814/15 handed much of Franconia over to Bavaria, with smaller portions going to Hesse, Baden and Württemberg. The monasteries were dissolved and works of art and valuable libraries carted off to Munich by Minister Montgelas.

### The first German railway

Although industrialisation was slow coming to Franconia, the region did boast the first railway in Germany in the Nuremberg to Fürth line. A modest 6.4 kilometres (ca. 4 miles) long, it was a major achievement when on December 7 1835 Germany's first steam engine took to the rails. The Adler (eagle) was a British-Franconian collaboration; the locomotive, purchased in England, chugged along newly-laid tracks fabricated in Raselstein, pulling coaches manufactured in Lohr, Fürth and Nuremberg. The enterprise boomed; by 1848 a route from Nuremberg to Hof via Bamberg had been finished. Other Franconian claims to 19th-century industrial fame include the pencils of Lothar Faber, the ball bearings of Friedrich Fischer in Schweinfurt and the paints of Wilhelm Sattler.

With Coburg's voluntary annexation to Bavaria in 1920 Franconia more or less reached its present proportions. In 1937 the administrative districts of Unterfranken, Mittelfranken and Oberfranken (Lower, Middle and Upper Franconia) were created and in 1945 Ostheim vor der Rhön was added to the area, formerly part of Thuringia. Under the National Socialists Nuremberg was the infamous venue of the Nuremberg Rallies. In 1935 the Nuremberg Laws were passed in which mixed-race marriages between Jews and "citizens of German or kindred blood" were punishable by law and in 1945 Nuremberg hosted the Nuremberg Trials in which the International Military Tribunal indicted and tried former Nazi functionaries. The old Nazi stadium with its ruined remains of a rule of terror now features a museum documenting the rallies and the Nazi propaganda machine.

The air raids of the Second World War largely destroyed the historic centres of Nuremberg and Würzburg and the industrial areas of Aschaffenburg and Schweinfurt and did much damage to many other smaller towns and villages. The rebuilding process was rapid and thorough but in the wake of the division of

Germany parts of Upper and Lower Franconia again found themselves on the front line of the new 'battle' between East and West. Only since the fall of the Berlin Wall in 1989 is Franconia again at the heart of Germany.

## The difference between Franconians and Bavarians

Franconia may now be the geographical nucleus of the country as a whole but as part of Bavaria – the federal state responsible for its administration – it feels decidedly sidelined. Often feeling neglected by the policies drawn up in far-away Munich – the regional capital of Bavaria – Franconians insist first and foremost that they are Franconian and not Bavarian. Like Bavaria with its autonomous tendencies towards Germany – it is very proud of its designation as a free state – many Franconians would also like their home to be a federal state in its own right. Even their name smacks of independence; the ethnic term "Franke" in German, from medieval Latin "francus", once meant "a free man" in reference to the Franks' great dominance as conquerors and rulers and to the freedom gained from being one of their tribe, a sentiment still echoed in the phrase "frank und frei" or "frank and free".

Incidentally, the Bavarians feel similarly towards their Franconian neighbours. The words Ludwig Thoma has his fictitious Bavarian government official Jozef Filser write in his *Briefwechsel eines bayrischen Landtagsabgeordneten* in 1909, claim: "Abroad begins across the Danube with the province of Franconia". And it's not just the river which separates them. Like Britain and America, Bavaria is also a nation divided by a common language. And not German, mind you, but Bavarian – or rather Franconian. And even this has its own quirks and idiosyncrasies. If you're struggling with your German, trying to converse with a Franconian who only speaks his or her very local variety of the lingo can be extremely frustrating. The simple name of a river, for example, can range from *Maa* to *Mee* to *Moo* – in High German (and English) the River Main (in itself confusing for non-German speakers as it's pronounced "mine" and not "main" as you might expect). And where things get really complicated is with the food. Fathoming German menus is not made easier by the fact that in Bamberg even the vegetables have their own special termini. *Keesköhl* is *Blumenkohl* (cauliflower), *Benät* is *Spinat* (spinach) and *Stazzänäri* are *Schwarzwurzeln* or salsify, the latter not only linguistically obscure but also a rarity to any British table. Once you've waded your way through the dishes of the day, possibly

*St Kilian and two of his companions are said to have once erected a cross on Kreuzberg in the Rhön, hence the name Kreuzberg ("crucifix mountain") for Franconia's holy hill.*

amid much sign language and frantic searching in dictionaries, when it comes to securing your meal you can expect the equivalent of a blunt – and to English-speaking ears pretty rude – "What d'you want?" instead of a (more usual) polite request for your order. In Bamberg you may also find yourself going thirsty; the desire for a top-up is indicated by lying your empty glass down on its side – that's if you've managed to secure a drink in the first place. At the traditional Mahrs brewery the famous beverage is served in response to two syllables only: "A" for "ein" or "a" and "U" for ungespundetes Bier, a non-carbonated beer.

### Of singers and poets

Luckily, the poets of Franconia preferred to use slightly longer sentences more readily discernible to the general public. Despite possible linguistic difficulties an abundance of literati famous well beyond the local boundaries lived and worked here. The Middle Ages resounded to the courtly minnesong of native Franconians, among them Wolfram von Eschenbach and Walther von der Vogelweide. The epic genre culminated in the *Meistersang* or master song, zealously cultivated by poet-craftsmen in the towns of the 14th to 16th centuries. Singing was governed by strict rules, with many of the guilds running their own affiliated singing schools. *Meistersingers* were responsible for singing in churches and taverns. The most famous of them all, Hans Sachs, was born in Nuremberg the son of a master tailor and trained as a shoemaker. Around 4,000 of his master songs have survived.

Another prolific literary circle with a slightly less musical bent was the group of poets based in Nuremberg, members of the delightfully-sounding Löblicher Hirten- und Blumenorden an der Pegnitz (the Commendable Order of Shepherds and Flowers on the River Pegnitz) founded by Georg Philipp Harsdörffer in 1644. Decidedly better known than their output of poems dedicated to nature, love and the joys of shepherding was one Jean Paul, one of the best-read authors of his day and said to be more popular among his contemporaries than Schiller and Goethe. After spending time in Weimar, Leipzig and Berlin he rented a room at the Rollwenzelei inn outside Bayreuth near the hermitage where he was so well cared for that he had cause to remark: "Unfortunately my body is also producing at an alarming rate and I am growing fatter by the day."

In 1808 ETA Hoffman came to Bamberg where he was to spend five years working at the theatre. The Romantic poet of Franconia per se was Friedrich Rückert. Clemens Brentano died in Aschaffenburg. Leonhard Frank from Würzburg, Jakob Wassermann from Fürth and Hermann Kesten from Nuremberg were all Franconian writers of the 20th century who suffered at the hands of the Nazis; Frank and Kesten both left Germany.

Franconia was not only famous for its literature, however; also in other fields its name travelled far and wide. During the 15th century Johannes Müller of Königsberg, better known as Regiomontanus, the Latin for Königsberg ("king's mountain"), was the most illustrious mathematician and astronomer in Europe and founded the first German observatory in Nuremberg. Martin Behaim from Nuremberg claimed to be one of his alleged pupils while in Portugal and was accepted as a member of the Junta of Astronomers and Mathematicians there. Back in Nuremberg he made the oldest globe still in existence, now on display at the Germanisches Nationalmuseum (National Germanic Museum) in Nuremberg. Staffelstein was the birthplace of master of sums Adam Ries, often incorrectly called Adam Riese, whose books on the practice of arithmetic dominated maths lessons for centuries. In the 19th century Wilhelm Conrad Röntgen discovered x-rays in Würzburg and Aloys Alzheimer, the first physician to diagnose the disorder of the brain named after him, came from nearby Marktbreit.

"Franconia is like a magic cupboard; there is no end to the number of drawers which keep appearing, each revealing a shiny, colourful gem", wrote Karl Immerman in 1837. His words still hold true today; time and again you discover the diverse stretches of countryside, the hills, forests and river valleys, the beautiful cities and picturesque villages, the artistic and cultural monuments of this truly blessed region anew and there's still so much more to explore...

*Page 22/23:*
*Each September the Reichsstadtfesttage in Rothenburg ob der Tauber mark historical events, among them the salvation of the city during the Thirty Years' War. Amateur actors dressed in period costume re-enact scenes from its past at various locations throughout the town.*

*Page 24/25:*
*Nordheim am Main, situated west of Volkach on a picturesque bend in the River Main, is the largest wine-growing community in Weinfranken. Here you can taste wines from the Nordheimer Vögelein and Nordheimer Kreuzberg vineyards straight from the cellar.*

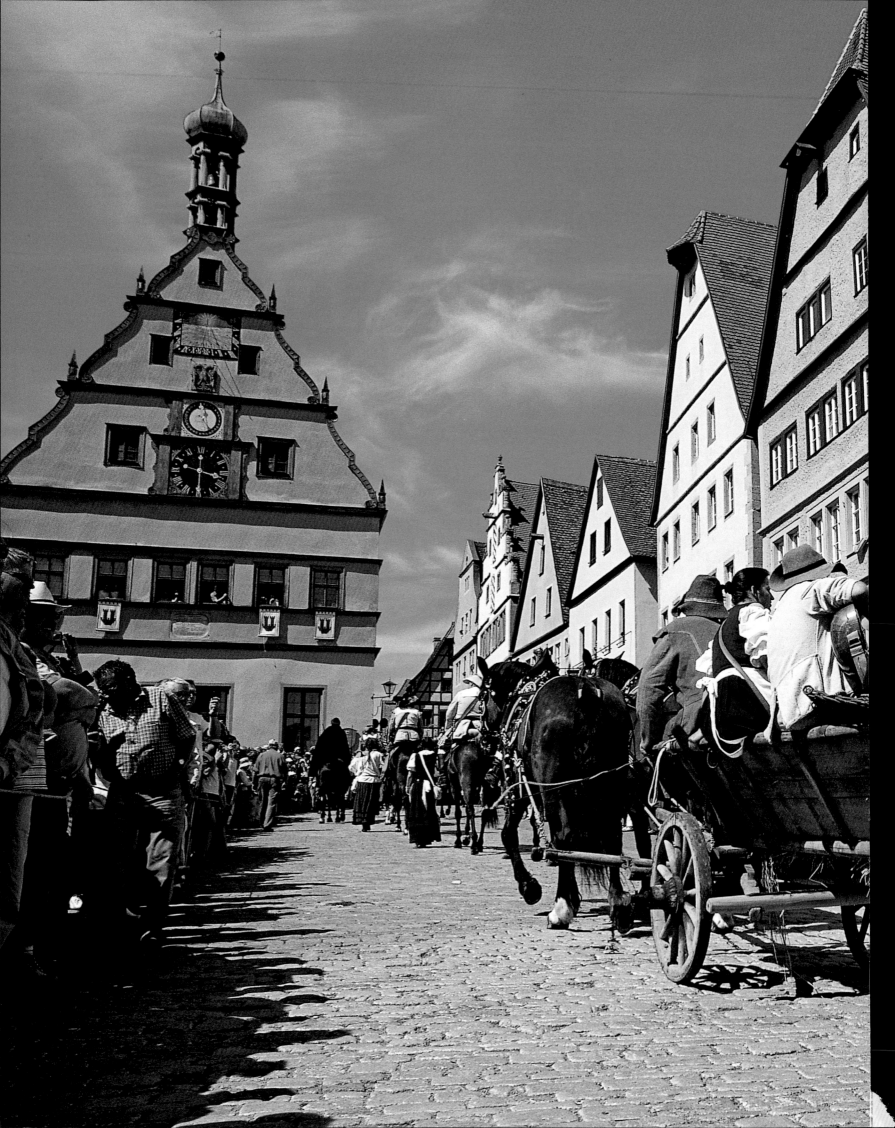

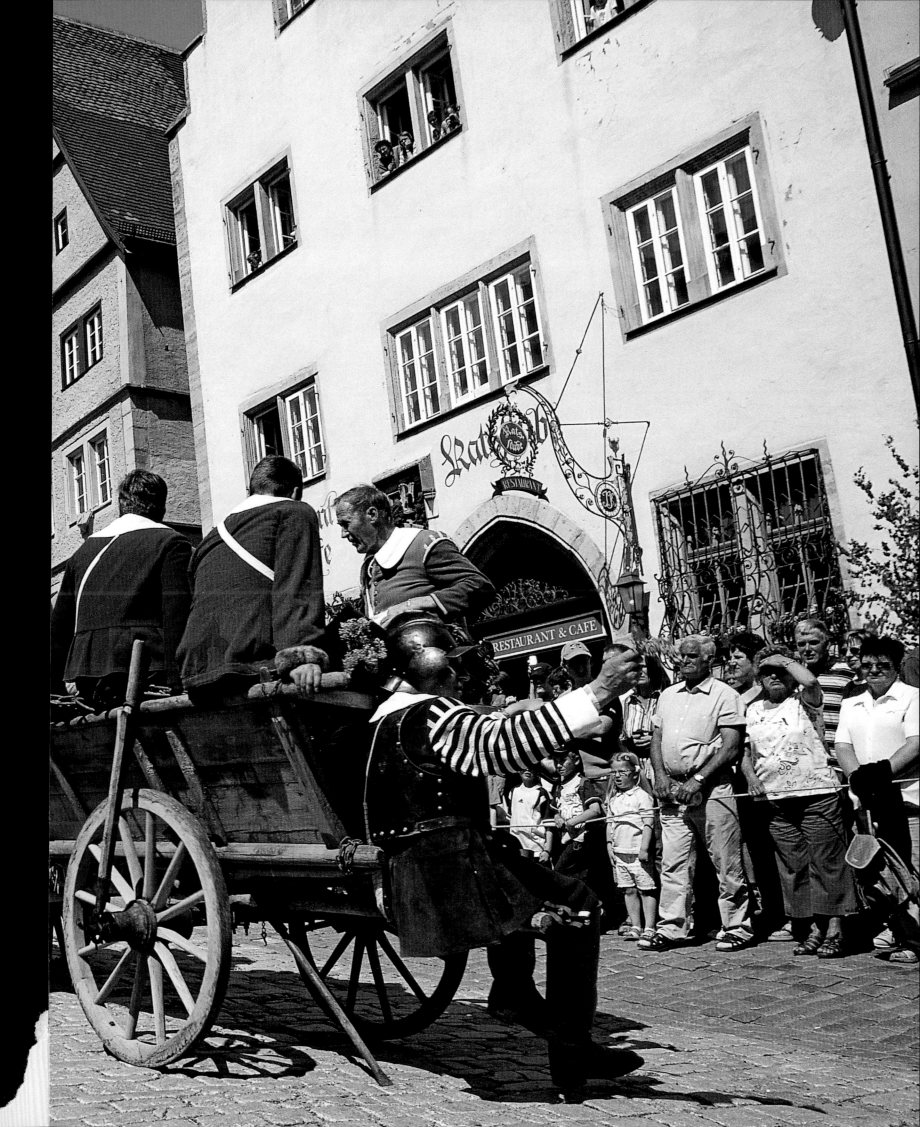

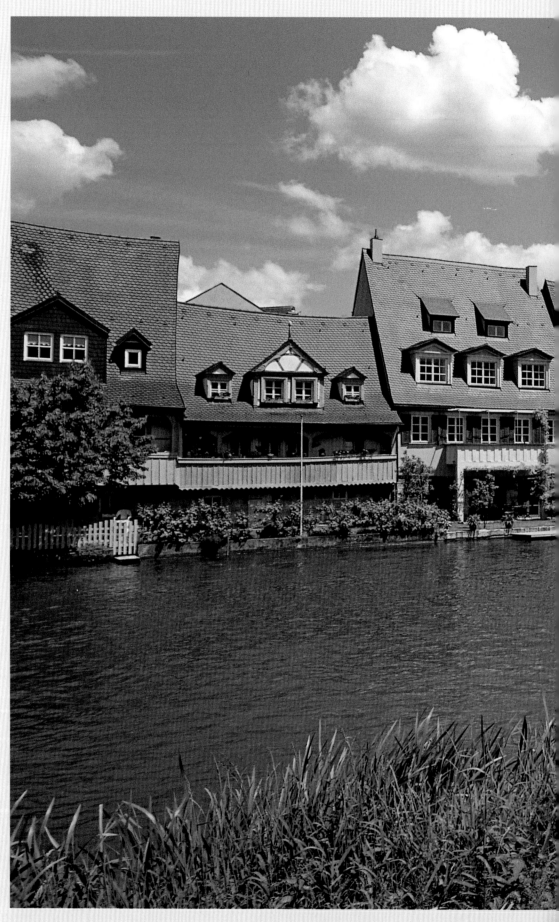

*The idyllic array of houses on the banks of the Regnitz, many with their own landing stages, is reminiscent of Venice and also known as such.*

*Klein-Venedig or Little Venice was home to the fishermen and boatsmen of Bamberg who once worked King Ludwig I's busy Main-Danube Canal.*

Three silver spikes on a red background make up the Franconian coat of arms, the 'Franconian rake' which symbolises the three administrative districts of the region: Unterfranken, Mittelfranken and Oberfranken (Lower, Middle and Upper Franconia). Contrary to expectations these names don't have anything at all to do with the geography of the areas – designating neither north and south nor up and down – with Oberfranken in the east next to Unterfranken and Mittelfranken south of these.

Historically speaking, the prince-bishopric of Bamberg and the margravate of Bayreuth were the largest and most important territories in the Frankish corner of the Holy Roman Empire. Architectural relics spanning one thousand years are still standing in Bamberg which hugs the contours of no less than seven hills and is now a World Heritage Site. The city's nine breweries are of a less ripe vintage but no less popular, especially in the hot summer months. Bayreuth is the administrative centre of Oberfranken and largely the work of Margravine Wilhelmine who turned the city into a sparkling royal residence peppered with palaces and parks. Her legacy is crowned by Wagner's impressive Festspielhaus atop its lush green mound. Coburg only became part of Franconia in 1920; prior to that it enjoyed special status under the auspices of the Wettin princes of Saxony.

To the south of the area lies the Fränkische Schweiz or Franconian Switzerland with its picturesque rock formations, idyllic river valleys, bizarre dripstone caves and mighty medieval castles, 'discovered' by German Romantics Ludwig Tieck and Wilhelm Heinrich Wackenroder on their wanderings. To the northeast Oberfranken culminates in the dark forest of the Frankenwald (Franconian Forest) and Fichtelgebirge (Spruce Mountains), the latter home to the Ochsenkopf and source of the Weißer Main, and also the highest peak in Franconia, the Schneeberg at 1,053 metres (3,455 feet) above sea level.

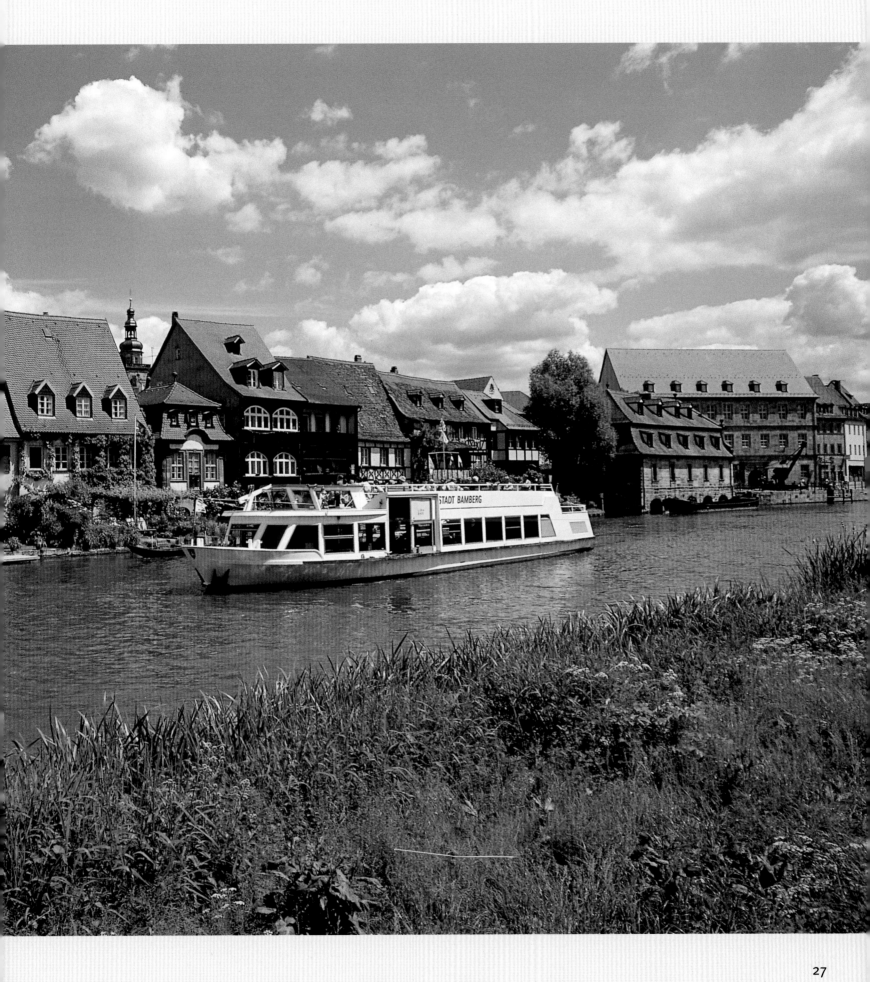

**Below:**
Archway underneath the Altes Rathaus in Bamberg seen from the Im Sand quarter. The three-storey tower on the Obere Brücke dates back to the Middle Ages; a baroque facade was later added with Rococo balconies and coats of arms by Bonaventura Mutschele. The facades on the long front were painted by Johann Anwander.

**Below:**
Parallel to the Obere Brücke is the Untere Brücke which crosses the Regnitz to the side of the Altes Rathaus or old town hall. Blown up at the end of the Second World War like so many other bridges, it wasn't restored but instead replaced by a plain concrete structure. Its one ornate feature is a Rococo statue of St Kunigunde by Peter Benkert, the only one of five to survive. In the background is the old slaughterhouse with its ox sculpture which now houses part of the university library.

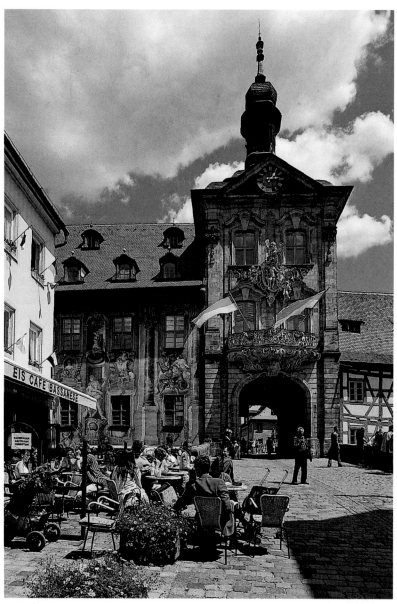

**Right page:**
Bamberg's Altes Rathaus enjoys a unique location on a man-made island in the River Regnitz. Since 1453 it has linked the old Im Sand quarter beneath the cathedral mound to the newer settlement on the other side of the Regnitz. The Rottmeisterhäuschen with its wonderful half-timbering was added in 1668.

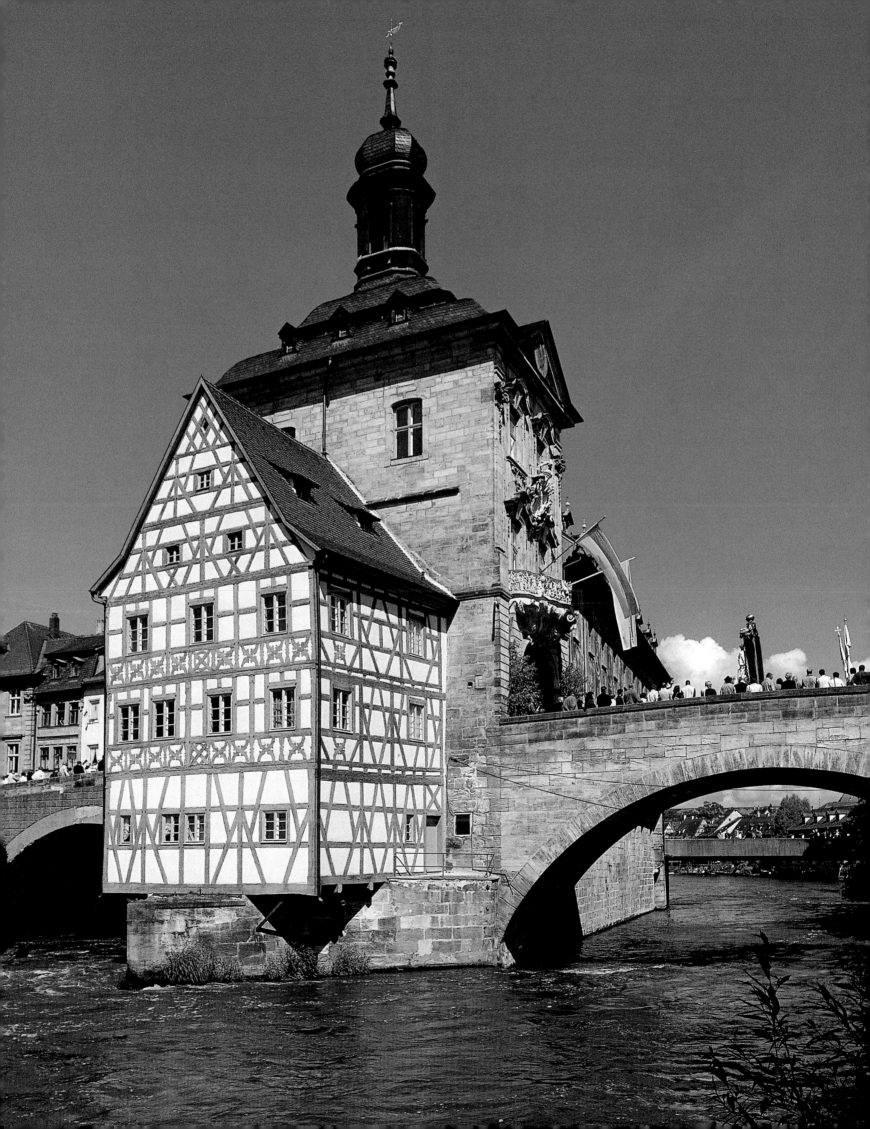

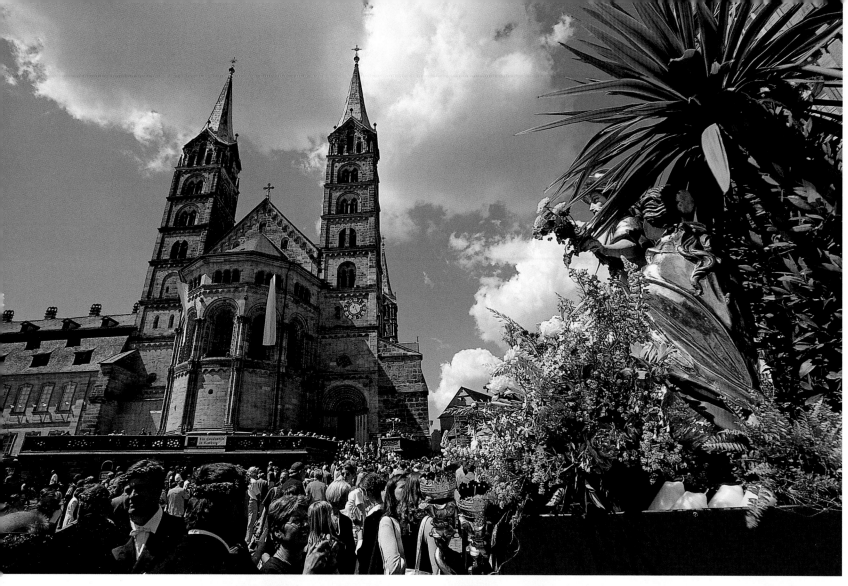

Corpus Christi is one of the highest feast days in the Catholic calendar. In honour of the occasion the bishopric of Bamberg holds a religious procession between the cathedral and Maxplatz where a concluding service is held. Life-size figures adorned with flowers of the Madonna and the saints and monstrances are paraded through the streets, with people singing and praying at makeshift altars set up along the route.

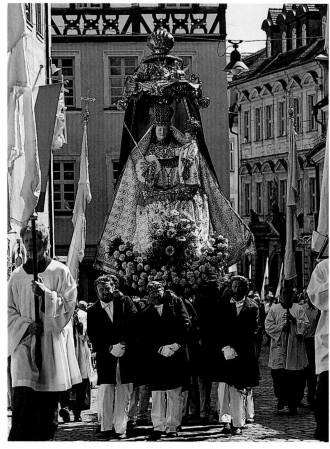

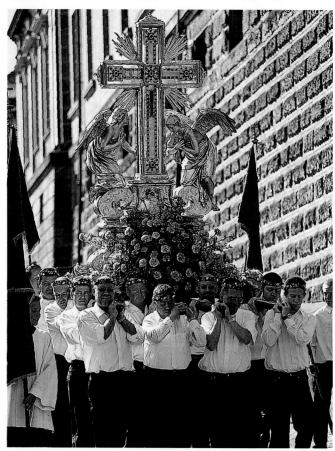

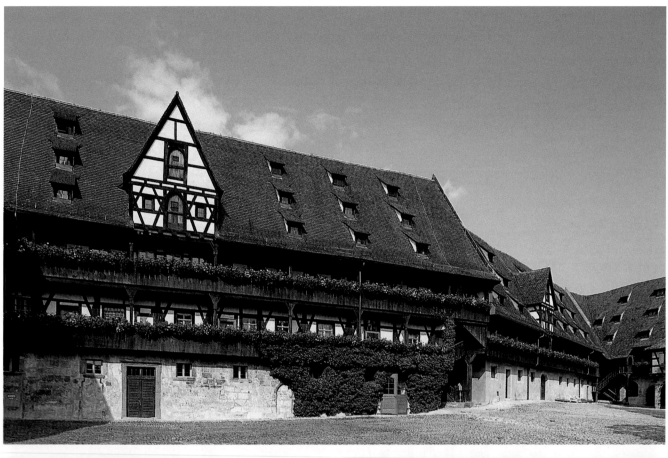

**Left:**
*Half-timbered buildings from the late Gothic period with high saddle roofs and long wooden balconies enclose the courtyard of the Alte Hofhaltung. In summer the square acts as a backdrop for the performers of the Calderon-Festspiele.*

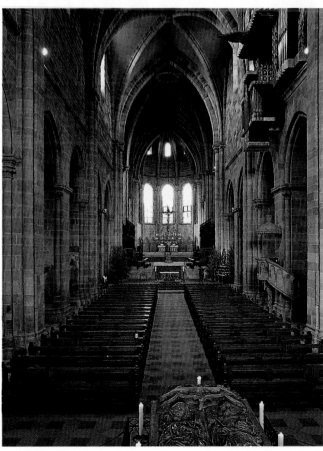

**Far left:**
*Bamberg's most famous statue is the Bamberger Reiter. To this very day this "masterpiece of western sculpture" remains a puzzle; we know neither the name of the figure the rider is supposed to represent nor of the artist. We do know that it was made in c. 1235 and that it was once painted.*

**Left:**
*View from the east choir (Georgenchor) of the early Gothic west choir (Peterschor) in Bamberg Cathedral. At the base of the photo is the tomb of Emperor Heinrich II and St Kunigunde sculpted by Tilman Riemenschneider. The west choir has the only papal grave north of the Alps, that of Clemens II who died in 1047. The interior of the church appears bare and cold due to the "stylistic cleansing" of the 19th century in which all post-medieval features were ruthlessly removed.*

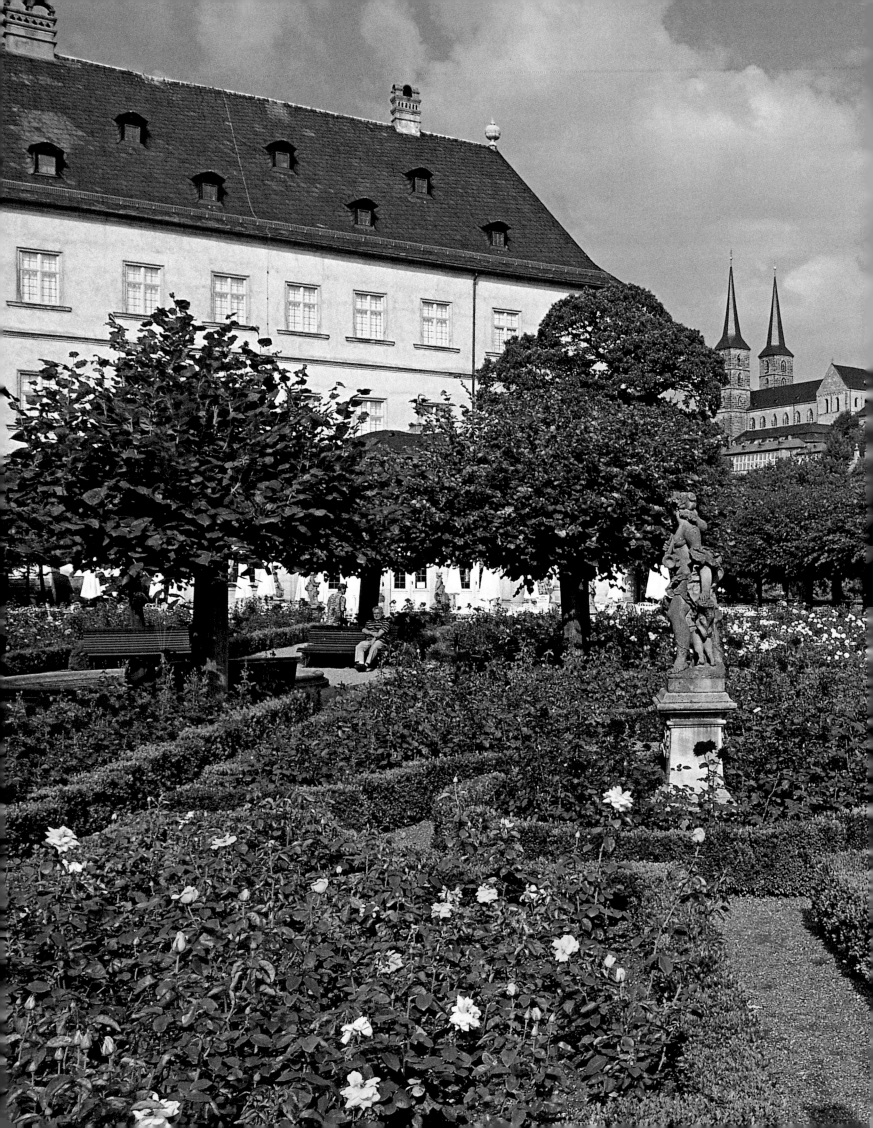

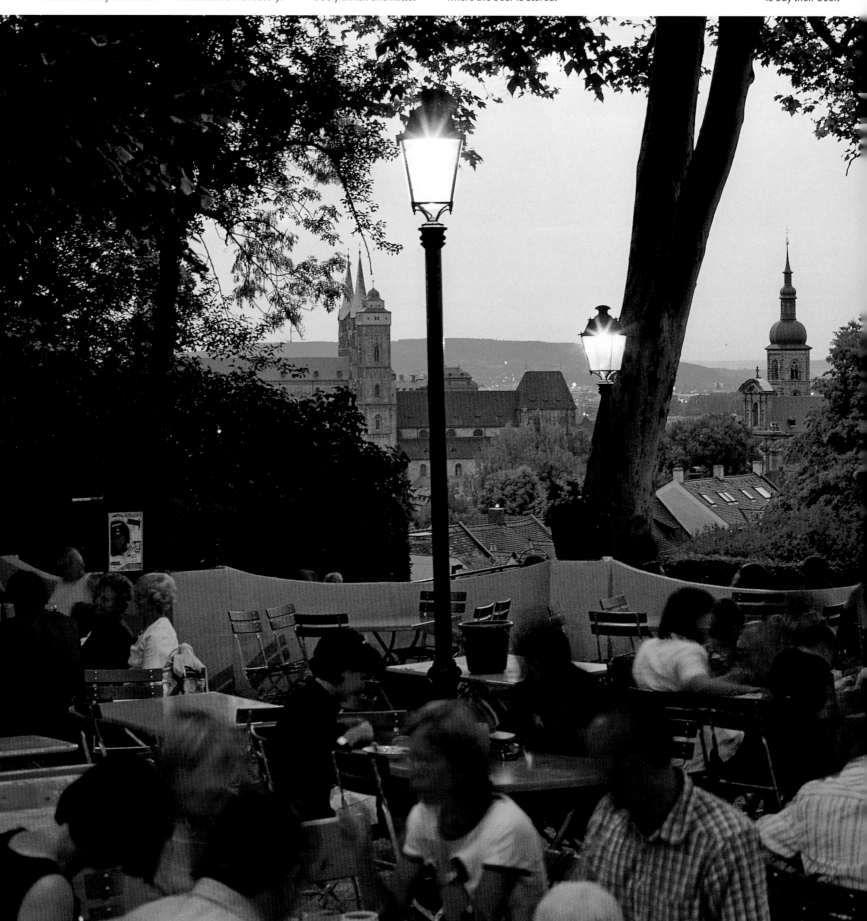

**Page 32/33:**
The rose gardens at the Neue Residenz in Bamberg are planted with 70 flower beds where 4,500 roses display their fragrant blooms over the summer months. The symmetrical array was laid out from plans by Balthasar Neumann in 1733. From here there are grand views out over Bamberg and the Michelsberg, crowned by what was once a Benedictine monastery.

**Below:**
One of the best views of Bamberg is to be had from the Spezial-Keller brewery over a cool Rauchbier. In Oberfranken and Mittelfranken you don't go down to the pub but "up on top of the cellar" for a drink as beer gardens are often laid out over the cellars below where the beer is stored.

**Top right:**
Young meets old at the beer gardens in Bamberg. Most of the city's microbreweries are unique in that they allow you to take your own Brotzeit or picnic; all you have to do is buy their beer.

**Centre right:**
The centre of Bamberg also has plenty of restaurants, brewery outlets and pubs where you can try Franconian specialities, such as Schäuferla (crispy fried shoulder of pork) and Krenfleisch (beef and horseradish).

**Bottom right:**
If you don't make it to the beer cellar, you can also try a genuine Schlenkerla Rauchbier or smoked beer on Bamberg's Katzenberg.

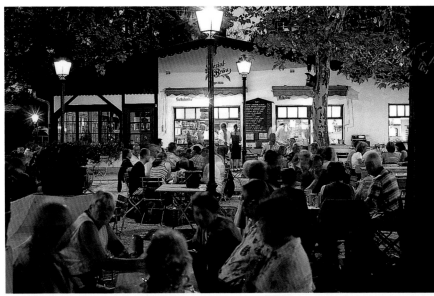

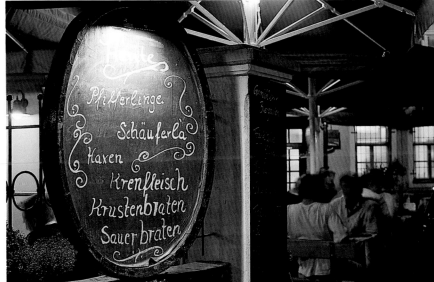

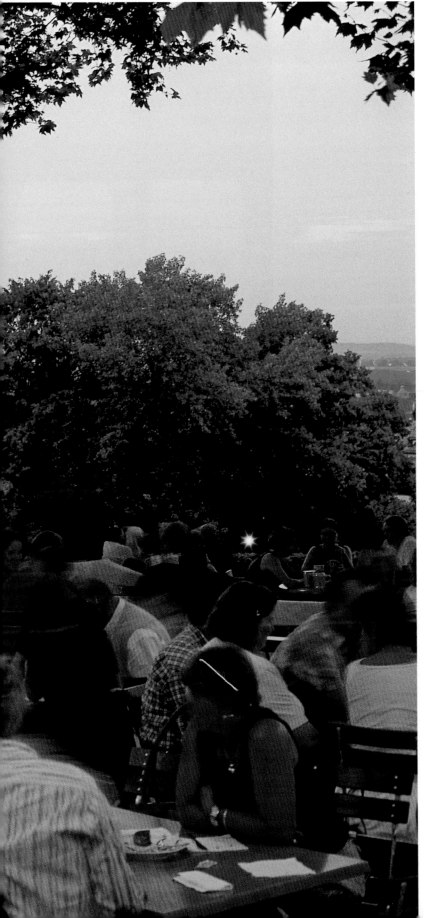

# STEINWEIN AND RAUCHBIER, BLAUE ZIPFEL AND ZIEBELESKÄS – FRANCONIAN DELICACIES

Send me a few bottles of *Würzburger*, for no other wine will satisfy my palate and I am morose when my accustomed drink has run out", Goethe once wrote to his wife Christiane. Where Goethe was disagreeable without his beloved dram, after wandering the wilds of Franconia satirical essayist Kurt Tucholsky was pained to comment the next morning: "We shouldn't have drunk so much *Steinwein*. But it was difficult; a thing of such purity, of sheer energy, abundant sunshine and sun-baked soil was unprecedented." Where both poets differ on the quantity of consumption, both at least agree on the quality of what must be Franconia's best-known beverage, *Würzburger Steinwein*. Würzburg is not, however, the only place in the region with wine; countless villages in the Maindreieck and Mainviereck areas and those clinging to the slopes of the Steigerwald serve their own fine vintages which as a rule are said to have a "noble dryness". Wine has been cultivated in Franconia since the 8th century. The oldest varieties of grape are Silvaner and Riesling; Müller-Thurgau was introduced here in 1880 and the new cultivars Bacchus, Scheurebe, Kerner and Rieslaner after the First World War. Schwarzriesling, Spätburgunder (Pinot noir) and Portugieser are used to make red wine which over the past few years is becoming ever less scarce in Franconia.

The symbol of Franconia wine per se is the rather crudely named *Bocksbeutel*, a wide, round bottle named after the scrotum (Beutel) of the ram (Bock). Wine is served in *Schoppen* (quarter-litre or ca. half-pint glasses); mixed with fizzy mineral water it's known as a *Schorle* and in autumn *Bremser* or *Federweiße* (wine which is still fermenting) is a speciality which can be savoured at one of the many *Heckenwirtschaften* or wine taverns selling their own wine and light meals for a limited period of time. The juice of the grape is celebrated at up to 250 festivals throughout the region – from the cosy gatherings at local wineries to the big-scale city events in Würzburg and Volkach.

### Schlenkerla, Spezi and Schäuferla
Wine is not the only drink indigenous to Franconia. *Weinfranken* has its beery counterpart in *Bierfranken* which covers parts of Oberfranken and Mittelfranken, with Kulmbach, Erlangen and Bamberg the urban epicentres of the region's brewing industry. Beer enjoys just as great a tradition as wine here and those who have exalted its praises include lyric poet Friedrich Hölderlin: "(...) and I easily forget our Neckar wine over a splendid beer which is drunk by myself and by

the masters alike. I also feel quite healthy drinking it." In Bamberg alone nine microbreweries are still up and running, each producing their own specialities. The most famous of these is Schlenkerla's *Rauchbier* which nonlocals are only said to acquire a taste for after drinking their third *Seidla* (half a litre or just under a pint). Its unique taste comes from the barley not simply being dried but smoked over a beechwood fire. The dark brew has been served at the Schlenkerla pub since 1678; another Bamberg *Rauchbier* or smoked beer which is second only in intensity to the first is even older, on tap at the Spezial or Spezi brewery since 1536. There are also wheat beers, light and dark ales, pilsners, lagers, bock beer and *Kellerbier*, with each brewery proudly touting its own individual varieties. And there are plenty of them, with the area around Bamberg having the most breweries per square kilometre in Germany. Aufseß in the Fränkische Schweiz even entered the Guinness Book of Records in 2000 for its output of beer per head of the population; its four breweries service a mere 1,500 inhabitants – statistically speaking, of course ...

Beer is the ideal accompaniment to a good Franconian *Brotzeit* – or vice versa. As the name suggests, this includes bread and any number of delicacies, ranging from *Ziebeleskäs* (quark), *Gerupfter* (camembert mashed with butter and onions), *Backsteinkäs* (Limburger cheese) dressed with *Musik* (oil, vinegar and onions) to *Leberwurst* (liver sausage), white and red *Presssack* (brawn), *Knäudele* (black pudding) and *Zwetschgenbamers* (beef smoked over wood from plum trees) to an entire plate or platter of *Brotzeit*, often served on a wooden board and usually featuring an array of homemade sausage and pâté. Sausages are also the staple of many warm dishes throughout Fran-

**Left:**
*Fine wines have been cultivated in Franconia since the 8th century. Silvaner, Müller-Thurgau and Riesling are best savoured at one of the many local wineries.*

**Above:**
*The Bayerisches Brauereimuseum (Bavarian Museum of Brewing) in Kulmbach pays homage to the great variety of beers in this marvellous collection of*

conia and vary in size and shape from the finger-sized *Nürnberger* to the long fat *Coburger*. One very unusual treatment of the pork sausage is the *Blauer Zipfel* which is boiled in wine and vinegar with onions to give it a blue sheen when cooked. Meat in any form indeed looms large on Franconian menus, some of the favourites being *Knöchla* (boiled pig's trotters) and *Schäuferla* (crispy fried shoulder of pork), roast pork, beef and *Kree* (horseradish) and also *Schlachtplatte*, a platter of various meats.

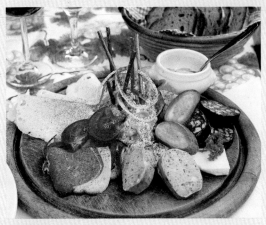

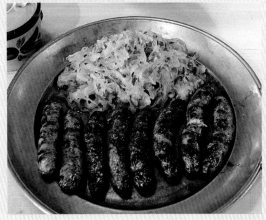

*mugs. Kulmbach also boasts the strongest beer in the world; with 11% alcohol and 28% original wort, its name is entirely appropriate: Kulminator.*

**Top right:**
*One of the culinary delights of early summer is white asparagus from Franconia. Opinions differ as to whether it tastes best with melted butter and boiled potatoes, a Hollandaise sauce or a few slices of pink ham.*

**Centre right:**
*A Franconian Brotzeit platter just isn't the genuine article without several types of home-made sausage, such as Leberwurst, Blutwurst or Presssack.*

**Right:**
*One of the classics of Franconian cuisine is the spicy Nürnberger sausage served with sauerkraut, ordered in various quantities to match your appetite.*

The courtyard of Schloss Weißenstein in Pommersfelden, one of the most sumptuous palaces of the Franconian baroque. Prince-Bishop Lothar Franz von Schönborn had his representational residence fashioned by Bamberg's court architect Johann Dientzenhofer on inheriting the property from the stewards of Nainsdorf and Pommersfelden.

The cascades and fountains in the gardens of Schloss Seehof near Memmelsdorf are a welcome relief on a hot summer's day. Antonio Petrini built the summer palace for the prince-bishop of Bamberg during the 17th century. It has recently been fully restored.

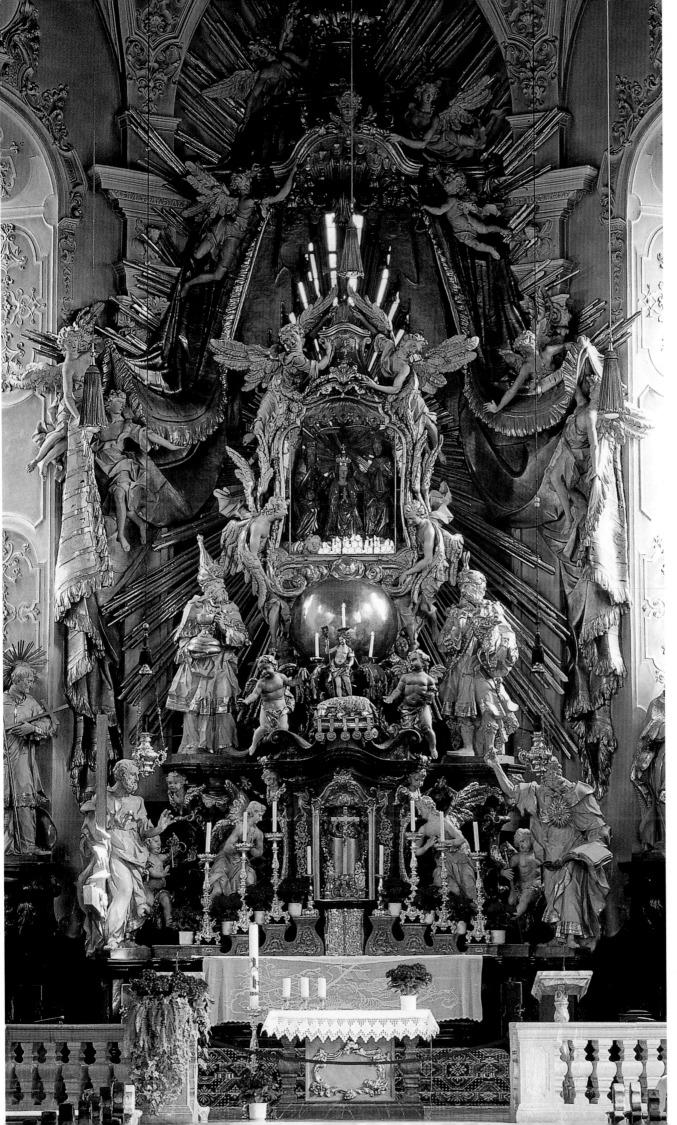

Pilgrims have been
coming to the altar of the
Holy Trinity in Gößwein-
stein since the 15th century.
By the 18th century the
number of visitors had
reached such great pro-
portions that the prince-
bishop of Bamberg, Karl
Friedrich von Schönborn,
had Balthasar Neumann
build the present basilica.

***Page 40/41:***
*View of Gößweinstein with
its pilgrimage basilica
and castle. The latter was
originally one of the oldest
in the Fränkische Schweiz
but was "Romanticised"
during the late 19th century.
Incidentally, the name
Gößweinstein has nothing
to do with wine (Wein) but
instead originates from an
11th-century count called
Goswin.*

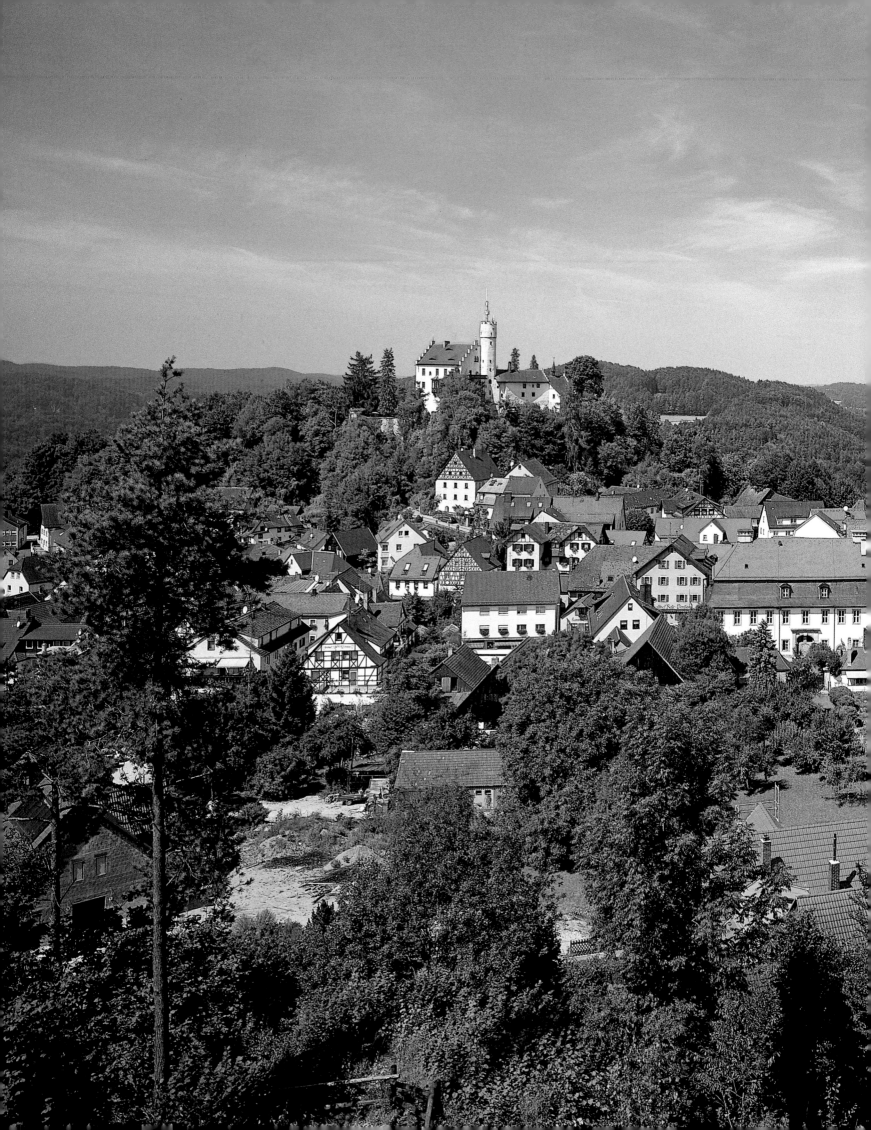

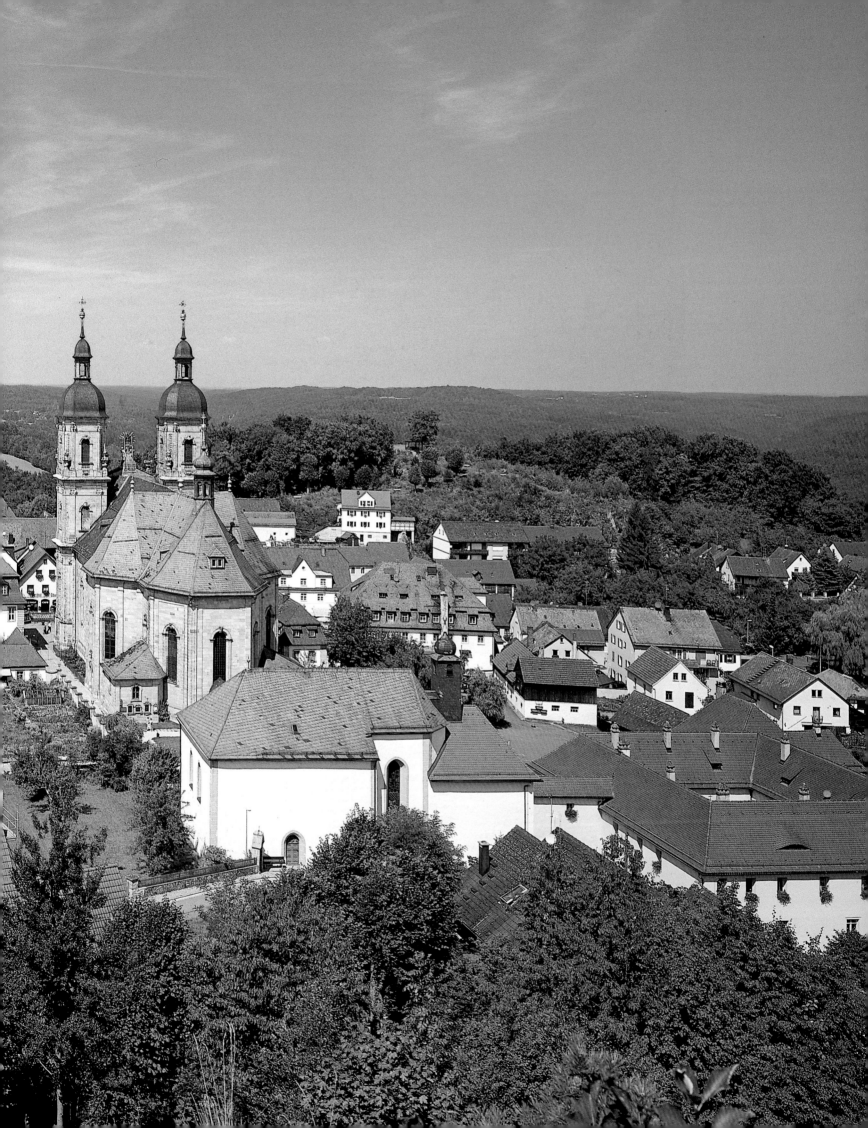

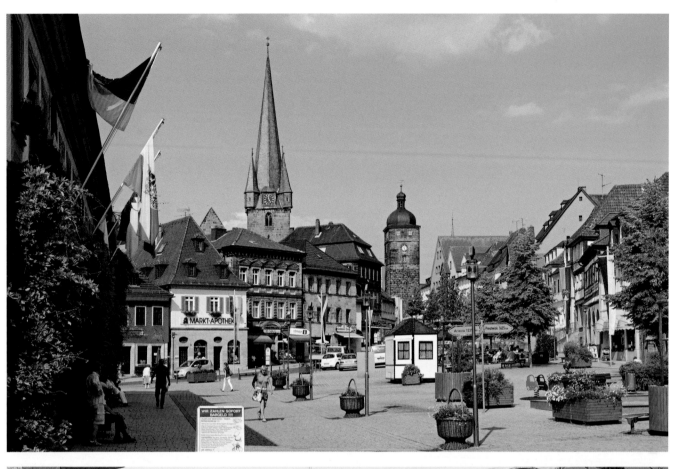

The marketplace in Lichtenfels, the largest town in the Upper Main Valley. The Catholic parish church Mariä Himmelfahrt in the background dates back to the late Middle Ages. The lower floors of the upper or Kronach gate tower were erected in the 15th century.

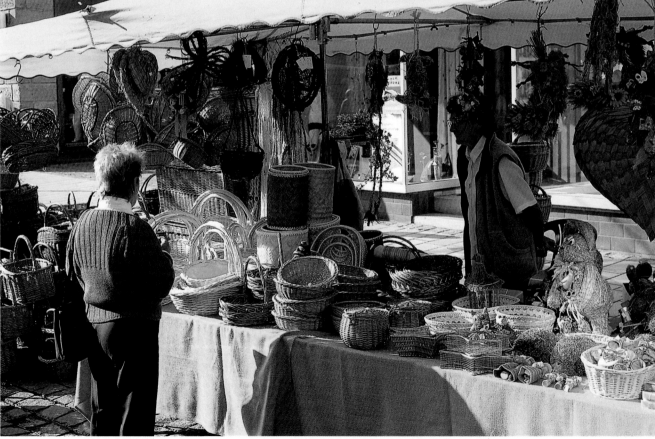

Lichtenfels is famous for its basket weaving and even has a college dedicated to the craft. The September wickerwork market is the largest in Germany.

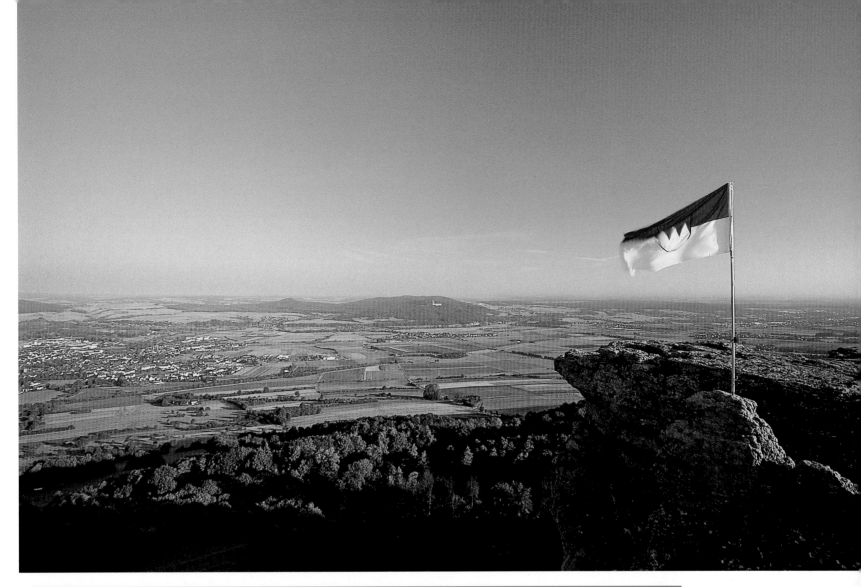

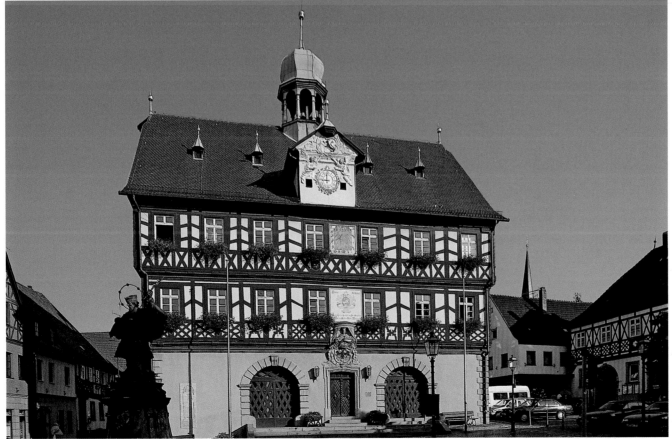

**Above:**
View from the Staffelberg of Bad Staffelstein, where in 1975 the warmest and most powerful thermal saline springs in Bavaria were discovered. Celts once settled on the Staffelberg, whose chalk plateau dominates the Main Valley; Victor von Scheffel holds a eulogy to the fantastic views in his famous Frankenlied.

**Left:**
Following a fire in 1684 the half-timbered upper storeys of the Rathaus in Bad Staffelstein were added to its late medieval stone base. Staffelstein's most famous local personality is mathematician Adam Ries who was born here in c. 1492.

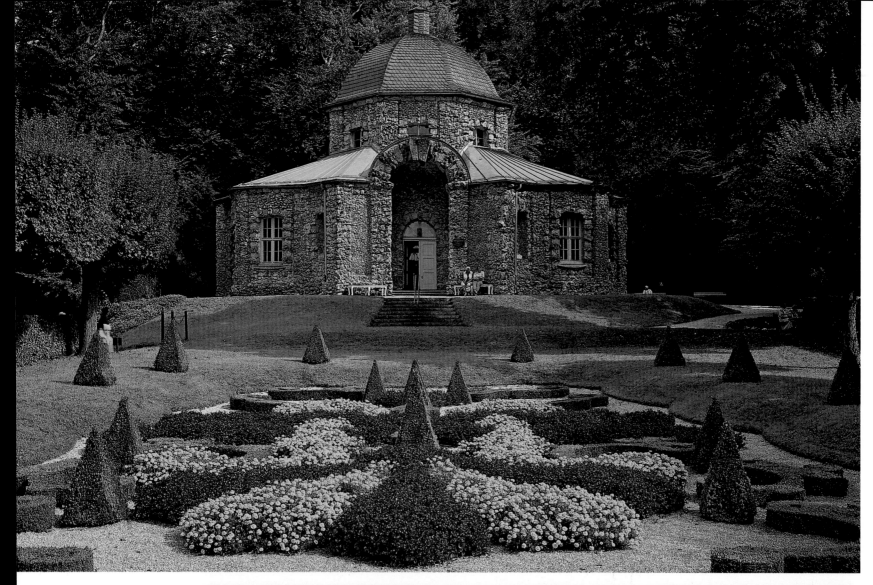

**Above:**
Margravine Wilhelmine von Bayreuth had the idyllic Sanspareil ("beyond comparison") created between 1745 and 1748 by court architect Joseph Sainte-Pierre. The gardens are dominated by the ornamental Oriental summerhouse, in itself a miniature palace.

**Right:**
A beech grove is the setting for the Rococo landscape garden Sanspareil, which also includes this theatre of ruins.

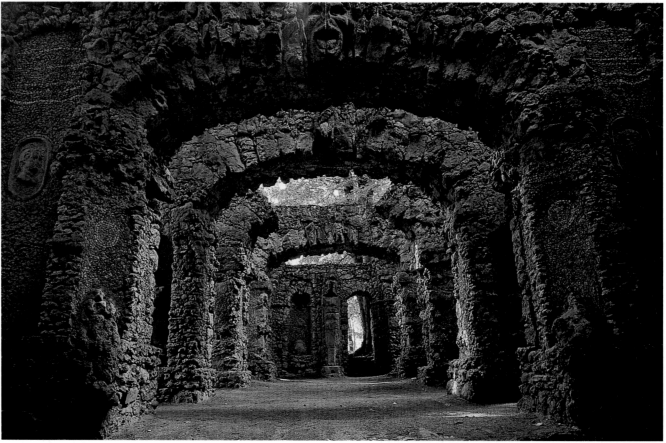

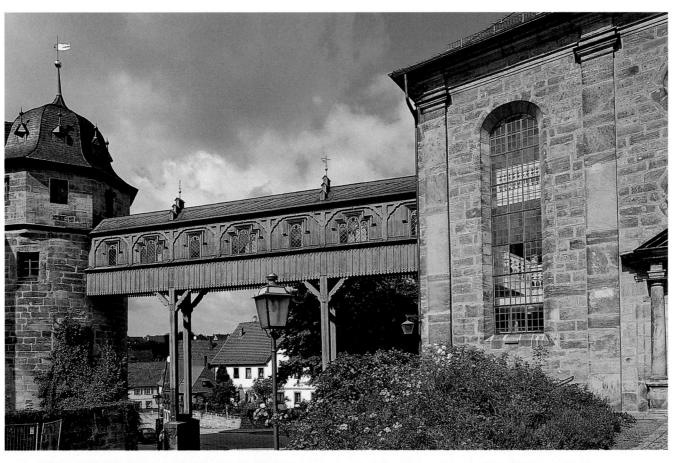

**Left:**
This covered walkway kept the lords of Thurnau dry and warm on their way from their castle to the neighbouring parish church. Hugging the northern edge of the Fränkische Schweiz, Thurnau is famous for its traditional pottery which dates back to the 14th century.

**Below:**
Burg Egloffstein, towering high above the valley of the Trubach, is one of many castles in the Fränkische Schweiz. Altered many times down the centuries, the oldest parts of the ancestral seat of the barons of Egloffstein are 12th century.

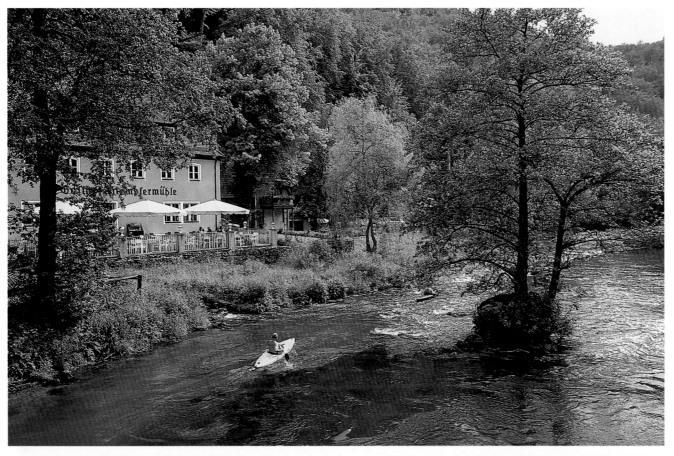

At the Stempfermühle on
the banks of the Wiesent
a steep path leads up
to place of pilgrimage
Gößweinstein. In summer
the river is popular with
canoeists.

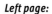

**Left page:**
In the valley of the Wiesent,
the main river running
through the Fränkische
Schweiz. At the end of the
18th century Romantics
Ludwig Tieck and Wilhelm
Heinrich Wackenroder
went into raptures over the
beauty of the countryside
here at Muggendorfer
Gebürg; in 1829 one Josef
Heller even compared it to
Switzerland, coining the
phrase Fränkische Schweiz
or Franconian Switzerland,
still used today.

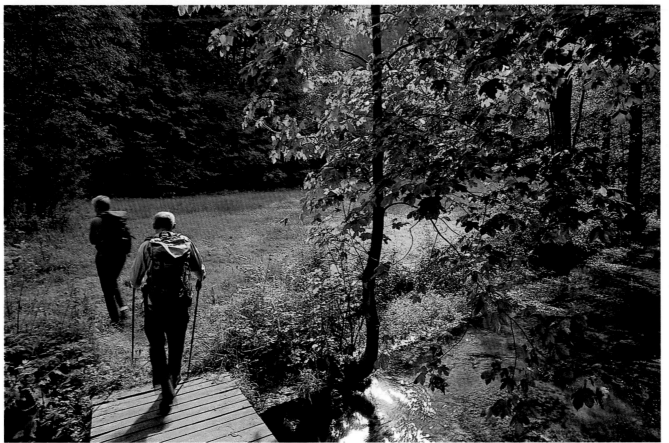

There are hiking trails
zigzagging across the
entire Fränkische Schweiz.
Here two wanderers cross
a stream in the Klein-
ziegenfelder Tal where the
River Weismain rises –
not to be confused with
the Weißer Main River
in the Fichtelgebirge.

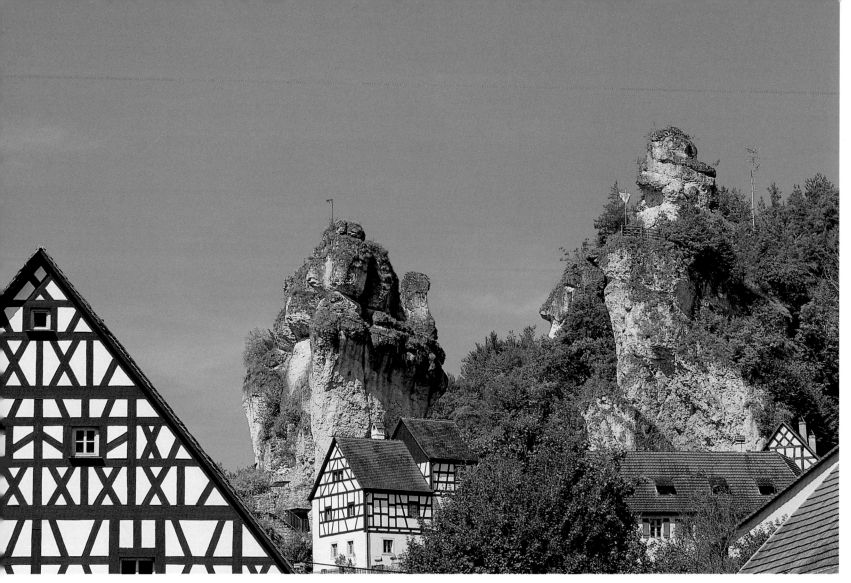

**Above:**
The half-timbered village of Tüchersfeld in the magnificent Püttlachtal is unmistakable with its distinctive towers of white rock. It grew up around two 13th-century castles which were later destroyed.

**Right:**
At the beginning of the 18th century a Jewish settlement was set up in the ruins of the lower castle. The Judenhof, as it was called, was disbanded in 1871/72.

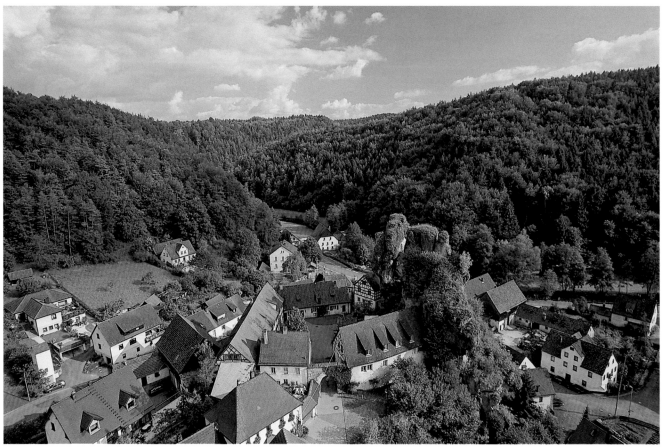

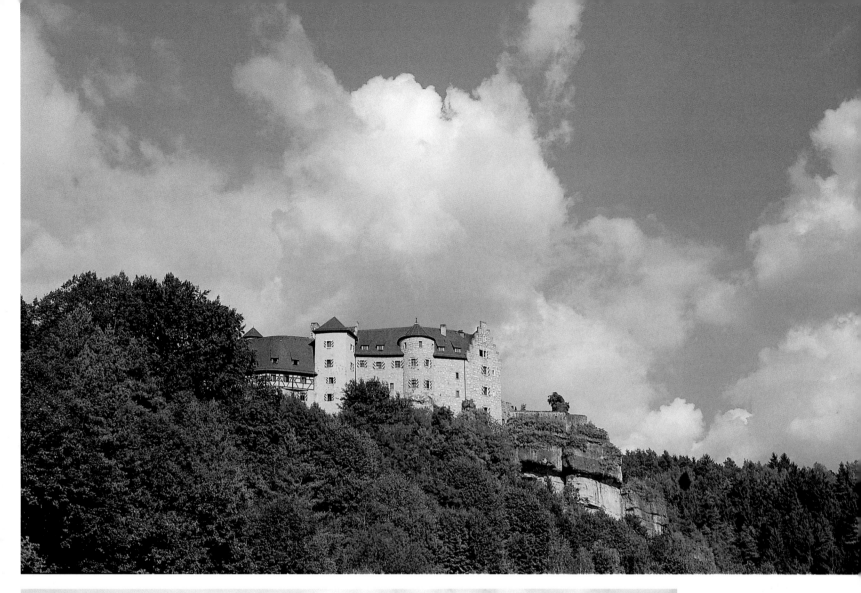

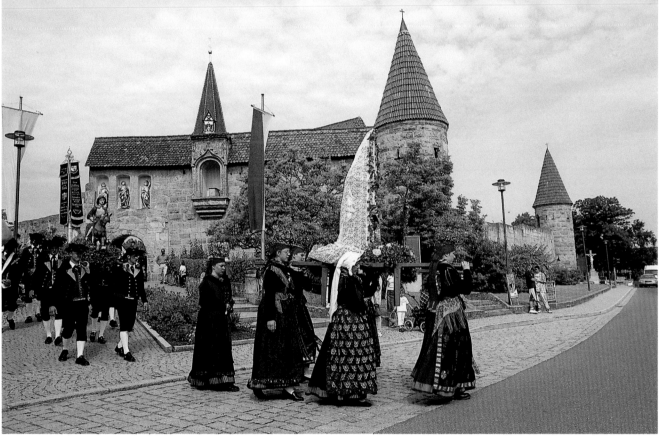

**Above:**
*Burg Rabenstein enjoys a romantic setting high up above the Ailsbachtal. The first fortification dates back to the 12th century; the present fortress is from c. 1829.*

**Left:**
*In Effeltrich on the western edge of the Fränkische Schweiz national costume is often worn, particularly on special feast days. Here the Corpus Christi procession parades past the fortified church of St Georg.*

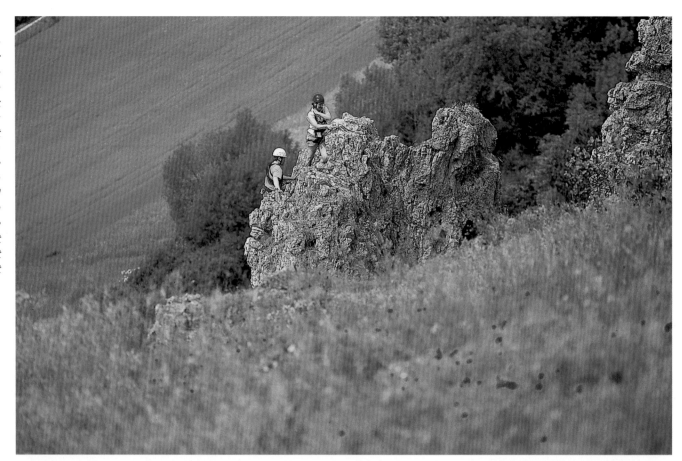

The rocks of the Walberla, a plateau high up above the valley of the River Wiesent, are paradise for climbers. Celts once settled on the bleak mountaintop; excavations have unearthed proof that there was once a heathen place of worship here upon which a Christian pilgrimage chapel dedicated to St Walpurga was later erected. The legendary Walberlafest held here on the first Sunday in May was first mentioned in 1360.

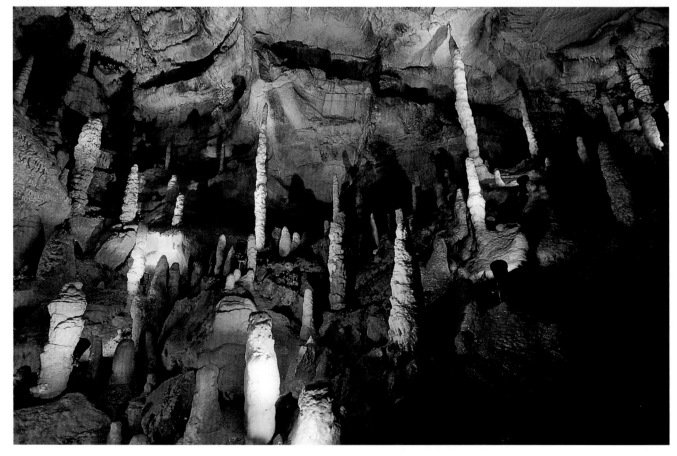

The Binghöhle in Streitberg is the best known of the many dripstone caves in the Fränkische Schweiz. It was discovered in 1905 by Ignaz Bing who sent a 13-year-old boy down to carry out a preliminary search of the depths, the opening being too small for an adult. The bizarre dripstone formations have been lit by electricity since 1907.

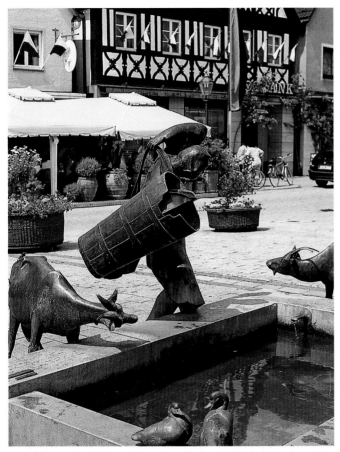

**Far left:**
The fountain on the market place in Ebermannstadt shows a bronze figure emptying his vat into the water, closely watched by his goat. The little town is idyllically situated in the wide lower valley of the Wiesent.

**Left:**
Rathausplatz in Forchheim is said to be one of the most picturesque squares in Franconia. The half-timbered facade and pencil-thin clock tower of the town hall date back to 1490; the neighbouring magistrate's building is from 1535. The beams fronting the edifice are carved with an array of detailed motifs.

**Left:**
Good farmhouse bread baked over a log fire is the main ingredient of a Franconian Brotzeit platter. Many old bread ovens, such as this one in Effeltrich, are back in use again.

The core of the abbey church in Ebrach, dissolved in 1803, is early 13th-century Gothic. The interior was drastically revamped during the 18th century. Ebrach was the first monastery founded by the Cistercian order in Germany.

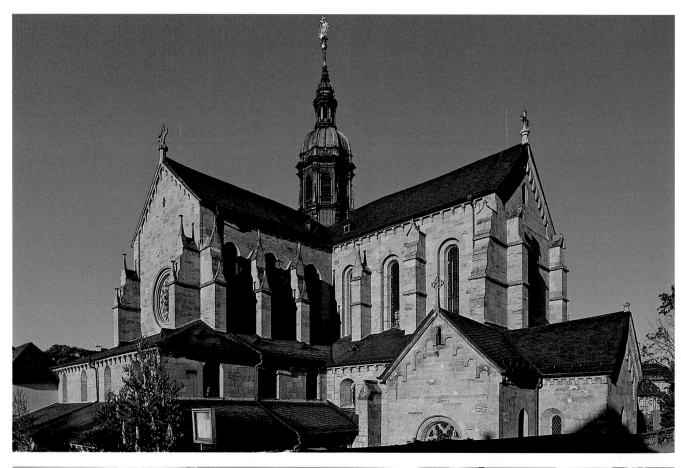

**Right page:**
Not far from Kloster Banz stands the pilgrimage church of Vierzehnheiligen. Built during the 18th century to replace a smaller chapel, the building is reckoned to be Balthasar Neumann's most perfect creation. Vierzehnheiligen is named after several apparitions of the 14 Auxiliary Saints and the Baby Jesus at this spot in 1445/46.

Kloster Banz, founded in 1070, lies high up above the wide valley of the River Main. Following the destruction of the monastery during the Thirty Years' War the present baroque buildings were erected by architects of renown Johann and Johann Leonhard Dientzenhofer and Balthasar Neumann.

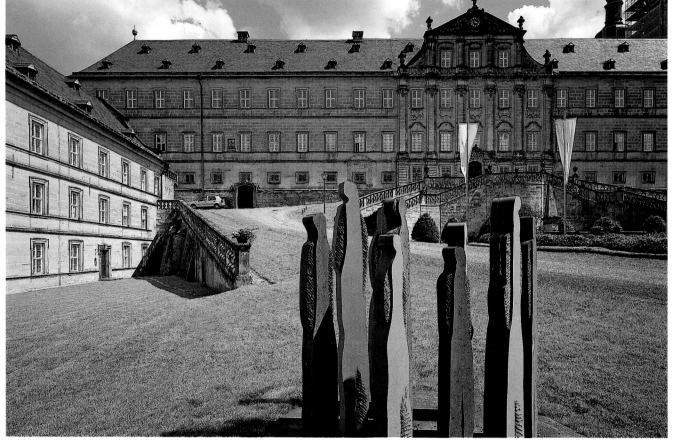

52

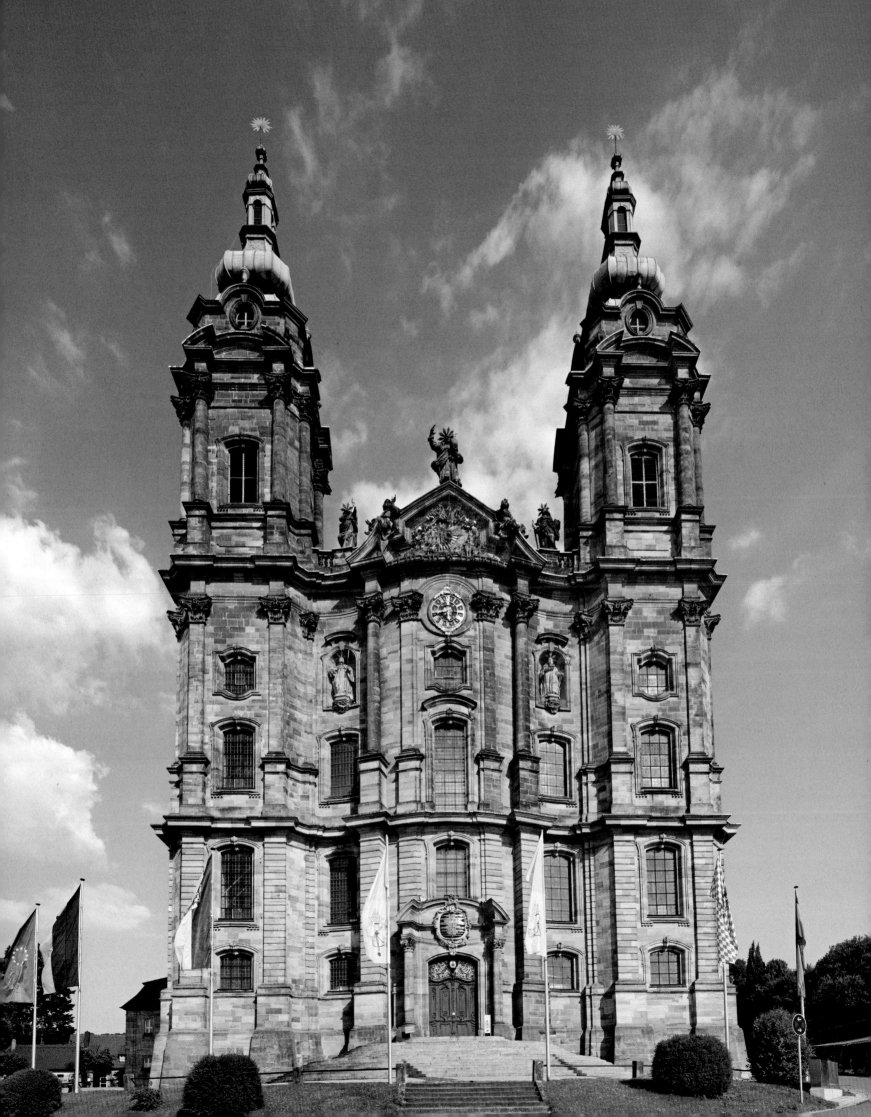

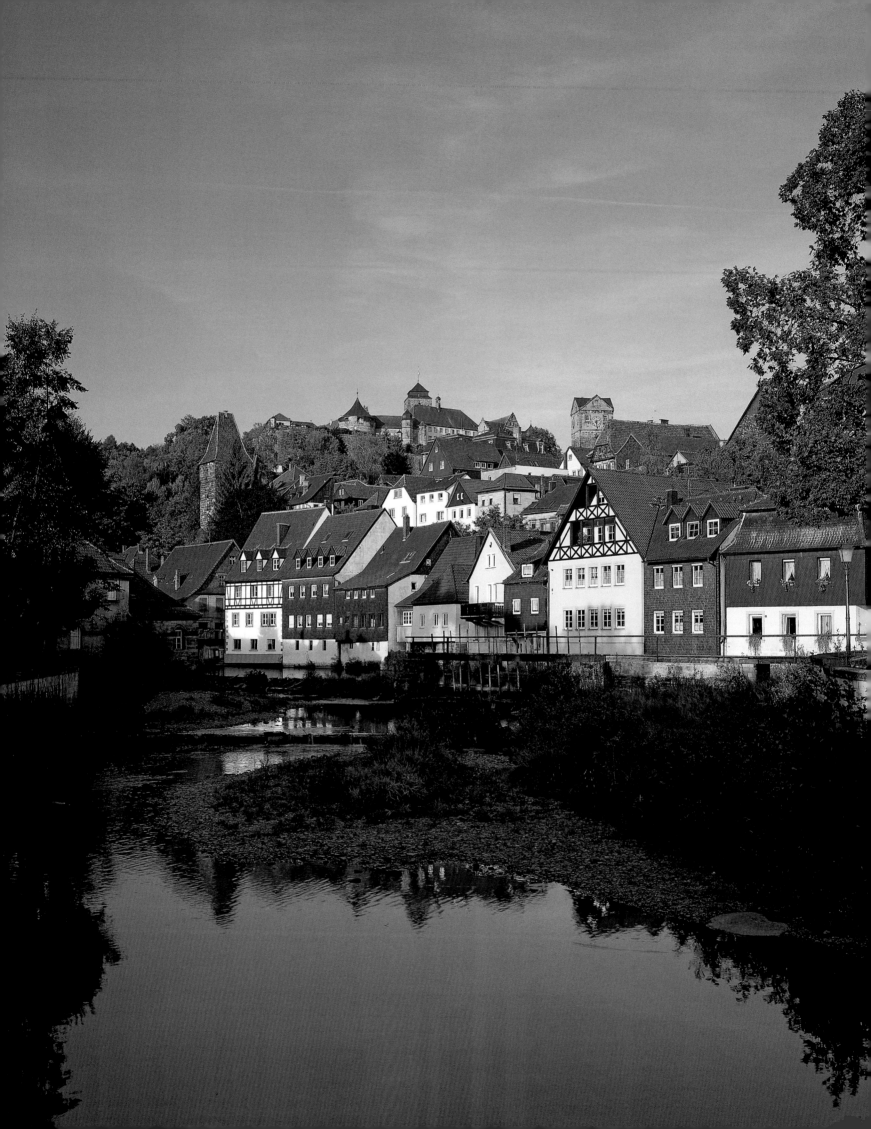

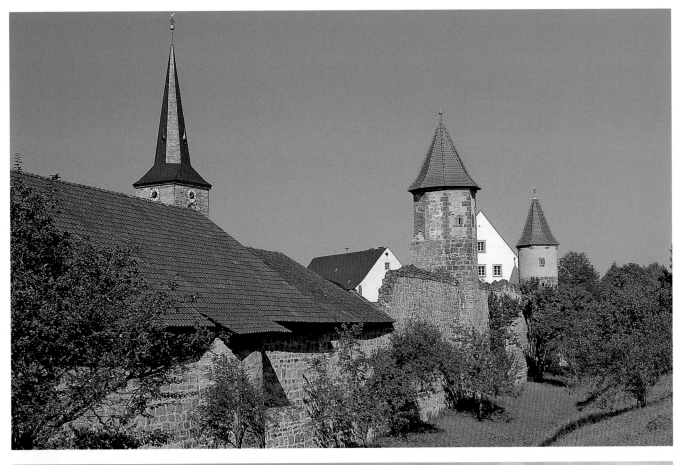

The medieval centre of Sesslach in the Coburger Land is still completely surrounded by a town wall defended by domineering towers. Another of its features is the communal brewery where the people of Sesslach have been making their own beer since 1335.

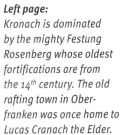

**Left page:**
Kronach is dominated by the mighty Festung Rosenberg whose oldest fortifications are from the 14th century. The old rafting town in Oberfranken was once home to Lucas Cranach the Elder.

Beneath Veste Coburg lies Schloss Ehrenburg, commissioned in 1543 and now fronted by an English neo-Gothic facade. Coburg only became part of Bavaria in 1920; prior to this date it was an independent duchy owned by the House of Saxe-Coburg and Gotha.

# KERWA AND KINDERZECHE – FRANCONIAN FESTIVALS

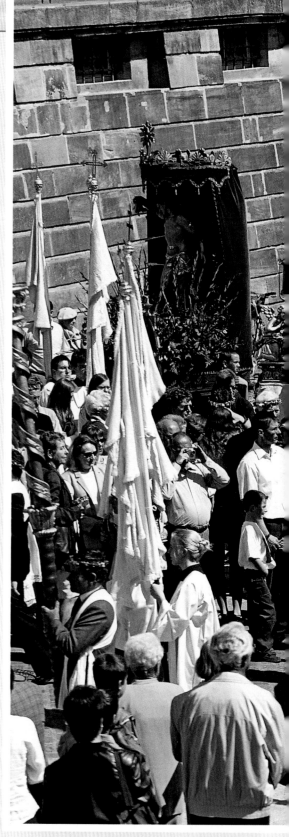

Much of the festival calendar in Franconia is rooted in religion. The many *Kerwas* or *Kirchweih-Feiern* regularly held across the region are actually church festivals (*Kirchweih* is the yearly parish fete held to commemorate the consecration of the local church) – even if this fact seems to be largely forgotten. The best-known *Kerwas* are the Bergkirchweih in Erlangen over Whitsun and the Sandkerwa in Bamberg in August. First staged in 1755, the merriment in Erlangen begins on the Thursday before Whit Sunday when the cool beer cellars on Burgberg are opened up for twelve days of jolly festivities. Even the university closes down for a week. At the Sandkerwa Bamberg's Sandstraße is one huge street party with stalls selling food and drink – and, of course, plenty of beer. Additional entertainment is provided by the customary *Fischerstechen* against the picturesque backdrop of Little Venice on the River Regnitz, in which two 'fishermen' precariously balanced on rowing boots try to push their opponent into the water with a long pole.

Other folk festivals have evolved from markets held on specific saint's days. The Anna-Fest in Forchheim takes place at the end of June and, like the Bergkirchweih in Erlangen, draws much of its charm from the inviting beer cellars around which market traders and street entertainers have set up shop. The patron saint of Würzburg, St Kilian, is celebrated at the beginning of July at the Kiliani-Fest.

Easter and Corpus Christi are of course high feast days for the Catholic populace of Franconia. As the church bells are silent between Good Friday and Easter Sunday, many of the villages here have children armed with wooden rattles 'ring' the chimes at midday and in the evening. Franconia's Easter fountains are also a big attraction, especially in Oberfranken where the village well is decorated with Easter eggs, twigs of blossom and flowers. Corpus Christi is marked with an array of magnificent processions. On this day Catholics confirm their belief that Jesus is among them in the form of the Eucharist. Monstrances and life-size figures of Jesus and Mary adorned with flowers are paraded through the streets which are decked with boughs of birch, village and religious flags and often also carpeted with flowers.

## Rothenburg's *Meistertrunk*

Not all of Franconia's gala days have religious connotations, however. Historical events have given rise to some of the region's fairs, such as the Reichsstadttage in Rothenburg and the Kinderzeche in Dinkelsbühl. On the second

weekend in September historic scenes from Rothenburg's past as a free city are re-enacted in a romantic setting, with the legend of the *Meistertrunk* the main focus of attention. In the autumn of 1631, in the midst of the Thirty Years' War, Commander Tilly marched into Rothenburg with the intention of razing it to the ground. On his arrival he was handed a welcome drink, a tankard holding over half a gallon of wine, upon which he declared that if anyone could empty it in one draught he would spare the city. Former mayor Nusch successfully mastered the challenge, saving his town from total destruction. The fabled event is also honoured by the Ratstrinkstube clock beneath which modern-day inhabitants and visitors to Rothenburg can test their ability to hold their drink.

During the Thirty Years' War Dinkelsbühl was saved by its youngest inhabitants. With the Swedes at the town gates, a brave young woman known as Kinderlore marched up to their leader with the town's children in tow and begged for mercy – which was duly granted. The heroic deed is celebrated each year in mid July.

Another major happening in the national German calendar also takes place in Franconia. During the Wagner-Festspiele in Bayreuth the city goes berserk. Prices soar, there isn't a room to be had for love nor money and the big stars of the entertainment business pout and pose for the cameras outside the Festspielhaus. Tickets for the latest production of *The Ring* – the hottest subject of festival debate – can only be purchased years in advance. Wagner isn't the only musician celebrated on such a scale in Franconia, however. Würzburg puts on a very good Mozartfest and is the venue of the Bachtage.

As the years closes the Christmas fairs set up their stalls on market squares across the land. The most famous is undoubtedly Nuremberg's Christkindlesmarkt opened by the Christ Child in person from the balcony of the Frauenkirche on the Friday before the first Sunday in Advent.

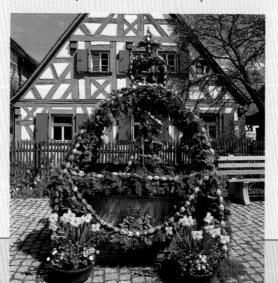

*Left:*
An Easter fountain in Mittelehrenbach. The Upper Franconian tradition of decorating the village well for Easter is now well known, drawing many visitors to the area each spring.

*Above:*
One of the yearly highlights for Franconia's Catholic majority is the feast of Corpus Christi, in honour of which many ceremonial processions are held, such as here in Bamberg.

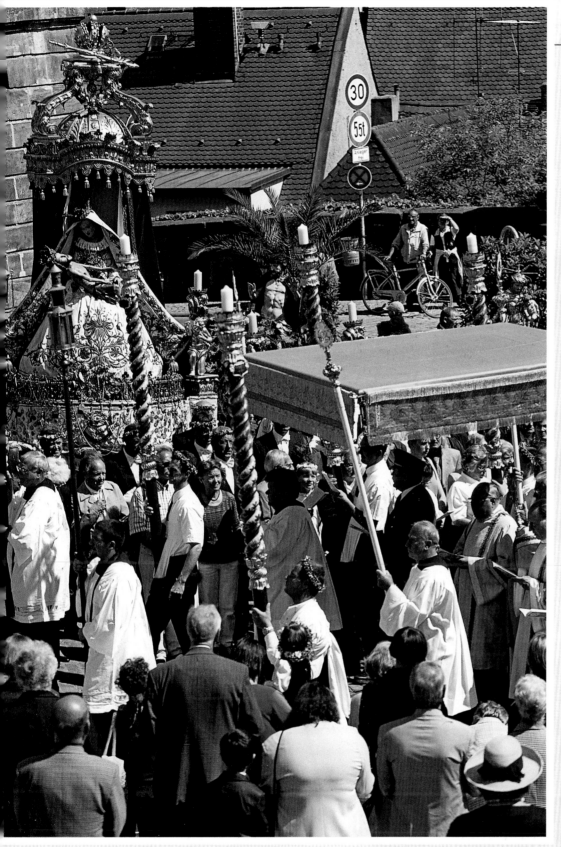

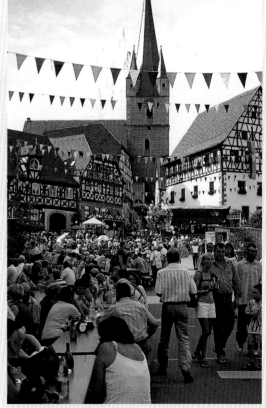

**Top right:**
The historic shepherd's dance on the market place in Rothenburg ob der Tauber is performed on Easter Sunday.

**Centre right:**
The people of Dinkelsbühl spend an entire week commemorating the events of the Thirty Years' War when the city was saved from certain destruction by its children.

**Right:**
Local vintages seem to taste even better against a backdrop as scenic as this one: Zeil am Main during the wine festival.

The Weißer Main rises
on the Ochsenkopf, the
second-highest peak in
the Fichtelgebirge. At
1,023 metres (3,356 feet)
above sea level snow is
guaranteed in winter,
attracting thousands of
skiers and snowboarders
each year.

The labyrinth of rocks
at Luisenburg on the
northern slopes of the
Kösseine, the highest
point in the mountain
range south of Wunsiedel,
was named after the then
queen of Prussia Luise.
A trail takes you through
over a mile of strange
granite formations, not far
from which is the Luisen-
burg open-air theatre,
opened in 1890.

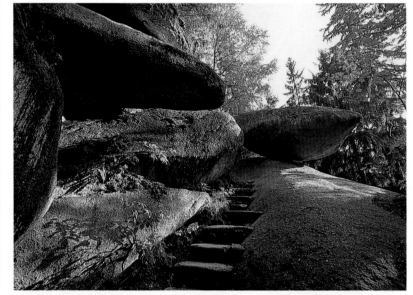

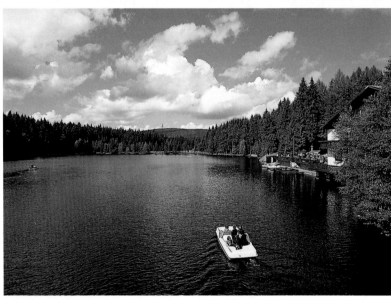

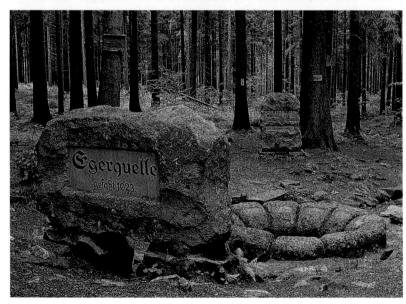

The Fichtelsee, dammed
to make a mining reservoir
during the late Middle
Ages, is now a popular lido
750 metres (2,460 feet)
above sea level in the
Fichtelgebirge.

In 1923 the source of the
Eger on the northern
incline of the Schneeberg
was set in stone. No less
than four rivers rise in the
Fichtelgebirge: the Main,
Saale, Naab and Eger.

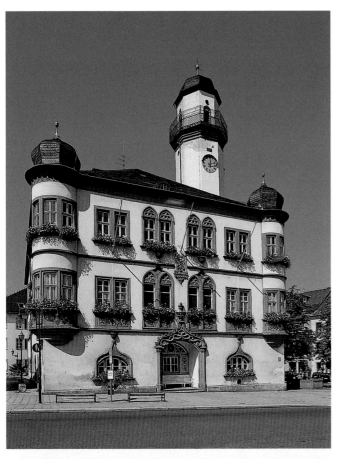

**Far left:**

*Hof in Oberfranken's undisputed landmark is its Rathaus with a tower over 30 metres (almost 100 feet) high. Built during the Renaissance, the town hall was remodelled in neo-Gothic following a fire in 1823. The city steps into the international limelight each year during its film festival.*

**Left:**

*Bad Berneck with its marvellous half-timbered houses lies in the beautiful valley of the River Ölschnitz and is crowned by its old Schlossturm and the ruins of two castles.*

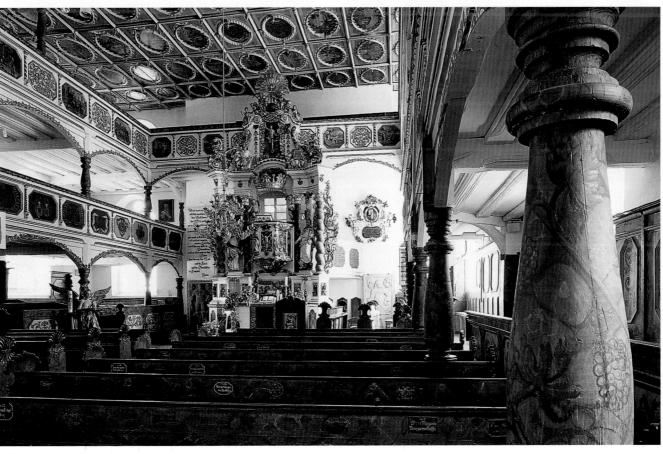

**Left:**

*Many of the churches in Franconia are a riot of baroque colour and form; here the Lutheran parish church in Regnitzlosau near Hof.*

**Below:**
The two defiant steeples of
the city church of Bayreuth,
joined by a bridge, are
built on 13th-century
foundations. They took on
their present form in 1621
following several fires.

**Right:**
The Festspiele in Bayreuth
were established by
Richard Wagner in 1872 for
the performance of his
works alone. Tickets are
still in great demand, with

music lovers coming to
watch both the spectacular
productions and to rub
shoulders with the many
stars and VIPs who con-
gregate at the festival hall.

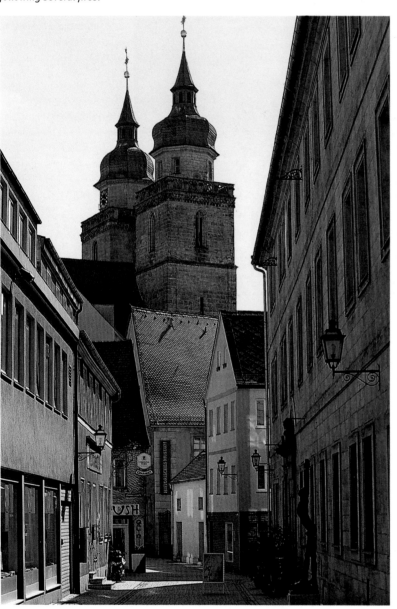

**Above:**
Bayreuth owes many of its
prestigious buildings, such
as the Neues Schloss and
margravial opera house, to
a period of prosperity under
Margravine Wilhelmine.

Rather plain on the
exterior, inside the latter
edifice is rich in baroque
embellishments, with the
auditorium elegantly
furnished entirely in wood.

**Right:**
Wagner moved to the Villa
Wahnfried on the north-
east edge of Bayreuth's
Hofgarten in 1874. The
famous composer and his
wife Cosima lie buried
here behind the house.

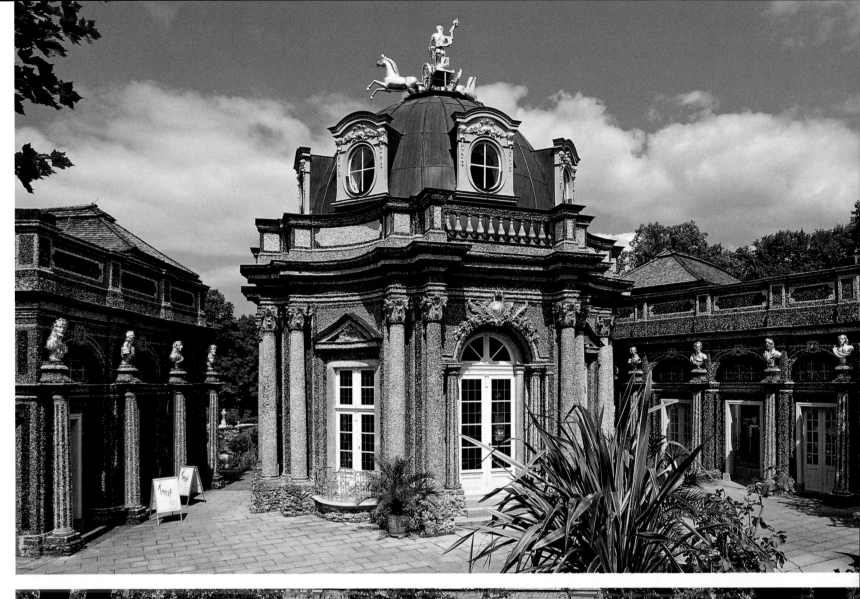

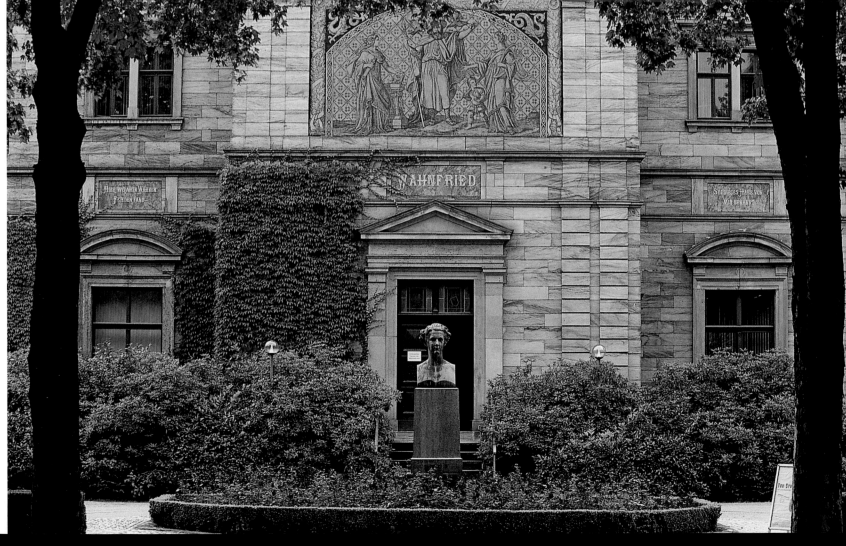

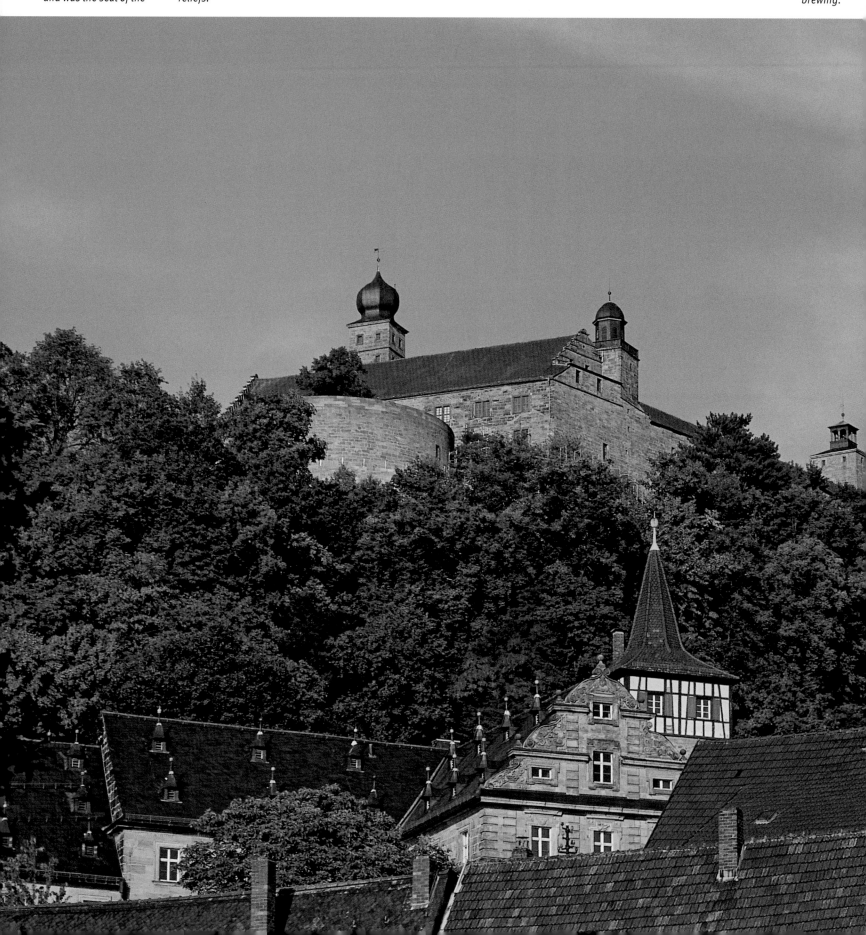

**Below:**
High above Kulmbach and the confluence of the Roter and Weißer Main rivers stands the Plassenburg which fell to the Hohenzollern dynasty in 1340 and was the seat of the local margrave until 1604. The fortress is particularly famous for its Schöner Hof, enclosed by three-storey Renaissance arcades adorned with numerous reliefs.

**Top right:**
Kulmbach's second claim to fame is its beer. The Bayerisches Brauereimuseum run by the Mönchshof brewery is devoted to the history, techniques and cult of brewing.

**Centre right:**
Burg Lauenstein is in the very north of Franconia, high up above the Loquitztal in the dark Frankenwald forest. It is first recorded in documents from 1222.

**Bottom right:**
In Himmelkron not far from Bayreuth is a former Cistercian convent. Founded in 1279, it was turned into a palace for the margraves of Bayreuth in the 17th century. The late

Gothic cloisters of the convent church are particularly noteworthy for their angel sculptures carved into the vaulting, each one playing a musical instrument.

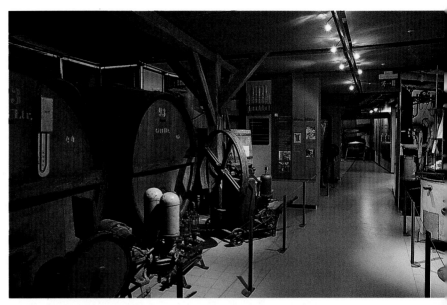

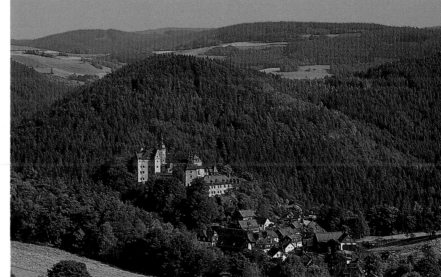

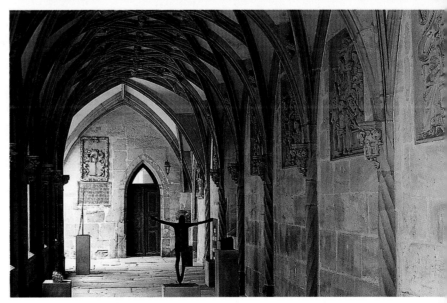

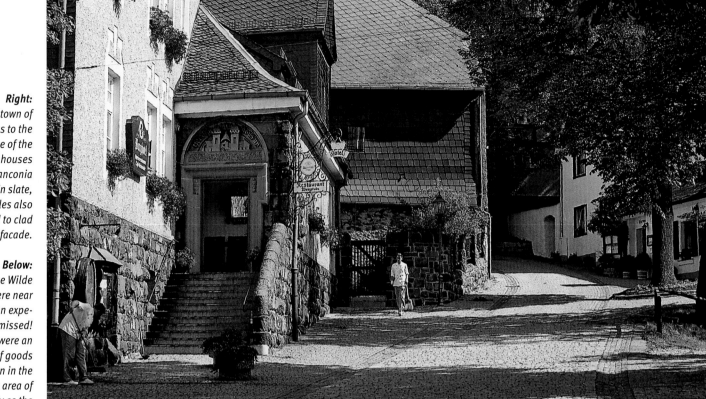

*Right:*
The mountain town of Lichtenberg clings to the eastern rise of the Frankenwald. The houses in this part of Franconia are often roofed in slate, with slate tiles also sometimes used to clad the facade.

*Below:*
Rafting on the Wilde Rodach River (here near Wallenfels) is an experience not to be missed! For centuries rafts were an important form of goods transportation in the Frankenwald, an area of forest known locally as the "green crown of Bavaria".

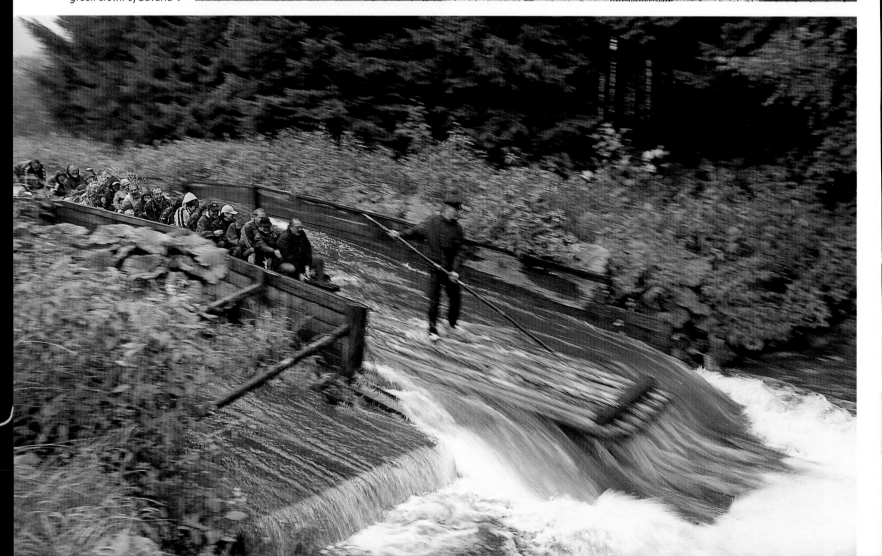

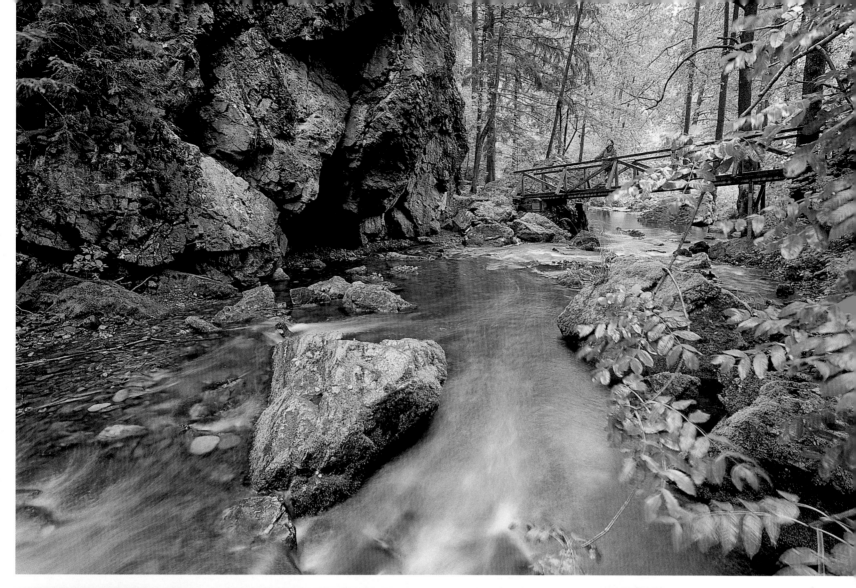

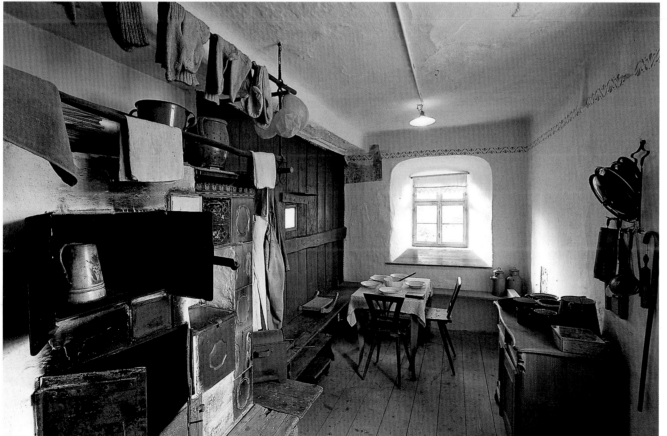

**Above:**
*A wander through the
Steinachklamm near
Stadtsteinach in the south
Frankenwald is guaranteed
to be romantic, with
scenery as lush and
spectacular as this.*

**Left:**
*For the original inhabitants
of the farmhouses open
to the public at the Ober-
fränkisches Bauern-
museum in Kleinlosnitz
life was hard. Upper
Franconia's open-air
museum has several
buildings typical for the
region on display, many
with intact interiors, and
also a cottage garden.*

# Free cities and Franconian lakes – Mittelfranken

*The old free city of Rothenburg ob der Tauber is the epitome of romantic Franconia. Following heavy damage during the Second World War many of the houses and parts of the town walls have been restored to their original state. The twin bridge from 1330 outside the city also had to be rebuilt after it was blown up at the end of the war.*

The legendary amalgamation of miniature states which was once Franconia is also evident in Mittelfranken where countless castles, fortresses and palaces bear witness to the fame and fortune of the rulers of yore. The margravial sparkle of courtly Rococo still twinkles in Ansbach, now the seat of local government in Mittelfranken. In the former free cities of the Holy Roman Empire Bad Windsheim, Dinkelsbühl, Nuremberg and the quintessentially romantic Rothenburg ob der Tauber stately buildings still smack of the pride of their former inhabitants. Rothenburg in particular, with its narrow streets, churches, towers and city walls, is for many the epitome of the medieval German town.

Nuremberg is the second largest city in Bavaria and the biggest in Franconia, home to the 1st FC Nuremberg football club supported by many far and wide. Its local landmark is the imperial castle or Kaiserburg which from its mound of sandstone positively dominates the historic centre, painstakingly reconstructed following its destruction during the Second World War. Nuremberg is famous not only for its Christmas market, gingerbread and spicy sausages but also for its Gothic churches, Germanisches National-museum (National Germanic Museum) and Spielzeugmuseum devoted to children's toys.

So close to Nuremberg that they are almost part of it are the cities of Fürth and Erlangen, forming a not always pleasant urban conglomeration in the heart of Mittelfranken. There are, however, plenty of escape routes – out into the Hersbrucker Schweiz, for example, identical in its origins and makeup to the neighbouring Fränkische Schweiz and thus also dotted with romantic river valleys, precipitous dolomite cliffs, caves, castles and ruins. To the south the Fränkisches Seenland between Ansbach and Weißenburg is a veritable eldorado for water sports fanatics. The Altmühlsee, Rothsee, Igelsbachsee and Kleiner and Großer Brombachsee have been recently created by damming the water system of the Danube and Altmühl rivers, creating a lake district over 2,000 hectares (4,900 acres) in size in the midst of beautiful scenery for swimmers, sailors and sunbathers alike.

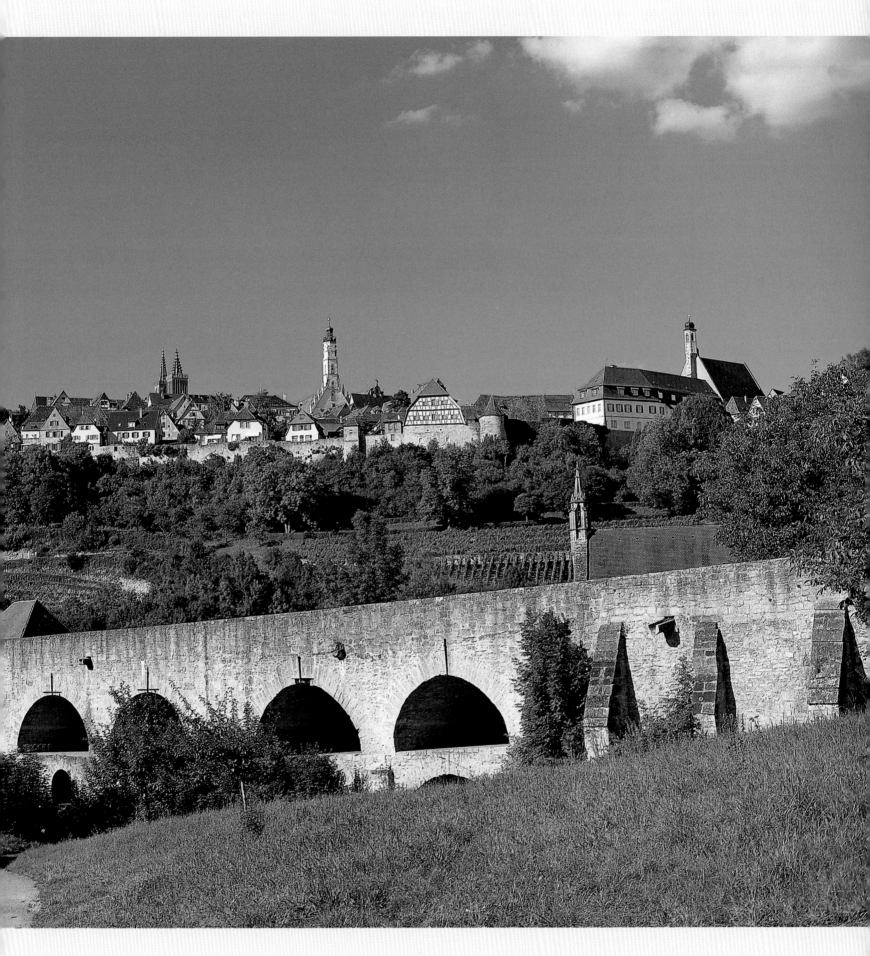

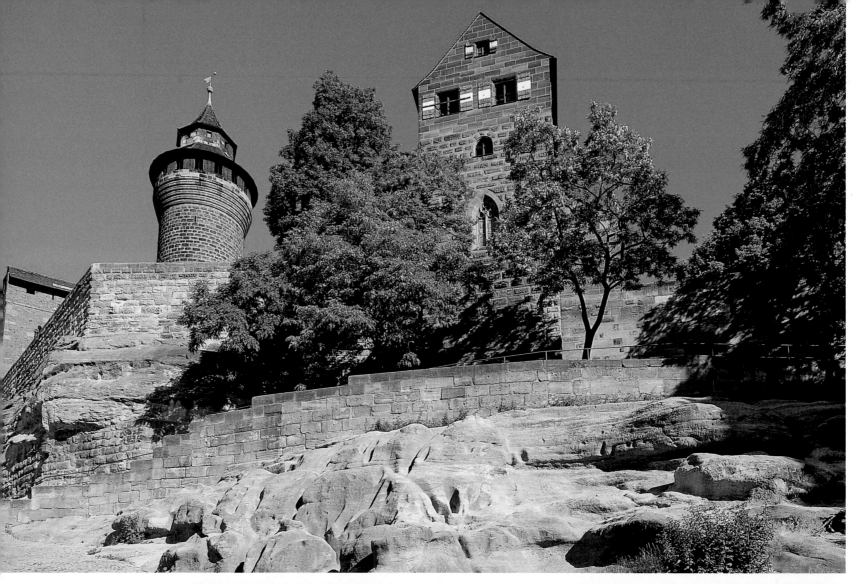

**Above:**
Nuremberg's local land-
mark is its indomitable
fortress surmounting
a massive slab of red
sandstone. The castle
has three sections: the
Kaiserburg to the west
from the 12th century, the
Burggrafenburg at the
centre and the buildings
erected by the free city of
Nuremberg to the east.
Germany's emperors and
kings held many of their
imperial diets here.

**Right:**
The Germanisches
Nationalmuseum (National
Germanic Museum) in
Nuremberg is dedicated
to the art and culture of
Germany. In over 70 rooms
ca. 20,000 exhibits can be
viewed from a grand total
of 1.3 million which
document German history.

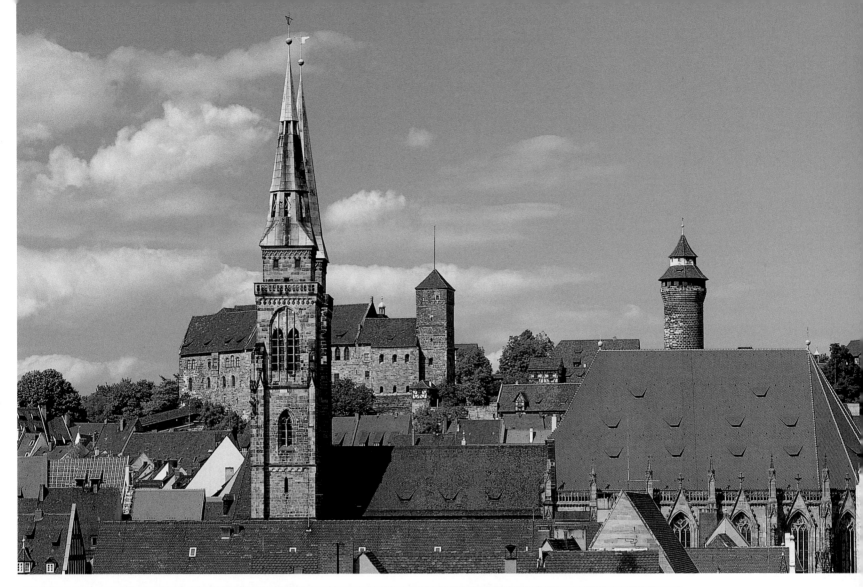

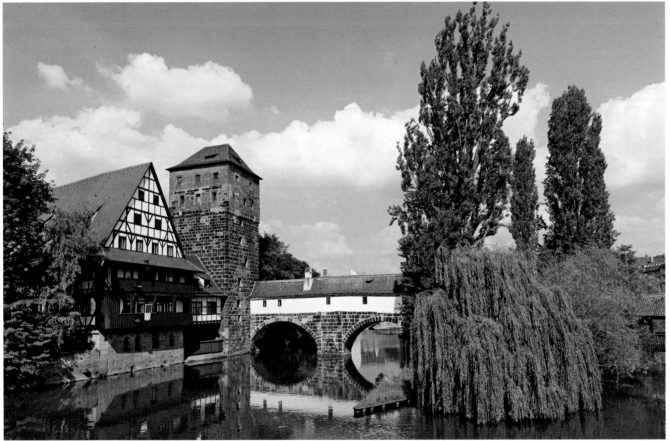

**Above:**
View of the old town of
Nuremberg with the
Sebalduskirche and castle.
The centre is split into two
halves which are named
after their principle
churches, one of which is
St Sebaldus and the other
St Lorenz. The Sebaldus
quarter was where the
upper classes erected their
noble dwellings and also
the town hall.

**Left:**
One of the most impressive
half-timbered structures in
Nuremberg is the Wein-
stadel on the River Pegnitz
which was built in the mid
15th century as an infirmary.
Wine was stored here from
1528. The Wasserturm
next to it was once part of
the city fortifications.

69

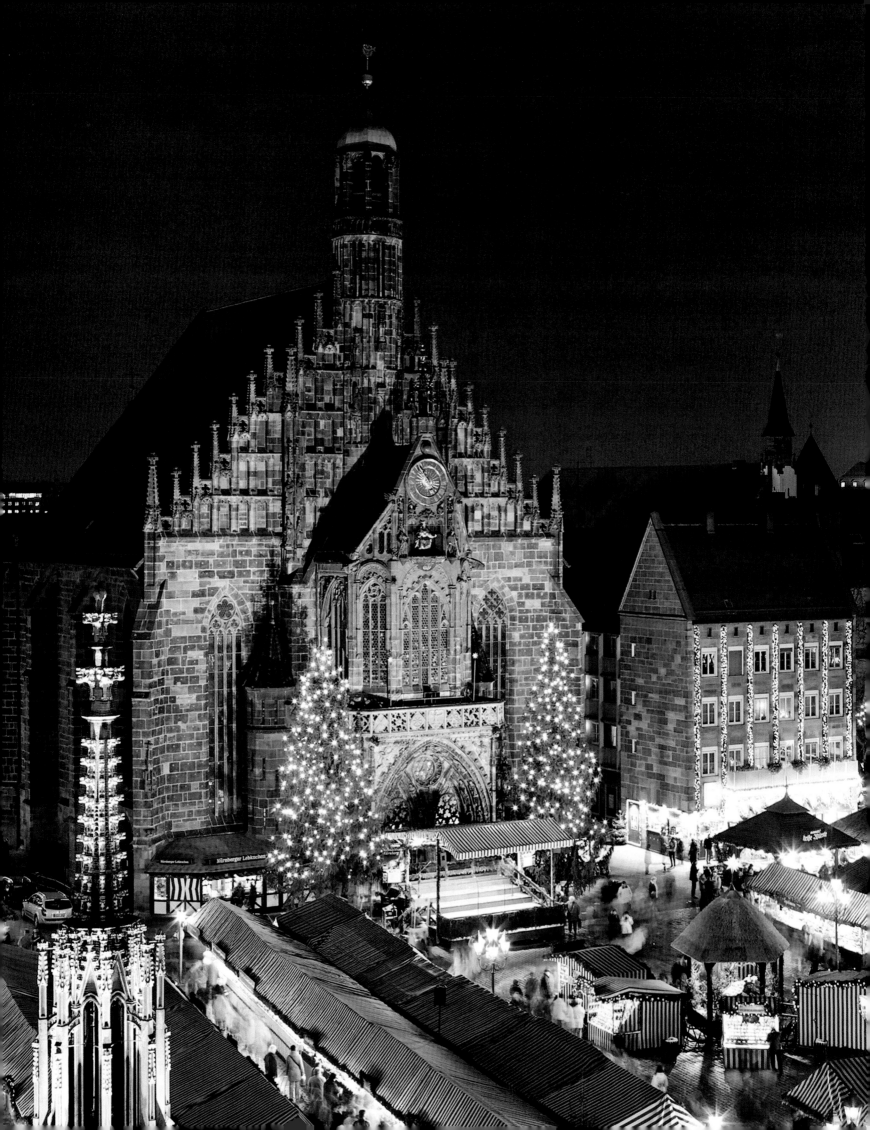

A delicious scent of gingerbread and mulled wine wafts from the stalls of the Christkindlesmarkt in Nuremberg, one of Germany's largest and most famous Christmas markets.

*Left page:*
The yearly Christkindles-markt in Nuremberg enjoys a romantic setting against the illuminated backdrop of the Frauen-kirche, the oldest Gothic hall church in Franconia. Every day at noon the chimes (Männleinlauf) of the church clock from 1509 show seven electors parading past Emperor Karl IV in homage to the issuing of the Golden Bull.

A gingerbread bakery in Nuremberg's Handwerker-hof. Made of flour, sugar, honey, almonds and all kinds of spices, including ginger, cloves and cinnamon, gingerbread is sold plain or covered with icing or chocolate.

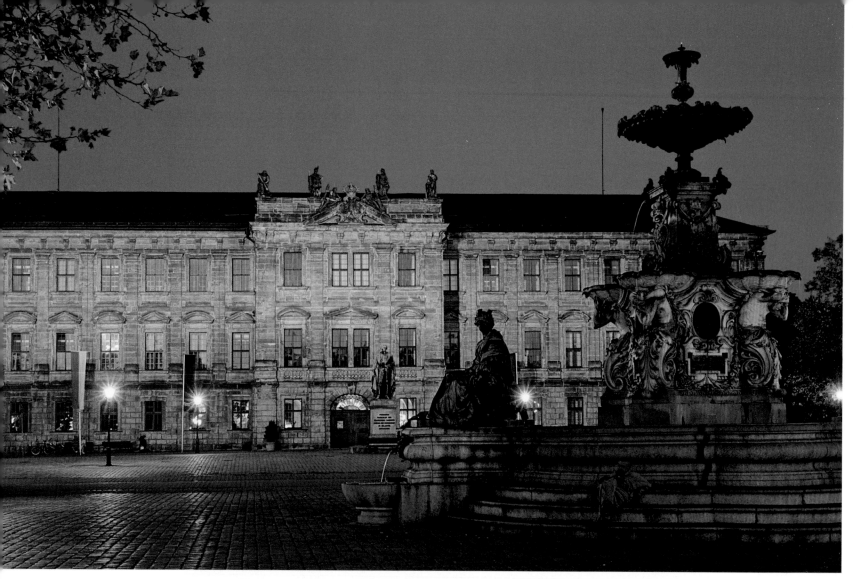

**Above:**
*Marktplatz marks the centre of the university town of Erlangen and is dominated by the vast facade of the baroque margravial palace. The statue in front of it is of the founder of the Friedrich-Alexander-Universität, Margrave Friedrich; the Paulibrunnen in the foreground was erected in 1886.*

**Right:**
*Enjoying the summer in Erlangen on Kirchplatz which is behind the church in the old part of town. The place of worship was built between 1706 and 1721 after a terrible fire that destroyed much of Old Erlangen.*

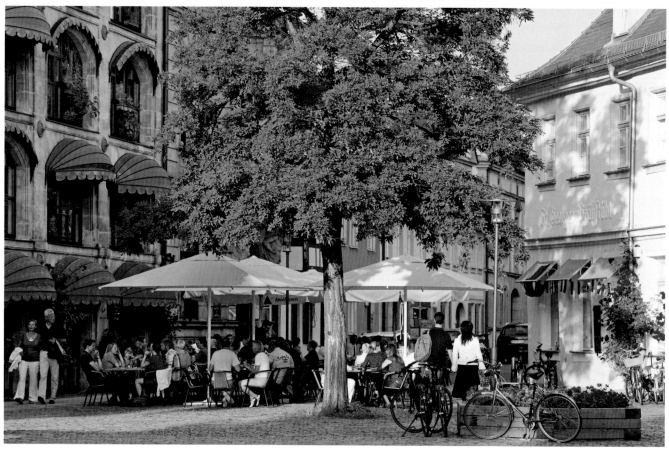

Behind the margravial palace in Erlangen is the spacious Schlossgarten, initially laid out as a set of French gardens at the beginning of the 18th century and in 1785 transformed into a less formal landscaped park.

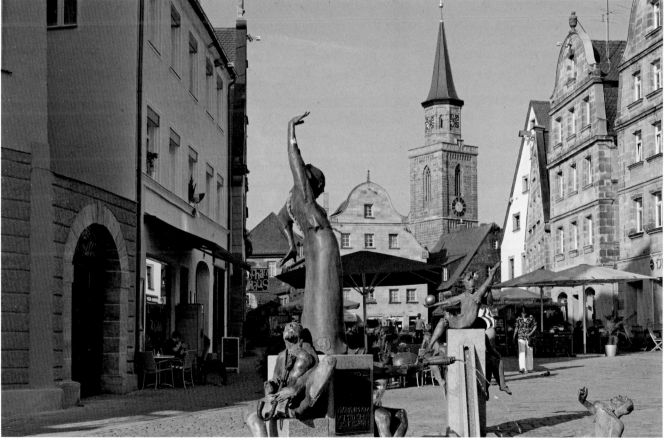

Harro Frey's new Gauklerbrunnen from 2004 tinkles peacefully on the market square in Fürth close to Nuremberg. The Michaelskirche in the background is the oldest building in town, with much of its fabric dating back to the 16th century. Fürth once had a large Jewish community and was formerly known as the Jerusalem of Franconia.

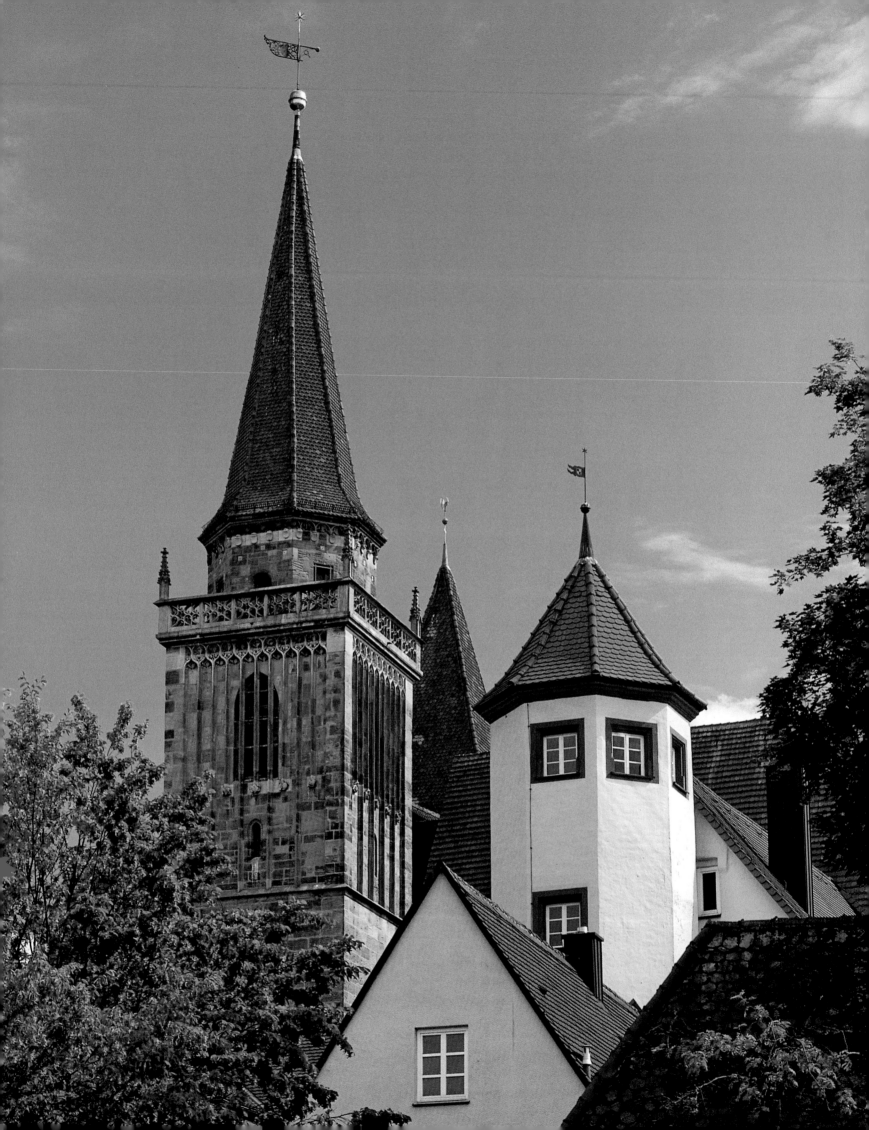

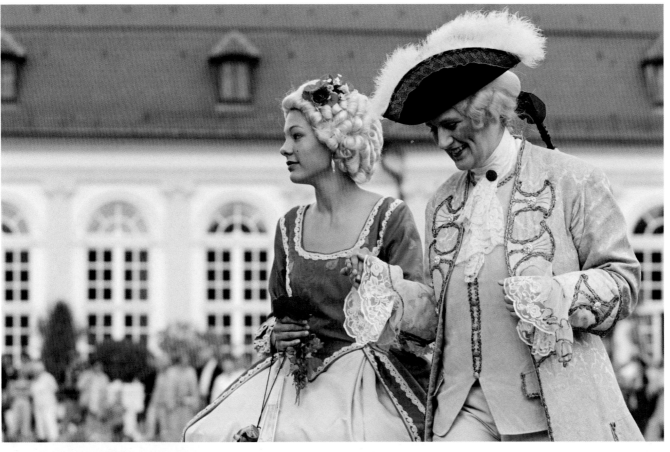

The furnishings of the margravial palace in Ansbach are claimed to be "the most significant Rococo interior in Franconia", at the forefront of what has been called the Franconian Rococo. This is celebrated each July at the Rococo festival held in the Hofgarten.

**Left page:**
The Johanniskirche in Ansbach, a late Gothic hall church, is from the 15th century. Tucked into a widening in the valley of the Fränkische Rezat River and surrounded by wooded slopes, Ansbach is the seat of local government in Mittelfranken.

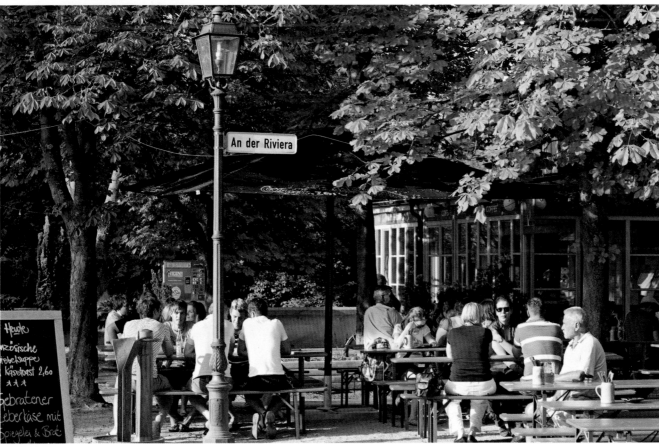

One pleasant way to spend a summer day in Ansbach is at one of the shady beer gardens, such as here „An der Riviera".

# THE MURDER AT ANSBACH –
# THE CASE OF KASPAR HAUSER

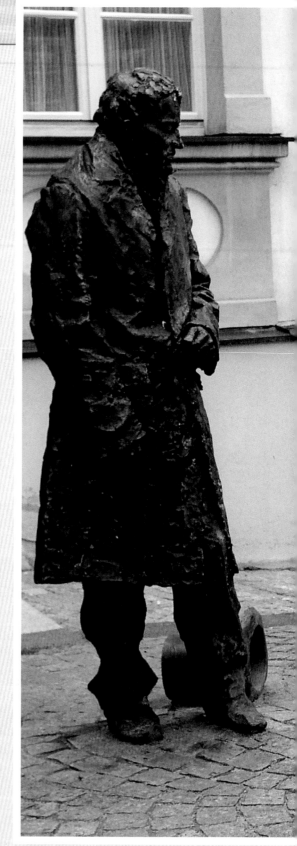

"Hic occultus occulto occisus est." – "Here a stranger was murdered by a stranger" are the words carved onto a black plaque in the gardens of the palace in Ansbach. The deceased in question is, however, not as nameless as the Latin suggests; he was called Kaspar Hauser and he had lodged with a teacher and his family in Ansbach since 1831. On December 14 1833 he was stabbed by his killer in the palace grounds and died of his wounds three days later on December 17. His death is mysterious, his background even more so.

On Whit Monday, May 26 1828, a strange boy aged about 16 appeared on Unschlittplatz in Nuremberg. He could only speak a few words, among them the famous sentence: "Ä sechtene Reutä möcht i wähn wie mei Vottä wähn is" ("I would like to be as good a rider as my father was"). At the police station he carefully wrote his name on a piece of paper: Kaspar Hauser. He had on him a letter addressed to riding master Wessenig; the latter, however, had never heard of the young man. Kaspar was held in the tower of the castle at Nuremberg and put on show to the public as a curiosity.

After a lengthy series of examinations it was assumed that he had spent several years in complete isolation which had left him both linguistically and physically retarded (he was very unstable on his feet and his pelvis and legs were slightly deformed). He was first sent to live with the teacher Georg Friedrich Daumer who began the task of educating what turned out to be a very fast learner. In October 1829 the first attempt was made on Kaspar's life, forcing him to be moved to safety on several occasions. It was at about this time that the inscrutable Lord Stanhope turned up to take on the guardianship of the stranger, sending him to board with teacher Johann Georg Meyer. Even the president of the appeal court in Ansbach, Anselm von Feuerbach, became interested in the case, coming up with the theory that Kaspar was a hereditary prince. Not long after his theory was made public, Feuerbach died a mysterious death.

## Of puzzling descent

Feuerbach's prince theory is just one of many fanciful stories as to the boy's puzzling descent. Hypotheses range from the boy being an impostor trying to worm his way into the aristocracy to his being the son of Napoleon. The most popular postulation was that he was the heir to the throne of Baden who had been abducted at birth.

He was thought to be the son of Grand Duke Karl Ludwig Friedrich and his wife Stephanie von Beauharnais who had had a dead infant laid in the crib to allow the insignificant Hochberg line to succeed to the throne. In 1996 scientists attempted to solve the case through genetic analysis, testing the blood on the underpants Kaspar Hauser had worn on the day of his murder. The DNA they managed to isolate was compared to that of proven descendants of the House of Baden – yet no matches were found. Was this the end of a legend? This was when the prince theory should have been shelved for good and serious investigations as to the real identity of Kaspar Hauser begun. Yet in 2002 a second genetic analysis was carried out on six different samples, this time including hair and tissue. All six tests yielded an identical genetic fingerprint, most probably that of Kaspar Hauser. This, however, did not match the genetic model of 1996, from which conclusions were drawn that the blood and thus the underpants were possibly not from the mystery boy. Was he a Baden prince after all? There is a good match for the genetic material – but not a perfect one. The puzzle remains.

The phenomenon of Kaspar Hauser has fascinated us ever since. The German satirist and poet Kurt Tucholsky even used it as one of his pseudonyms. Around 2,000 books, countless brochures, articles and poems, imaginary novels and even scientific treatises have been written on the case. Four German films have focussed on the tale, the last made in 1993 by Peter Sehr and starring André Eisermann. The science of psychology even uses the name; people who are emotionally retarded and have difficulties making contact have a Kaspar Hauser Complex.

Kaspar Hauser was buried on December 20 1833 at the city cemetery in Ansbach. On his tombstone are written the words: "Hic jacet Casparus Hauser, aenigma sui temporis, ignota nativitas, occulta mors." "Here lies Kaspar Hauser, an enigma in his time, his birth unknown, his death mysterious". This holds true to this very day.

***Above:***
*The bronze monument on Platenstraße in Ansbach has two likenesses of Kaspar Hauser: as he might have looked on his sudden appearance in Nuremberg in 1828 and shortly before his violent death in 1833.*

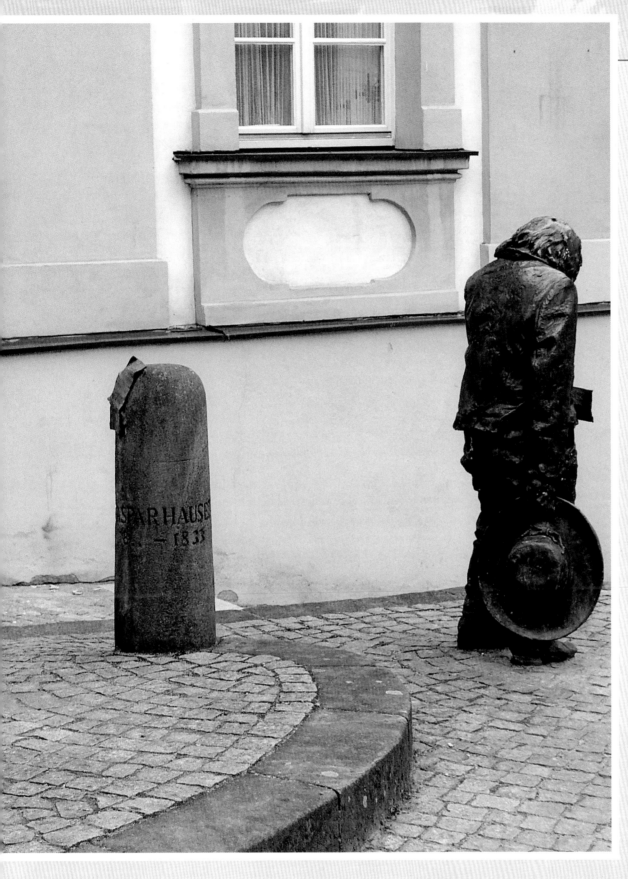

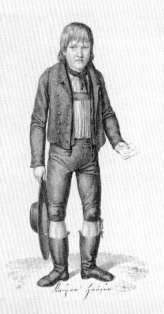

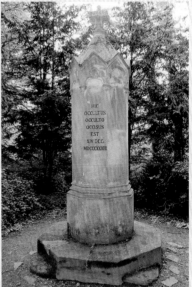

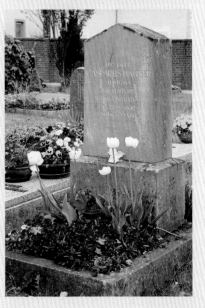

**Top right:**
Lithograph of Kaspar Hauser from 1828. "The foundling child of Europe" was the subject of much debate during his short lifetime, an interest which was greatly heightened by his mysterious death.

**Centre right:**
In the Hofgarten, at the spot where Kaspar was murdered, a plaque bearing a Latin inscription commemorates the young man's untimely demise.

**Right:**
Kaspar Hauser was buried on December 20 1833 at the city cemetery in Ansbach where his headstone still stands.

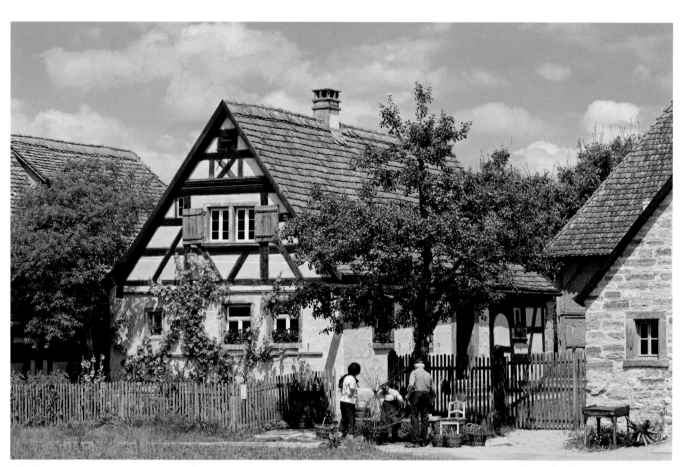

**Right:**
*Outside the Fränkisches Freilandmuseum in Bad Windsheim. At the spacious open-air museum old farmhouses and barns, mills and pubs have been carefully reconstructed and furnished as they would have been at the time of their use. Various events also help to recreate the days of yore in a typical Franconian village.*

**Below:**
*The centrepiece of Bad Windsheim's historic Weinmarkt is a fountain from 1590 which sports the figure of Emperor Karl IV.*

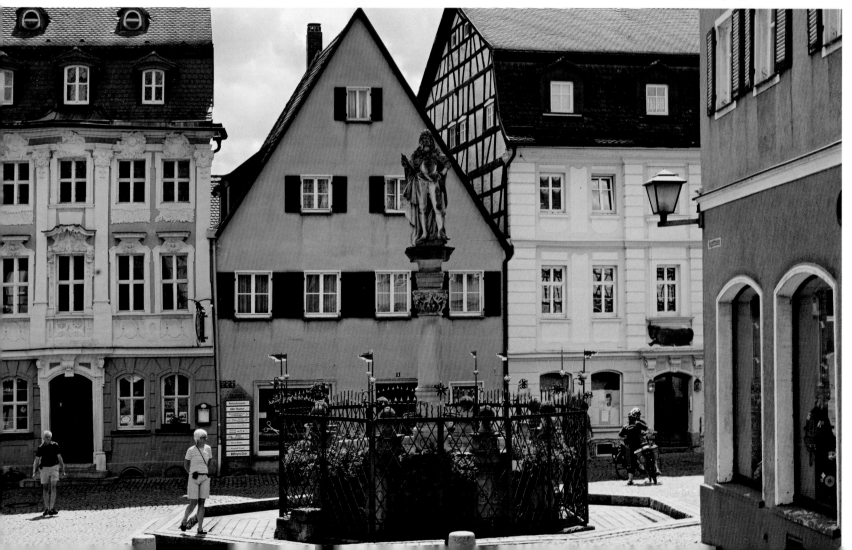

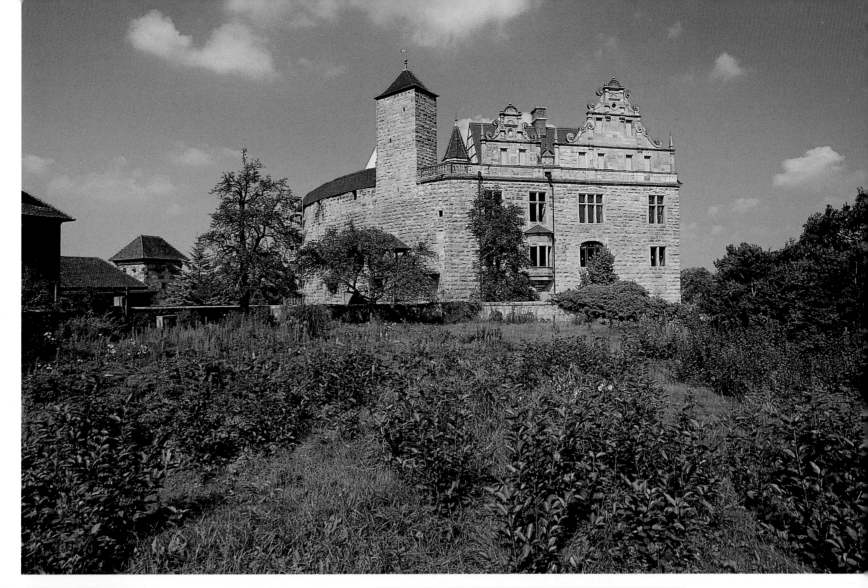

**Above:**
The castle of Cadolzburg
stands proud on a spur
of rock above the village
of the same name. It was
home to the House of
Hohenzollern in the first
half of the 15th century.

**Left:**
An ancient stone bridge
crosses the River Aisch
in Höchstadt. The Stadt-
schloss behind it was
erected on a castle mound
in c. 1400. The region is
famous for its fish, a
delicacy known locally as
Aischgründer Spiegel-
karpfen or mirror carp.

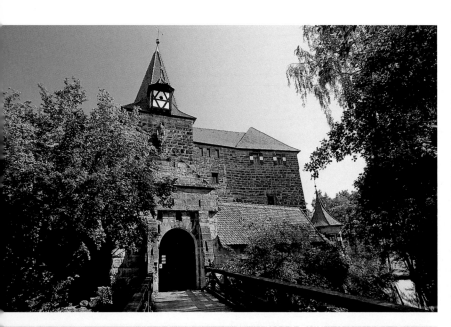

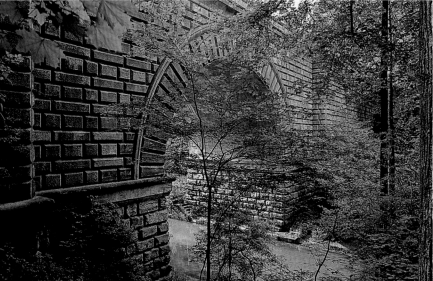

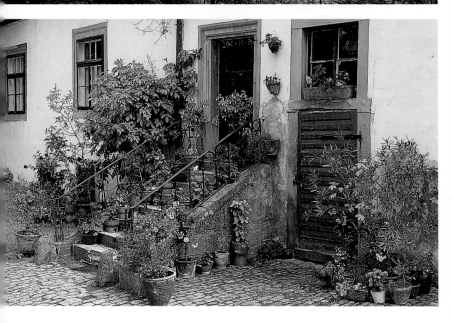

**Left:**
The Wenzelschloss in Lauf an der Pegnitz was erected between 1356 and 1360 for Emperor Karl IV. The castle was named after St Wenceslas (German: Wenzel) to whom the castle chapel is also dedicated.

**Centre left:**
King Ludwig I of Bavaria's ambitious plans for a large-scale industrial canal which once joined Bamberg and Kelheim have come to nothing more than this dreamy stretch of backwater. Ludwig's Main-Danube Canal at its most idyllic, here near Feucht.

**Bottom left:**
A floral array in the
courtyard of Schloss
Schwarzenberg in Schein-
feld. The castle was
first documented in 1150
and rebuilt during the
Renaissance following
a fire. It now houses a
boarding school.

**Below:**
Lazy days on the river:
King Ludwig's Main-
Danube Canal near
Schwarzenbruck. The first
ships began navigating
the waterway in 1846; it
was made redundant soon
afterwards by the event of
the railway.

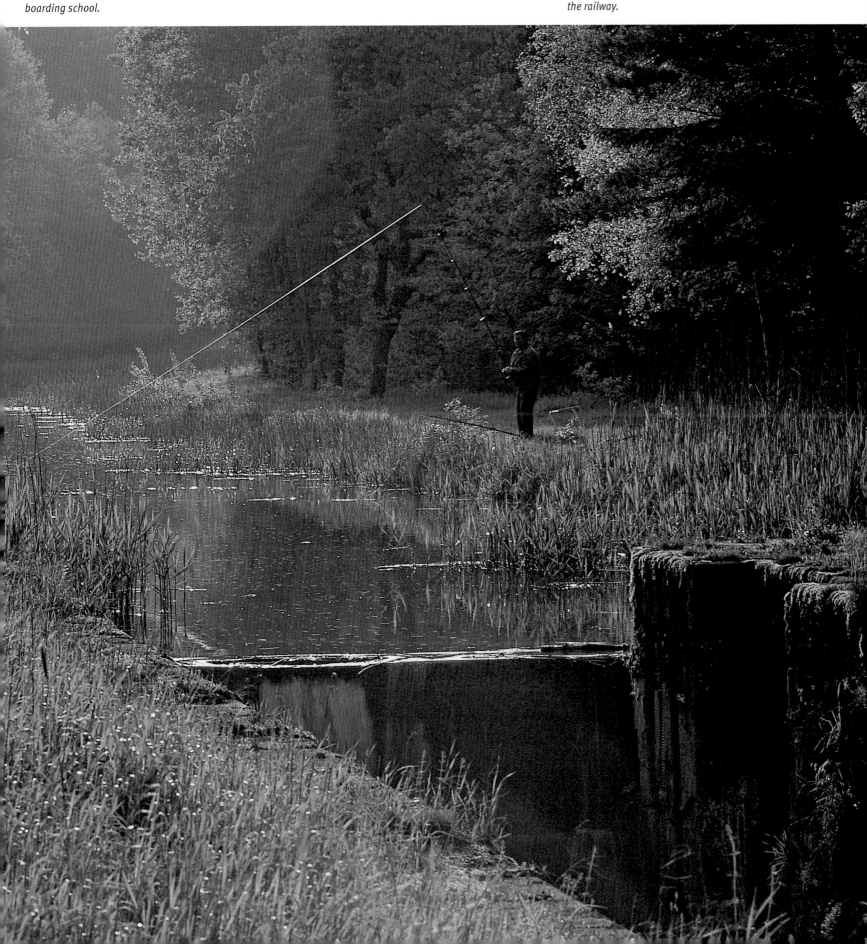

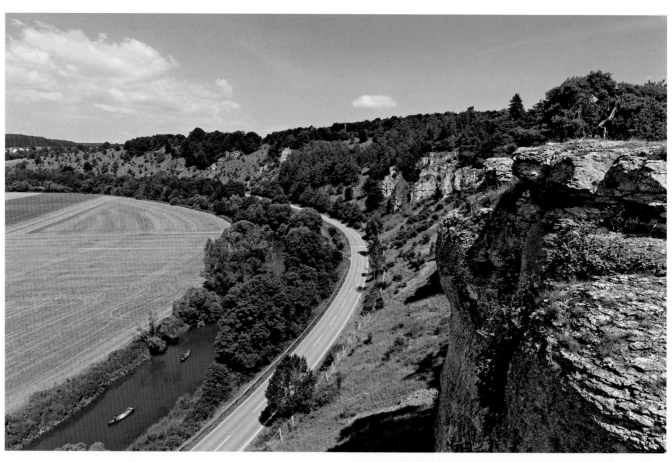

*View of the delightful Altmühltal near Eßlingen. Only the upper reaches of the winding River Altmühl are in Franconia.*

**Right:**
*The little town of Abenberg is still protected by its castle from the first half of the 13ᵗʰ century, first mentioned in 1071. Abenberg also has the only museum of lace in Germany and a school of lacemaking.*

**Far right:**
*The Mühlreisig-Haus in Spalt celebrates the fact that the town is the centre of the Franconian hop-growing industry. The half-timbered building contains no less than five drying rooms, one piled on top of the other.*

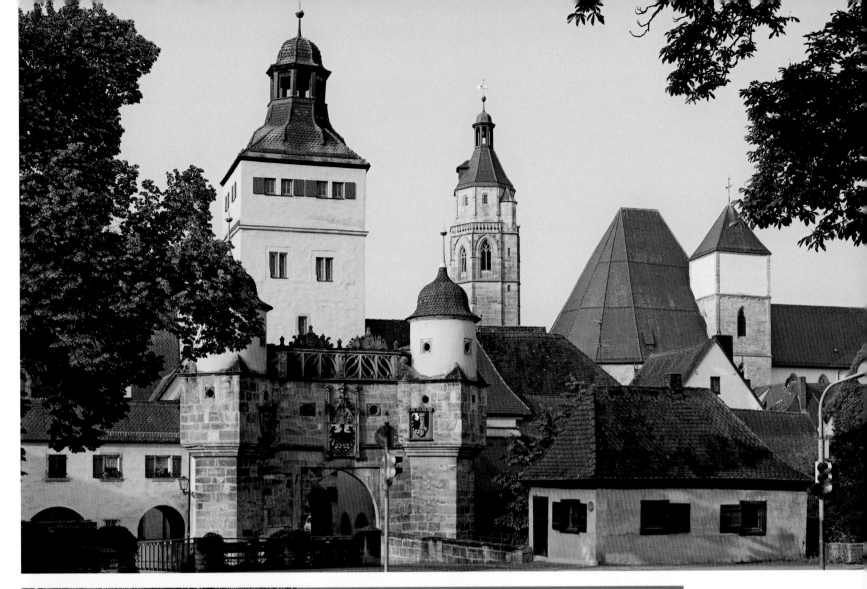

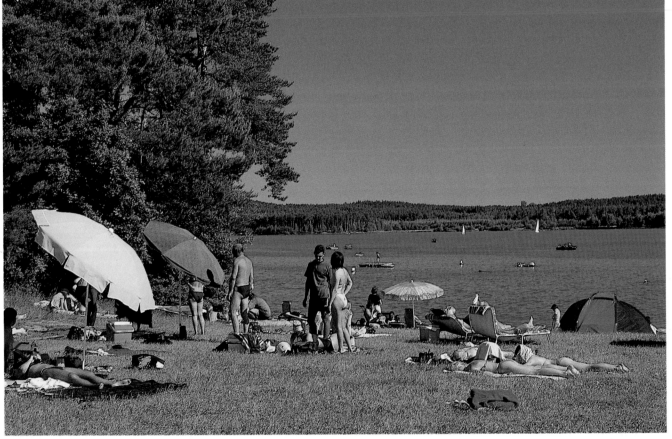

**Above:**
The 14th-century Ellinger
Tor is a local landmark in
the old free city of Weißen-
burg. The defensive
wall with its impressive
38 towers encircling the
town is still almost
completely intact.

**Left:**
Soaking up the sun on
the shores of the Kleiner
Brombachsee. The
Fränkisches Seenland
between Ansbach and
Weißenburg provides
locals and visitors alike
with plenty of scope for
exercise and relaxation.

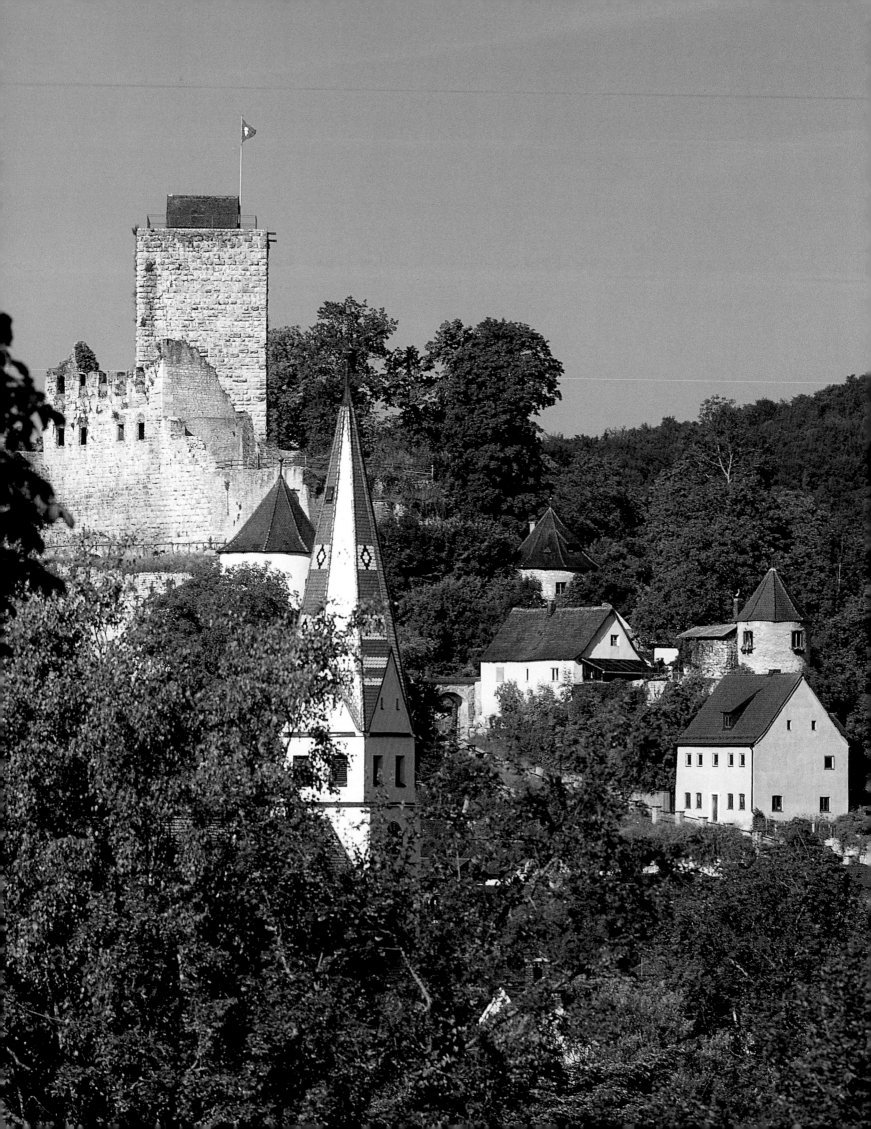

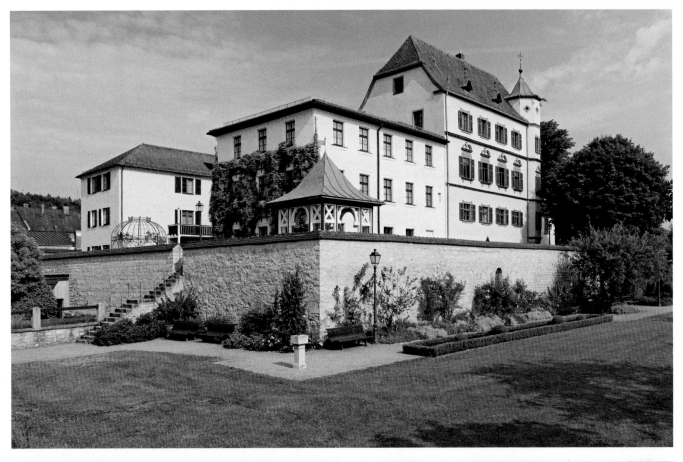

The Stadtschloss in Treuchtlingen was once a moated castle whose moat has been turned into a park. Treuchtlingen, the gateway to the Altmühltal Natural Park, has a long history; remains of a Celtic settlement and no less than eight Roman villas have been excavated here.

**Left page:**
The ruins of the Pappenheim family's former seat stand tall above the town of Pappenheim which hugs a bend in the River Altmühl. The oldest parts of the castle date back to the second half of the 12th century.

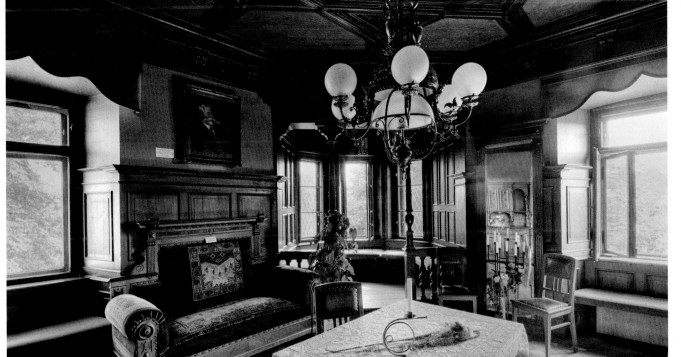

Room in the Stadtschloss in Treuchtlingen. The castle, built in 1575, is now a hotel and also accommodates the local tourist office.

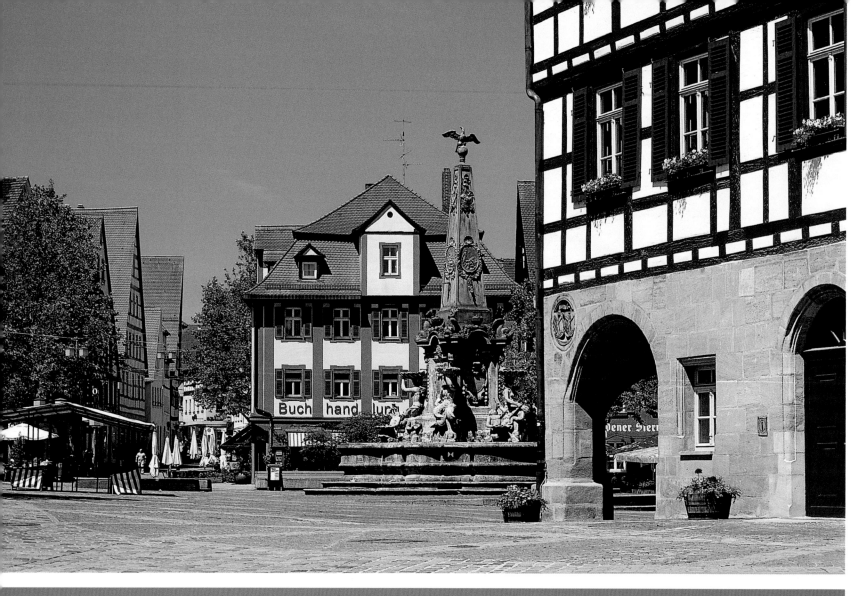

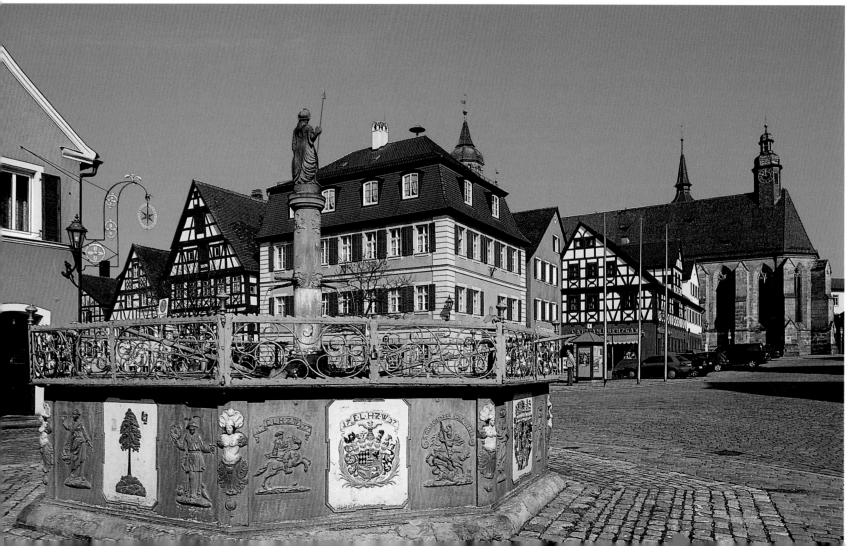

**Left:**
Marktplatz or Königsplatz in Schwabach with its fountain and town hall. Crafts have a long tradition in the old margravial town, particularly the processing of gold for gold leaf and the manufacture of needles for needlework and sewing machines.

**Below:**
Herzogenaurach is famous first and foremost for sportswear; Adidas and Puma are both based here. Its old town centre is also of merit, however; its historic houses and two distinctive towers from the 14th century, the Fehnturm (shown here) and Türmersturm, effuse a unique sense of Franconian charm.

**Left:**
Half-timbered houses and proud town dwellings line the market place in Feuchtwangen with its fountain from 1727. The city evolved around a Benedictine monastery, was made a self-governing entity under the Emperor in 1285 and in 1376 was mortgaged to the margravate of Ansbach.

**Above:**
Splendid summer bedding in Lauf an der Pegnitz. The river's strong current prompted the building of several mills here at an early stage in the town's history; a castle was later built on a river island to protect them. Lauf was granted a town charter in 1355.

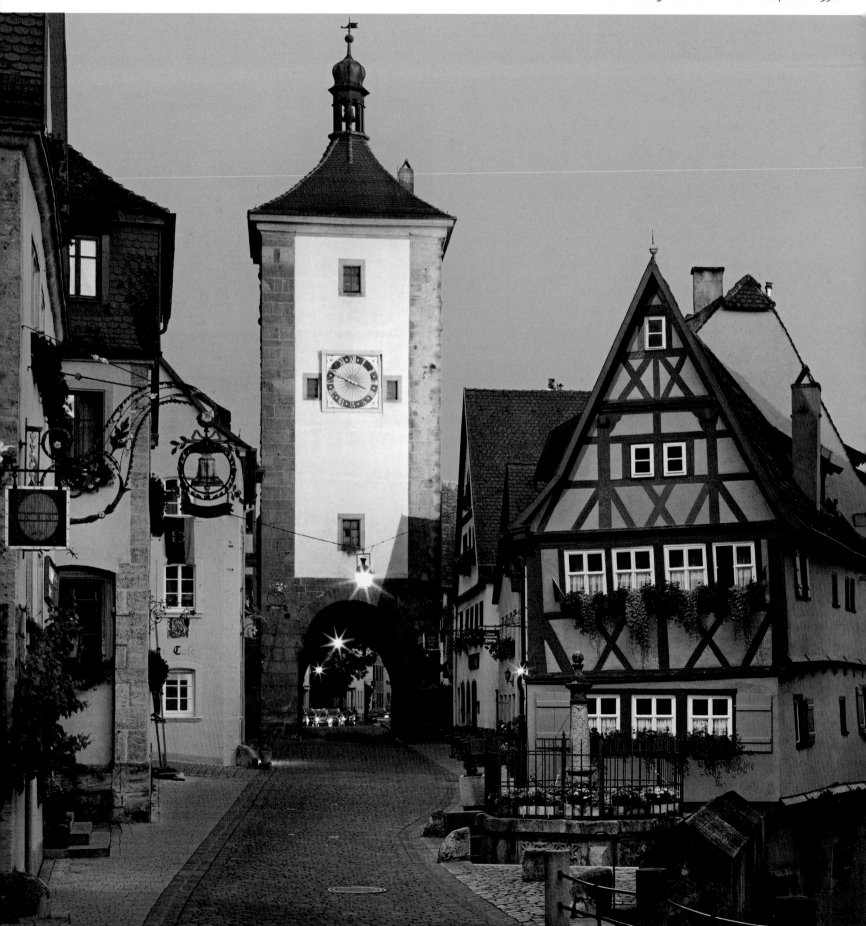

**Below:**
*Plönlein square in the beautiful medieval town of Rothenburg ob der Tauber. The name of this idyllic spot is allegedly derived from the Latin planum or "flat area".*

**Top right:**
*High up above the valley of the River Tauber lie the castle gardens of Rothenburg, entered via the oldest gatehouse on the town wall, the Burgtor. They mark the site of the old Hohenstaufen stronghold, destroyed by an earthquake in 1356.*

**Centre right:**
Herrngasse in Rothenburg
which runs from Rathaus-
platz to the Burgturm.
If it weren't for the many
tourists, souvenir shops

and pavement café
umbrellas, you would
almost expect the streets
to be filled with medieval
townsfolk going about
their business...

**Bottom right:**
Living in the past in
Rothenburg. At Whitsun
the Meistertrunk legend
from the Thirty Years' War
is religiously re-enacted;
in September the city
celebrates its history as
a free city of the Holy
Roman Empire.

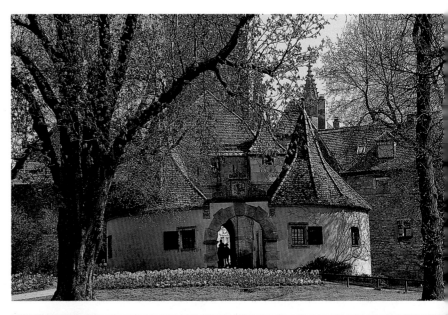

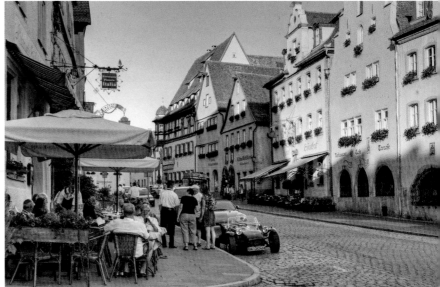

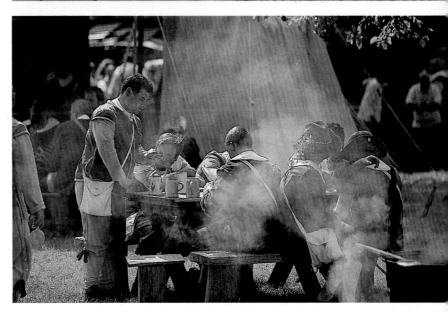

89

**Below:**
The aisled nave of the
parish church of St Georg
in Dinkelsbühl, one of the
most magnificent hall
churches in Germany,
creates an incredible
sense of space. The late
Gothic edifice was built
between 1448 and 1499;
the lower levels of the
tower originate from the
late Romanesque period.

**Below:**
Fine masonry adorns the
facade of the Georgskirche
in Dinkelsbühl. Over half
of the houses in the old free
city on the River Wörnitz
are from before 1600.

**Right:**
The mighty Nördlinger Tor
in Dinkelsbühl. Four gates
and a battery of towers
punctuate the city walls,
erected from the 13th to the
15th centuries to defend
Dinkelsbühl's indepen-
dence as a free city of the
Holy Roman Empire.

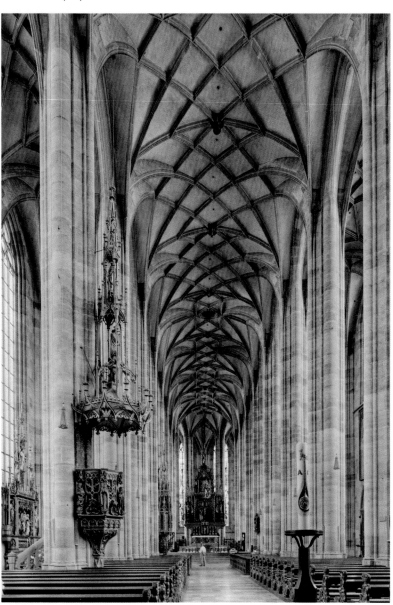

**Right:**
Each July in Dinkelsbühl
Kinderlore leads an army of
children to beg the Swedes
'besieging' the city for
mercy. The historical
procession commemorates
an event which occurred
during the Thirty Years' War.

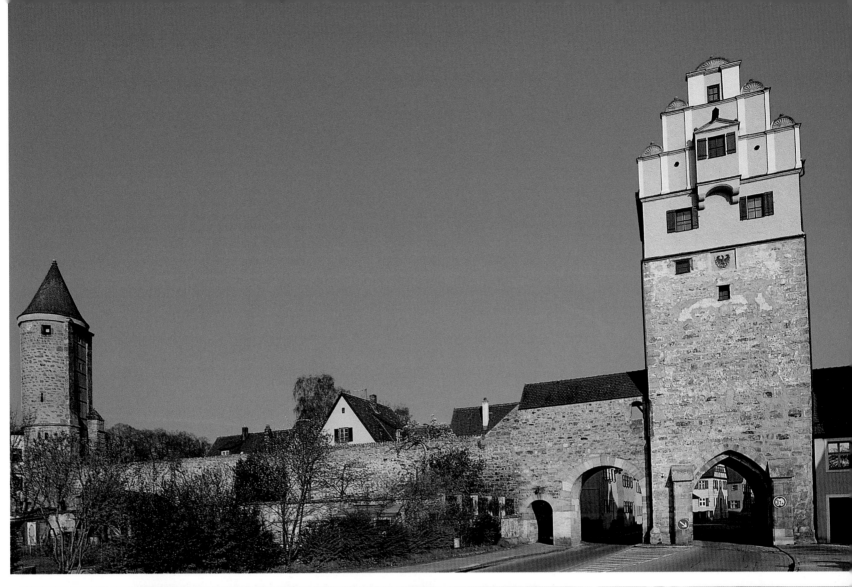

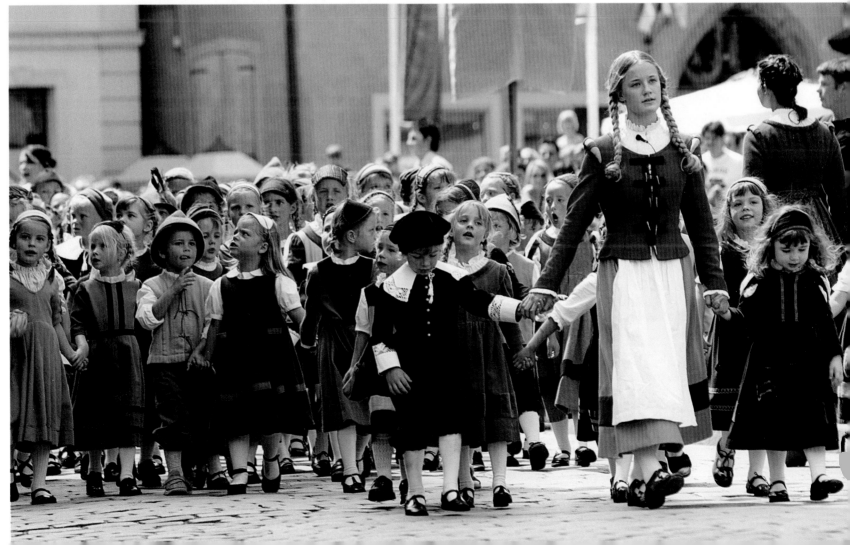

# Meandering rivers, dark forest and holy mountains – Unterfranken

*From Festung Marienberg there are marvellous views of Old Würzburg, where many church spires and steeples punctuate the blue Franconian sky. The Alte Mainbrücke forms a direct axis from the fortress mound to the city cathedral.*

The largest and most important river in Franconia makes its most erratic bends and diversions in Unterfranken. At Schweinfurt, the region's industrial centre, the River Main turns a sharp corner into the triangular Maindreieck where the Fränkisches Weinland begins. Here beneath sloping vineyards lie the pretty villages of Volkach, Sulzfeld, Sommerach and many more, where hardly a summer weekend goes by without a wine festival being celebrated in some spot or other. The local cultural and administrative capital was and still is the see of Würzburg, which with its residential palace and fortress effuses a sense of palpable history and great charm.

At Gemünden the River Main again changes direction, meandering past the seemingly impenetrable depths of the Spessart to form three sides of a square. One of the largest swathes of forest in Germany, the Spessart was once a hunting ground for the bishops of Mainz which is why the area is only sparsely populated. Its towns and villages have been pushed to the edge, with many of them situated on the Main where wine is also cultivated. Lohr, Wertheim (which strictly speaking is no longer part of Franconia) and Miltenberg have historic old towns; Klingenberg is famous for its red Spätburgunder wine. Schloss Johannisburg in Aschaffenburg is one of the most impressive secular buildings of the late Renaissance; the Pompejanum, a reconstruction of a Pompeiian villa, was presented to the city or the "Nice of Bavaria" by Ludwig I.

Pure unadulterated scenery can be found in the mountains of the Rhön with its highland moors and rich variety of flora and fauna, made a biosphere reserve by UNESCO in 1991. The highest elevation in the Franconian Rhön is the Kreuzberg, the "holy mountain" of the Franks. St Kilian is said to have erected a cross here as early as in 686, making it a place of pilgrimage in the Middle Ages whose religious pull was greatly increased by the monastic brewery set up here by the Franciscans in 1731.

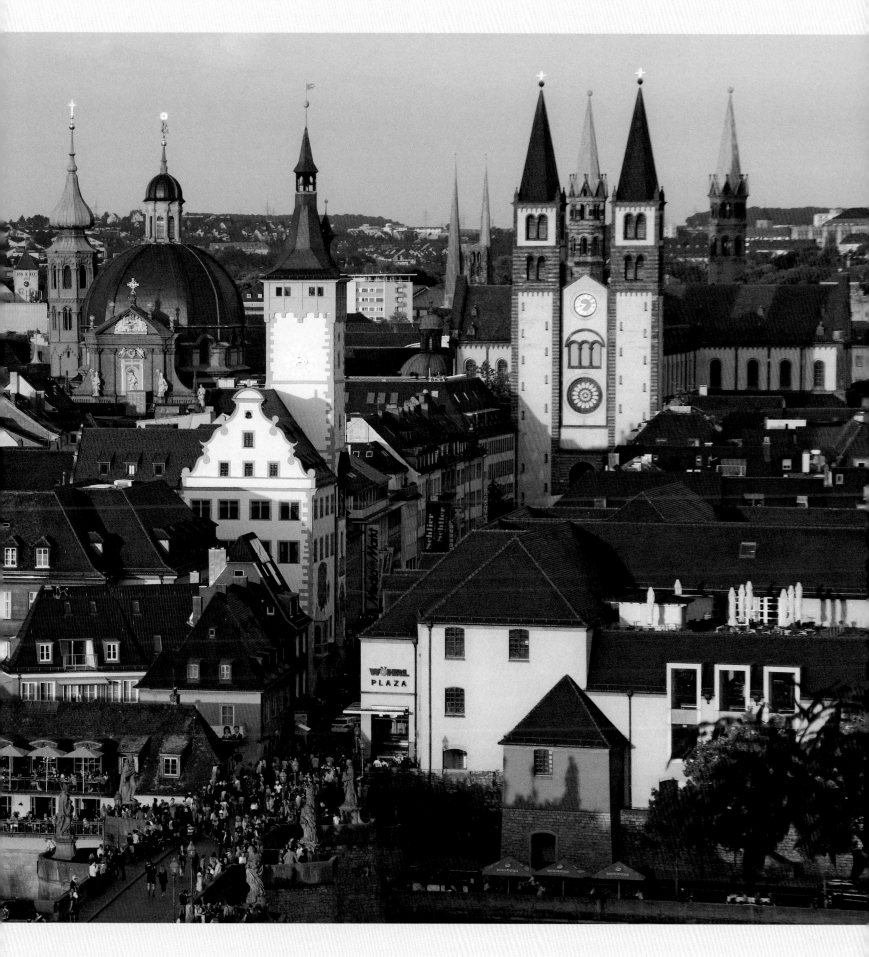

The spring gardens of the Würzburg Residenz. Magnolias and ornamental cherries blossom in the symmetrical beds of the Rococo gardens which open out onto an informal landscaped park.

**Right page:**
In the palace gardens the city's former fortifications have been turned into a green work of art. The ground of the old bastion has been elegantly terraced to lead up to the Gartensaal (Garden Room) and Kaisersaal (Imperial Hall), to which spacious circular beds were added by court gardener Johann Prokop Mayer between 1770 and 1779.

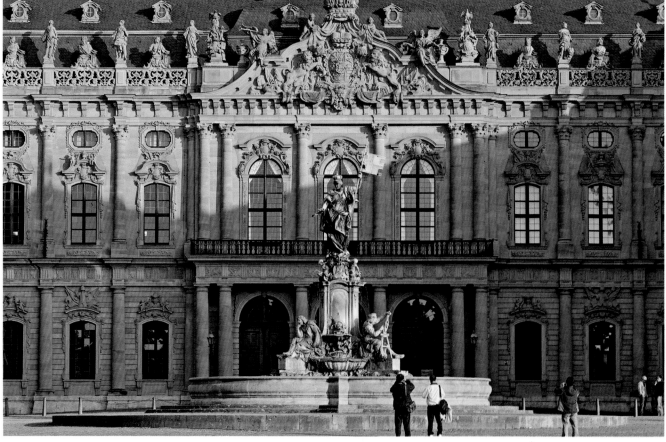

The courtyard facade of Würzburg's residential palace is particularly rich in its ornamentation. Over the three entrance portals a narrow balcony services the three arched windows of the Weißer Saal or White Hall; above these is an elaborate sandstone gable bearing the coat of arms of Friedrich Carl von Schönborn, the second of the dynasty to work on the palace begun by Johann Philipp Franz von Schönborn. The Franconia fountain with its statues of Walther von der Vogelweide, Tilman Riemenschneider and Matthias Grünewald was installed in the court of honour in 1894.

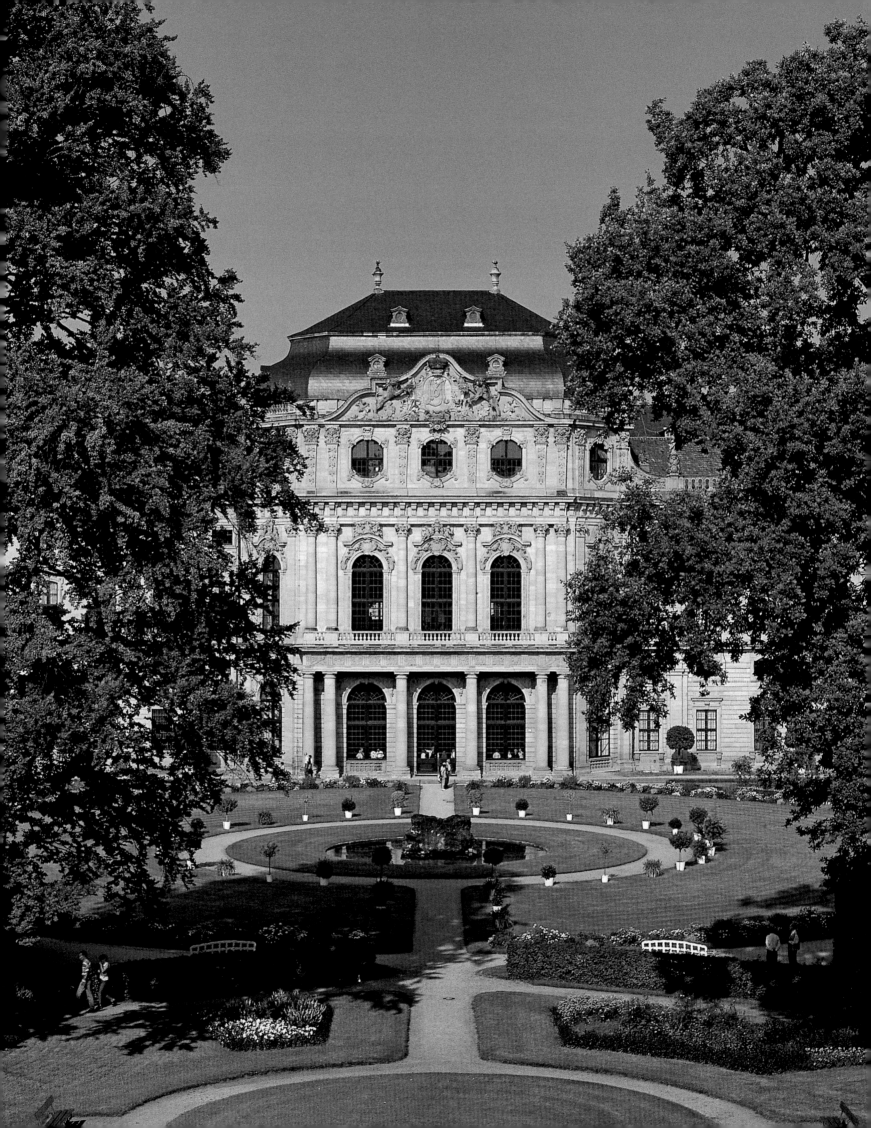

The twelve statues on the Alte Mainbrücke in Würzburg date back to the 18th century. Over four metres (12 feet) tall, they are the work of Claude Curé on the north side of the bridge and of the brothers Johann Sebastian and Volkmar Becker on the south. In the background on the left is the old town hall, with the cathedral on the right.

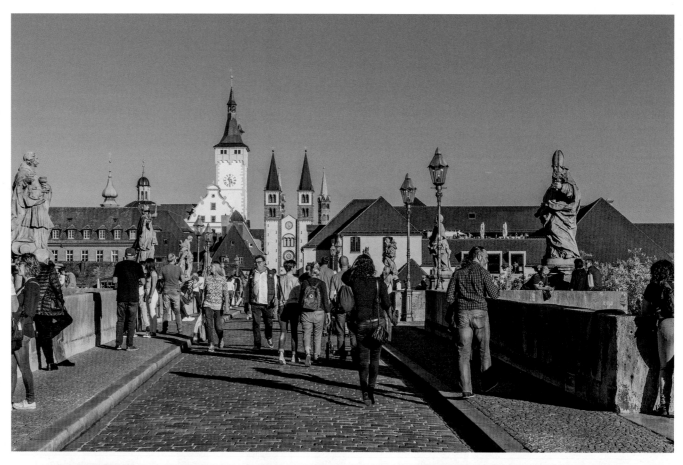

**Right page:**
Against the backdrop of the Würzburger Stein vineyards pleasure boats weigh anchor where goods were once traded. The old crane on the Mainkai, erected by Balthasar Neumann's son Franz Ignaz Michael Neumann in 1772, is a reminder of how busy the quay once was.

Each year a colourful procession with over 60 groups in local costume heralds the opening of Würzburg's huge festival staged in honour of the city's patron saint Kilian. Here, the parade is seen passing the Rennweger Tor of the Residenz.

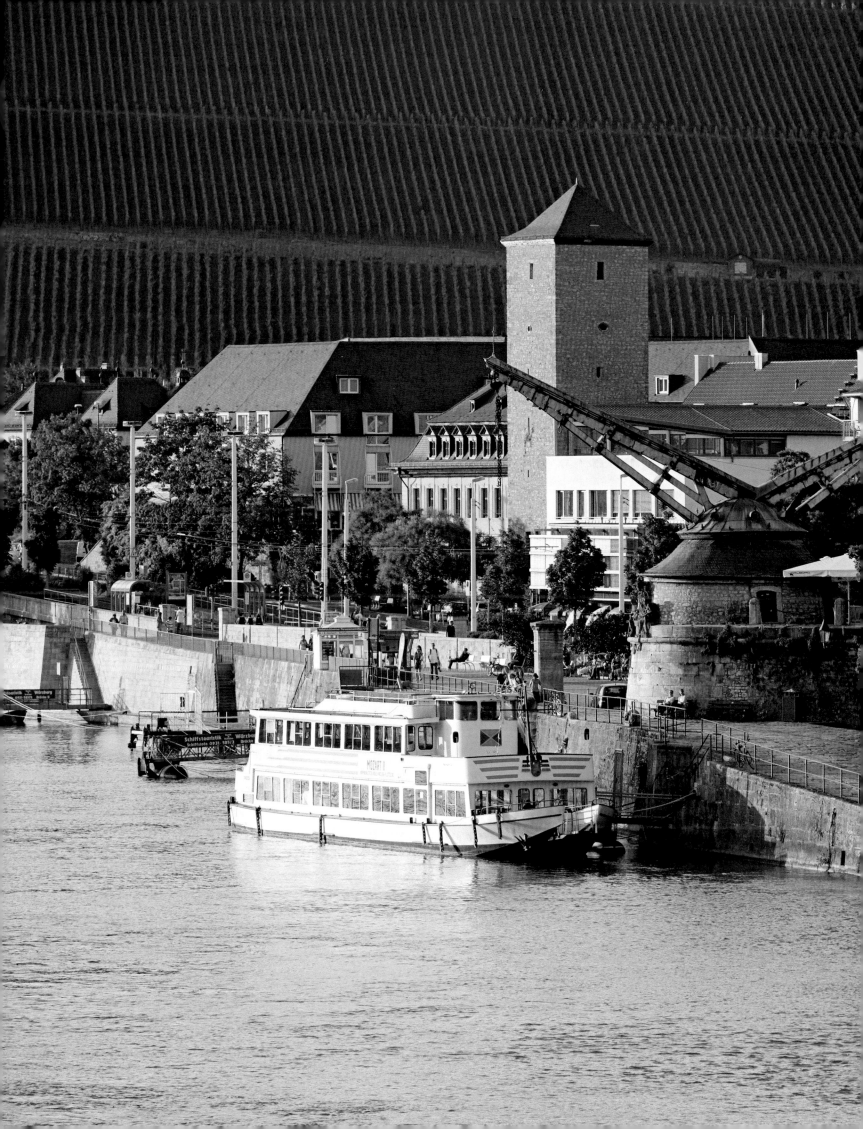

**Below:**

The oldest part of Würzburg's Rathaus, the Grafeneckart building, marks the start of Domstraße which culminates in the facade of the cathedral. The town hall was founded as the seat of the episcopal castle counts during the 13th century and has been greatly extended and altered over the centuries.

**Below:**

The vast number of churches in Würzburg pays homage to the fact that it is an old episcopal see. Here the view from the Michaelskirche of the spire of the Neubaukirche, part of the old university founded by Prince-Bishop Julius Echter in 1582.

**Right:**

The market square in Würzburg is dominated by the Gothic Marienkapelle, built at the end of the 14th century by the local townsfolk as their place of worship. On the right next to the choir on its east side is the Haus zum Falken with its beautiful Rococo façade. This splendid building from 1751 now houses the city library and various other institutions.

**Right:**

In early summer Würzburg sets up its own wine village on Marktplatz in front of the Marienkapelle. Here you can taste any number of Franconian vintages, including a range of refreshing sparkling wines from the region.

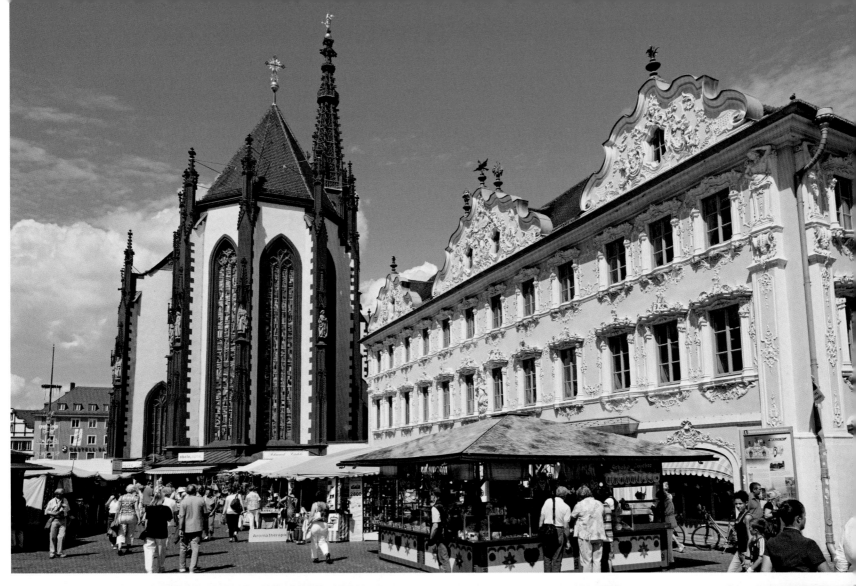
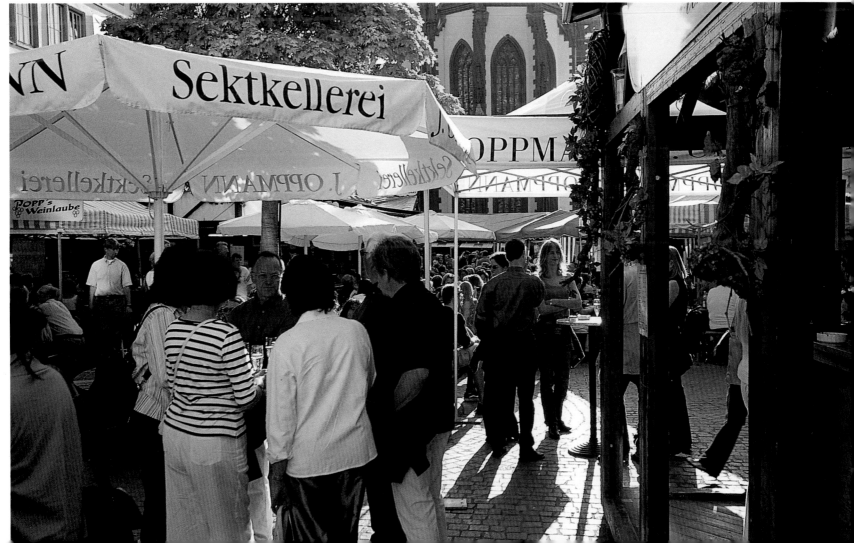

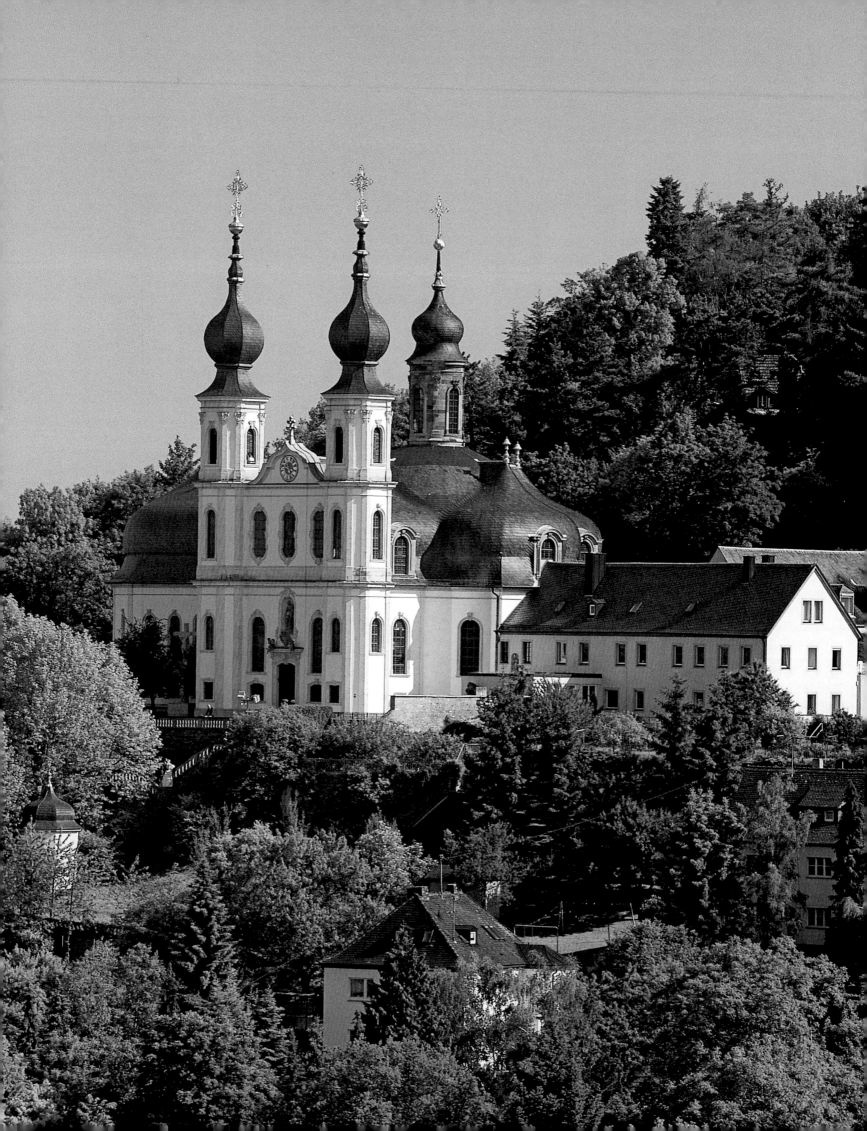

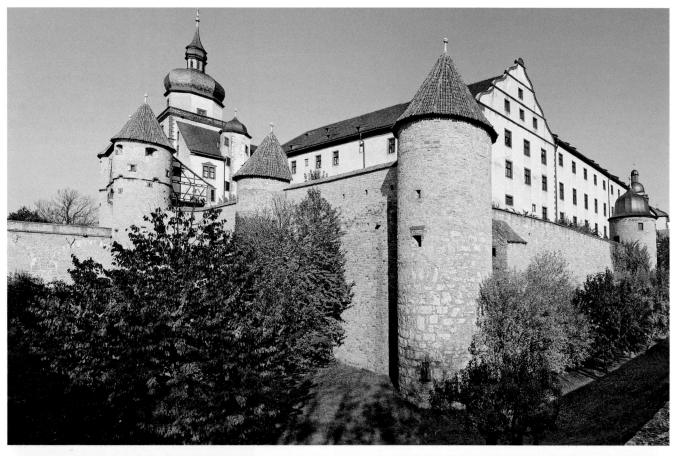

Würzburg's mighty
Festung Marienberg is
only marginally softened
by its green skirt of vines.
Initially the site of a Celtic
fort, a chapel dedicated to
St Mary was first built here
until the fortress proper
was begun in 1201. The
local prince-bishops lived
in the stronghold until
1719 when the residential
palace in the centre of the
city was begun.

**Left page:**
Opposite Festung Marien-
berg in Würzburg, high up
on the Nikolausberg on the
left bank of the River Main,
is the Käppele pilgrimage
church dedicated to
St Mary. Balthasar Neu-
mann's final masterpiece
from 1747 to 1750 can be
reached via the steep
Stations of the Cross which
feature groups of figures
by Peter Wagner.

From the Alte Mainbrücke
you enter the fortifications
of Festung Marienberg
through the Neutor or new
gateway, built in 1652.

# FROM VEIT STOSS TO BALTHASAR NEUMANN – THE HISTORY OF ART IN FRANCONIA

With its countless churches, castles and stately homes Franconia is one of the most significant cultural landscapes in Germany. The old town in Bamberg and the residential palace in Würzburg are both World Heritage Sites. Since the early Middle Ages the region has attracted artists to its very heart from far and wide and has also produced several great names in the history of European art.

The Kaiserdom or imperial cathedral in Bamberg is lauded as a masterpiece of the late Romanesque and early Gothic periods. Its sculptures in particular are unusually realistic for their day and age. Where the masons who worked on the cathedral in Bamberg were from Reims in northern France, by the late Gothic period the local art world was dominated by a number of Franconians. Veit Stoß (1447/48–1533) set himself up as a sculptor, carver and copper engraver in Nuremberg where one of his creations, the *Annunciation*, still adorns the interior of St Lorenz. Sculptor Adam Kraft (c. 1460–1508/09) was also from Nuremberg; his contribution to the church of St Lorenz was a splendid tabernacle. Würzburg and the surrounding area were serviced by the workshop of Tilman Riemenschneider (c. 1460–1531) who among other works fashioned the figures of Adam and Eve for the south portal of the Marienkapelle in Würzburg and also a *Madonna of the Rosary* for the pilgrimage church of Maria im Weingarten outside Volkach.

One of the most significant painters of the 15th and 16th centuries was Lucas Cranach the Elder (1472–1553) from Kronach. He was friendly with Luther whom he painted on several occasions and for whose translation of the Bible he made illustrations of the Apocalypse. Albrecht Dürer (1471–1528) was from Nuremberg. After two trips to Italy he broke with the artistic traditions of the Gothic, heralding the arrival of the Renaissance. On his return to Nuremberg in 1494 he began painting his Franconian surroundings, making him the first painter to consider the landscape a motif worthy of artistic study.

Following the Thirty Years' War architectural activity reached its zenith, particularly under the auspices of the illustrious House of Schönborn. Architects the dynasty commissioned included members of the Dientzenhofer family and also Balthasar Neumann. Two of the four Dientzenhofer brothers, originally from Upper Bavaria, did a lot of work in Franconia; Johann Leonhard (1660–1707) built St Martin and the Neue Residenz in Bamberg and also the Ebrach and Banz monasteries, with Johann (1663–

1726) responsible for Schloss Weißenstein in Pommersfelden and the facade of Neumünster in Würzburg.

## Star architect Balthasar Neumann

Balthasar Neumann first came to Würzburg in 1711 as an apprentice bell caster. Architect Andreas Müller sponsored and encouraged Neumann and in 1719 the young man received a commission to build a residential palace in Würzburg for Johann Philipp Franz von Schönborn. The staircase is a masterpiece of unsupported vaulting, a technique Neumann was to pursue in his sacred buildings. From this point forward Neumann found himself the most popular architect of his day, creating many edifices in Franconia – and elsewhere – which still bear witness to his great expertise. The pilgrimage church in Vierzehnheiligen is a perfect example of his ability to combine ovals of different sizes to make a spacious whole. The pilgrimage chapels in Gößweinstein, Maria Limbach near Eltmann, the Käppele in Würzburg and many smaller places of worship, such as the parish church in Gaibach and the Heiligkreuzkapelle in Kitzingen, are also by Neumann.

The intense architectural industry of the baroque brought many other artists to Franconia. Antonio Petrini from Trent erected the Stift Haug in Würzburg and the city church in Kitzingen; Giovanni Battista Tiepolo painted the enormous ceiling fresco for the staircase of the Würzburg Residenz. Stucco artists Antonio Bossi and Pietro Magno were also from Italy. When Franconia lost its independence and thus the royalty and wealth to fashion even more palaces and churches the number of architectural ventures waned. During the 19th century a new class of builder emerged: the bourgeoisie. The most famous Historicist structure in Franconia is perhaps the Wagner Festspielhaus by Otto Brückwald in Bayreuth. Richard Wagner himself worked on the plans and at the same time had architect Carl Wölfel build him a house to match – in the style of the Renaissance.

**Left:**
*Pen-and-ink lithograph by Friedrich Ludwig Zacharias Werner and Ernst Theodor Amadeus Hoffmann. ETA Hoffmann was made musical director of the Bamberg theatre in 1808, a post he held for just a few years.*

**Above:**
*Unlike his contemporaries Tilman Riemenschneider did not frame or back his wood carvings. The "Altar of the Holy Blood" in*

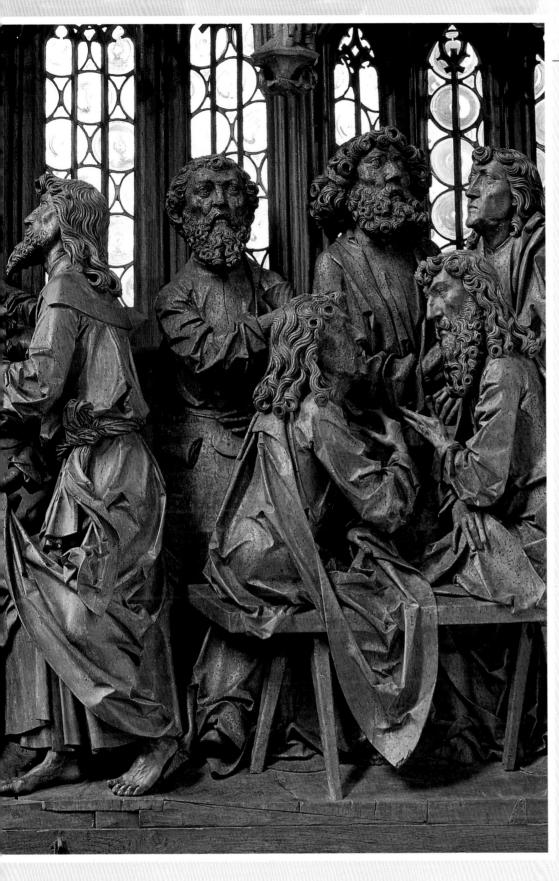

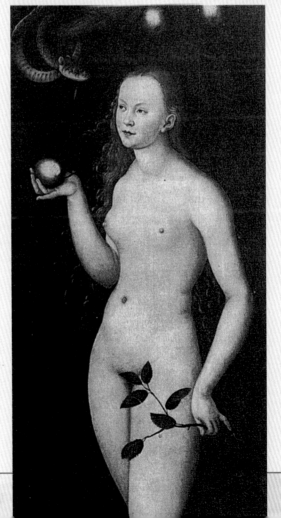

Rothenburg which depicts
The Last Supper was made
in c. 1500. Surprisingly,
the figure of Judas – and
not Jesus – is at the centre
of the scene.

**Top right:**
Sculpture of woodcarver
and sculptor Tilman
Riemenschneider on the
Franconia fountain outside
the Residenz in Würzburg.
The grand master of the
late Gothic period was also
mayor of the city in 1520/21.

**Centre right:**
The Drahtziehermühle an
der Pegnitz (Wire-Drawing
Mill on the Pegnitz) was
probably executed in 1494.
Albrecht Dürer from Nurem-
berg was the first German
artist to paint landscapes
featuring local motifs.

**Right:**
This portrait of Eve by
Lucas Cranach the Elder
from 1528 now hangs
in the Uffizi gallery in
Florence. The painter was
born in Kronach and later
worked for the Saxon court
in Wittenberg.

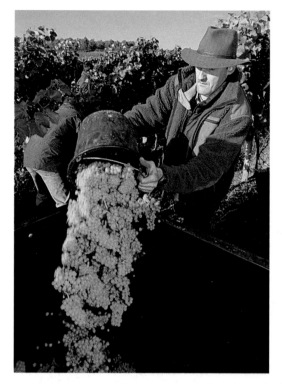

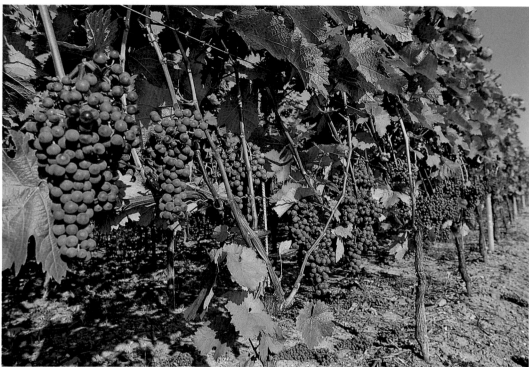

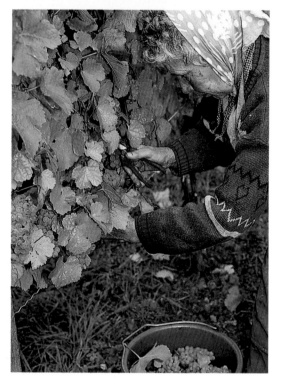

Harvesting the grapes in Unterfranken. Viniculture has a long tradition in Franconia; vines were planted on the slopes of the River Main as early as in the 8th century. Even today the majority of Franconia's grapes are cultivated on the Muschelkalk of the Maindreieck and Mainviereck areas. At the top corner of the former lie the vineyards tended by the idyllic wine villages of Sommerhausen (here Weingut Steinmann, top and bottom left) and Frickenhausen (bottom right and right page). The vines near Iphofen on the inclines of the Steigerwald (top right) thrive on Keuper. As many of the vineyards in Franconia are steep the grapes are still mostly harvested by hand – a strenuous task, at the end of which a Brotzeit platter is particularly welcome!

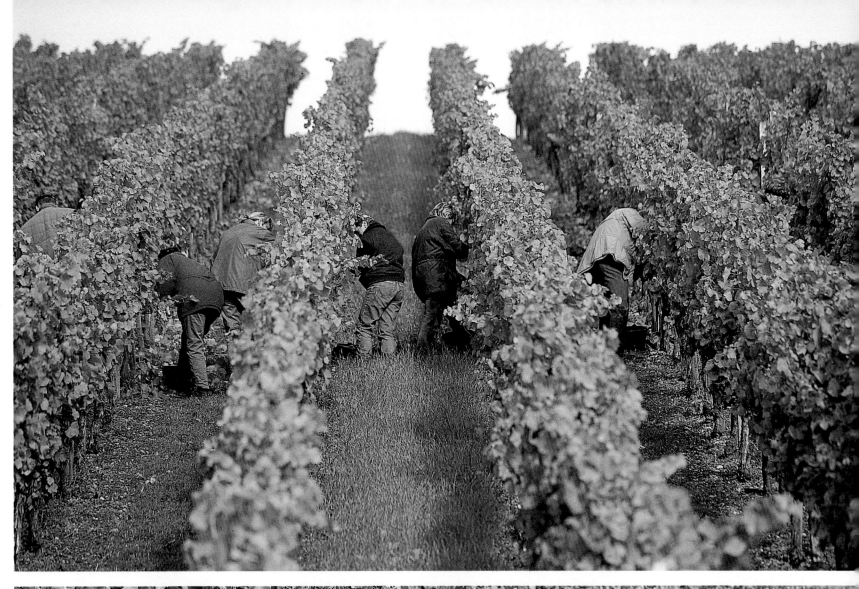

**Below:**
*The walls of Dettelbach were built at the end of the 15th century when the prince-bishop of Würzburg granted the little wine village on the River Main its town charter and the right to hold a market. Nearby is the pilgrimage church of Maria im Sand, an impressive product of the Franconian Counter-Reformation.*

**Below:**
*This part of Marktbreit, the southernmost town in the Maindreieck, is known as the Malerwinkel or artist's corner. The slim half-timbered building on the right is a museum. In the centre is the Renaissance Maintor under which the River Breitbach flows into the Main.*

**Right:**
*Hub of the wine trade Kitzingen is characterised by its many steeples. On the left are the twin towers of the former Jewish synagogue, with that of the otherwise ruined Deusterschloss to their right. The next in line are the Marktturm and the tall facade of the Lutheran church, built by Antonio Petrini, followed by the Catholic Johanniskirche. The ensemble is rounded off by the bulbous roof of the Stadtkirche.*

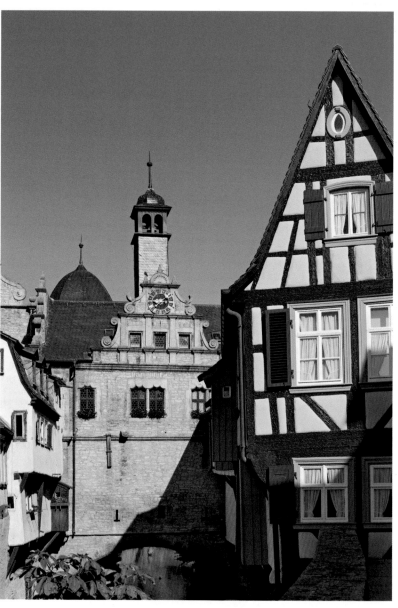

**Right:**
*The wine village of Iphofen on the western edge of the Steigerwald still has its late medieval defences. Of its many towers and gates the Rödelseer Tor is perhaps the most striking, with its brilliant red-and-white half-timbering. Iphofen is also the seat of western Europe's biggest plaster manufacturer.*

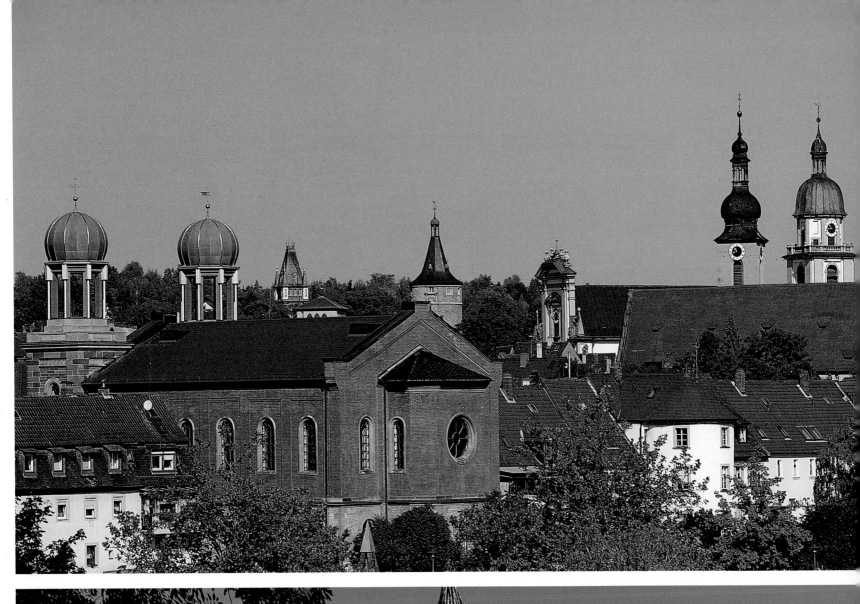

Ornate wrought iron pub signs, here lining the main street running through the wine village of Sommer-hausen, are a mark of hospitality in Franconia. In the background on the left is the steep gable of the old palace.

**Right page:**
View from the valley of the River Main of Sommer-hausen and Winterhausen beyond it. Its many boutiques and art studios have earned Sommer-hausen something of a reputation as an artisan's paradise – where wine nevertheless plays a major role. To the right is the spire of the Lutheran Bartholomäuskirche which dates back to the 13th century.

The Maintor in Sommer-hausen. The most famous gate in town is the Würz-burger Tor, however, in which the smallest theatre in Germany was set up in 1950 by Luigi Malipiero. Veit Relin ran the enterprise from 1950 to 2013.

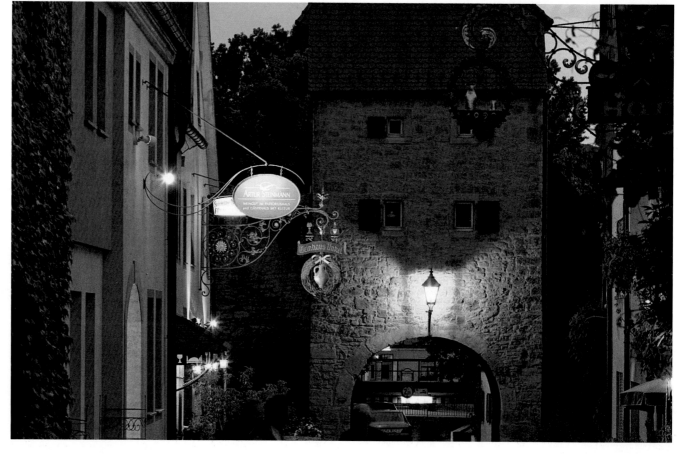

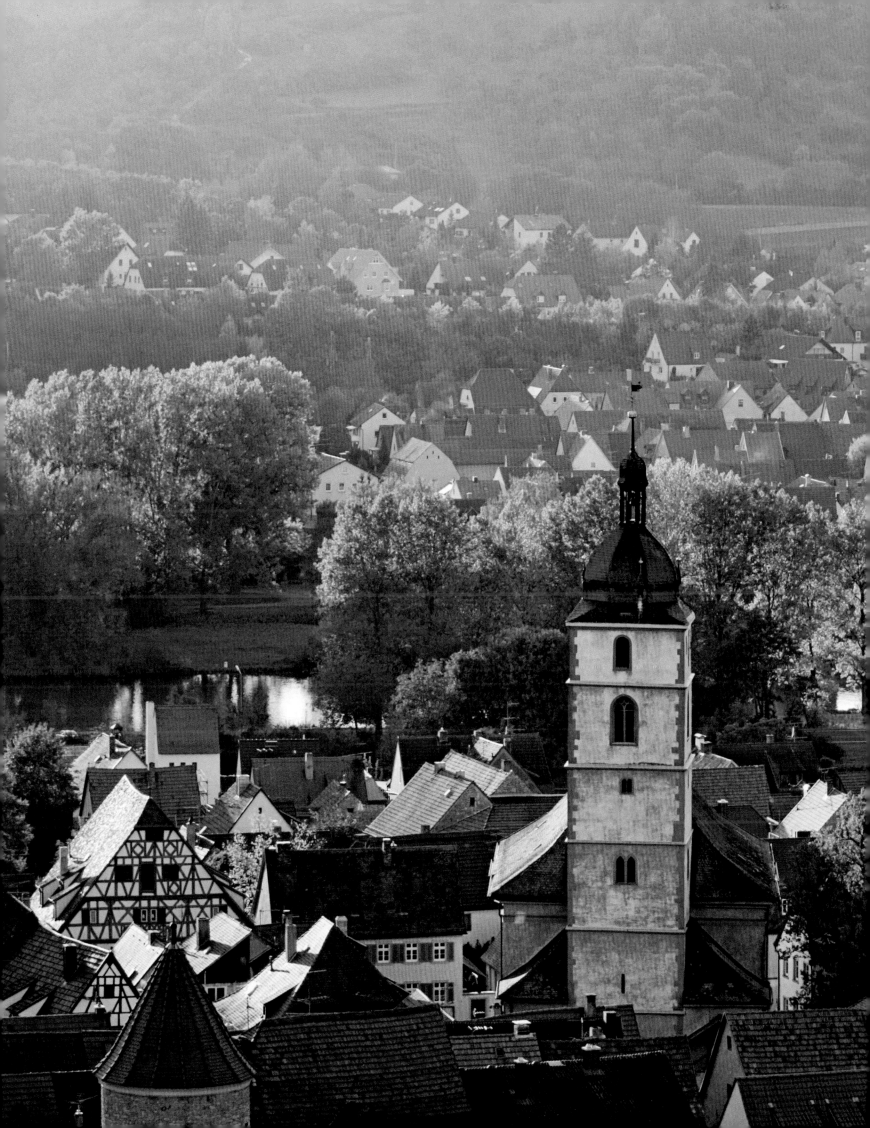

*Wine festival in Sulzfeld. At the beginning of August the market place and narrow streets in this tiny, romantic wine village bustle with revellers and connoisseurs. On a fine summer's evening out beneath the stars the town walls and Renaissance facade of the Rathaus (far right), brightly illuminated in honour of the festival, seem especially beautiful.*

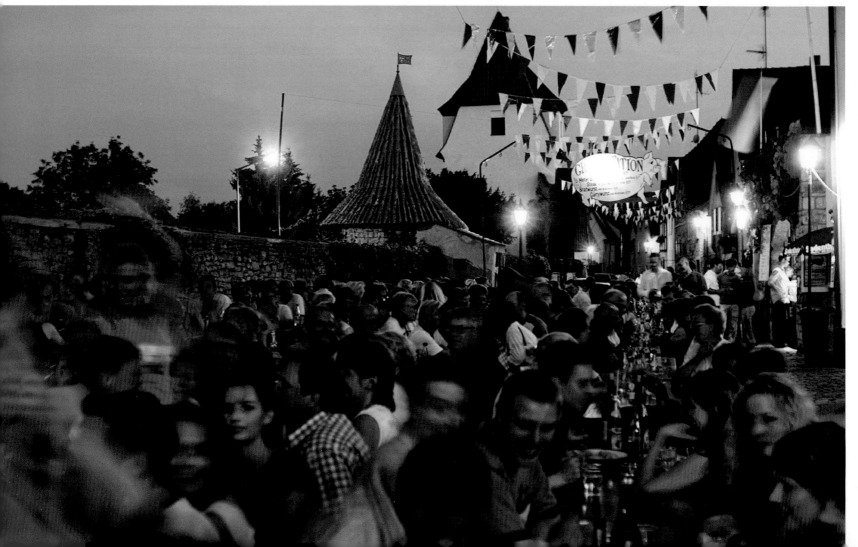

The atmospheric Beim
Batzenärrle wine tavern in
Karlstadt is a great place
to savour a glass or two of
Franconian wine.

**Left:**
Local vintages are
also served in style at
Michelskeller in Sulzfeld,
an old Franconian wine
cellar from c. 1300 which
was opened up as a tavern
in 1973.

**Above:**
View of Castell, the ancestral seat of the lords of Castell. On top of the castle mound the ruins of their castle still stand, demolished in 1746. A more comfortable baroque palace was later erected in the town next to the tall spire of the Schlosskirche.

**Right:**
Early neoclassical stucco adorns the interior of the Lutheran Schlosskirche in Castell. One of its more notable features is the altar from 1788, into which the pulpit has been integrated.

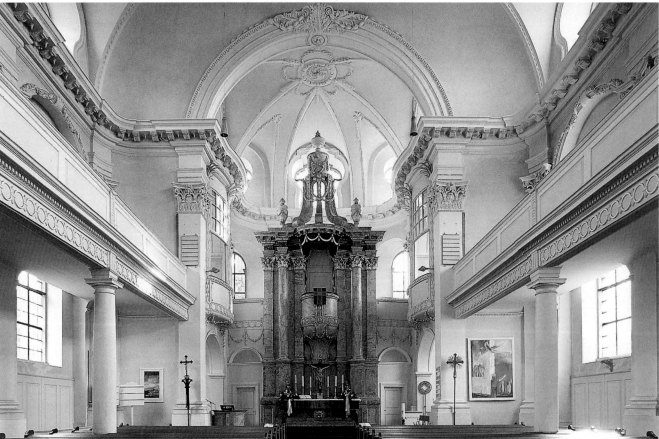

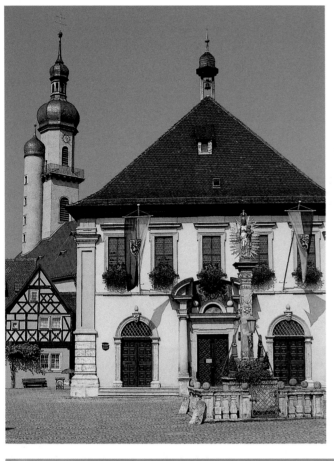

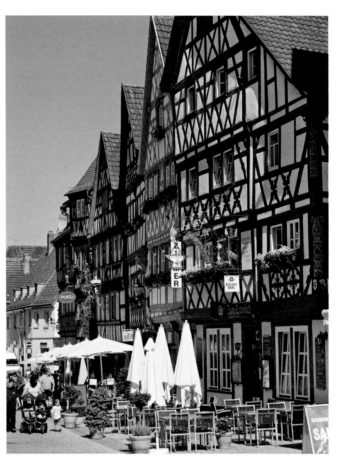

*Far left:*
In front of Eibelstadt am Main's late baroque town hall stands a statue of the Madonna in a form typical for the region. Behind it is the unusual twin steeple of the town's parish church, much of which is late Gothic.

*Left:*
The houses lining the high street in Ochsenfurt are excellent examples of Franconian half-timbering. The picturesque little town, complete with town wall, was founded in the second half of the 12th century by the prince-bishops of Würzburg.

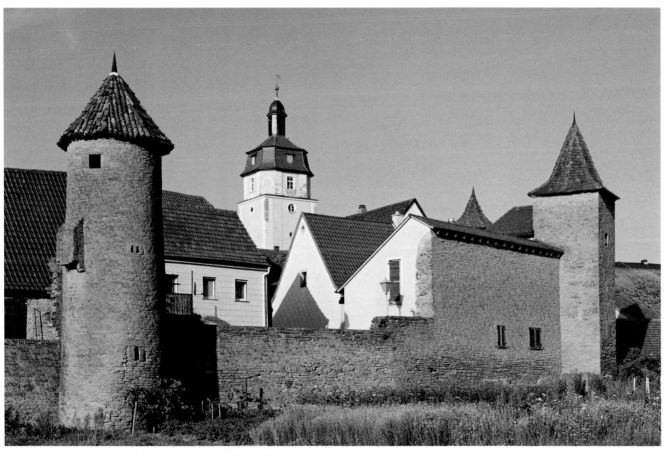

*Left:*
The town walls of Main-bernheim go back to the early 15th century. Main-bernheim was granted its town charter in 1328.

**Right:**
Today Schweinfurt is in essence a modern industrial city; only a handful of historic buildings have survived the Second World War. One of its highlights is the Georg Schäfer Gallery opened in 2000 which has an extensive private collection of works of art on display.

**Below:**
Idyllic Franconian half-timbering in Arnstein west of Werneck. Arnstein is famous for its Gothic pilgrimage church of Maria Sondheim which contains several tombs of the Hutten family.

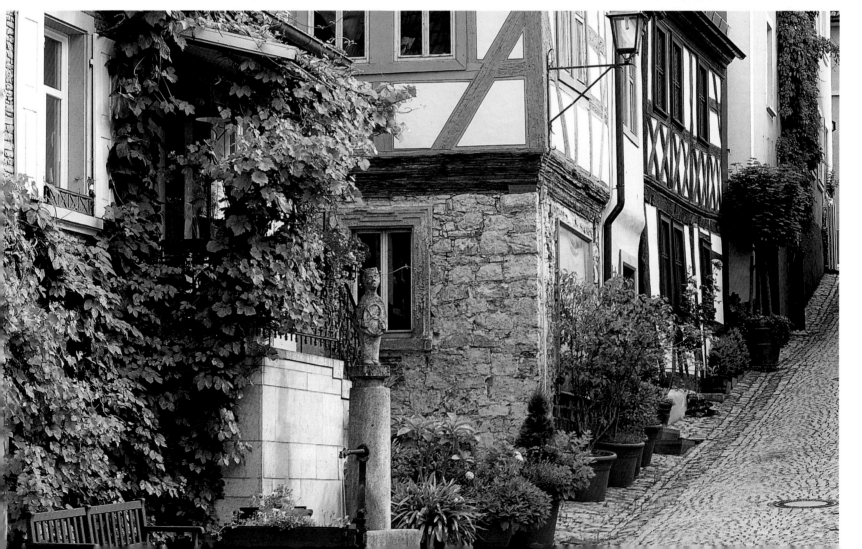

**Above:**
One pleasant way of crossing the River Main is by ferry which in some places still replaces bridges either destroyed or never built, such as here in Obereisenheim.

**Left:**
The Altmain near Volkach and Sommerach is blissfully scenic with its many bends and meanderings. Its shores are punctuated by old quarries which have been turned into cool bathing lakes.

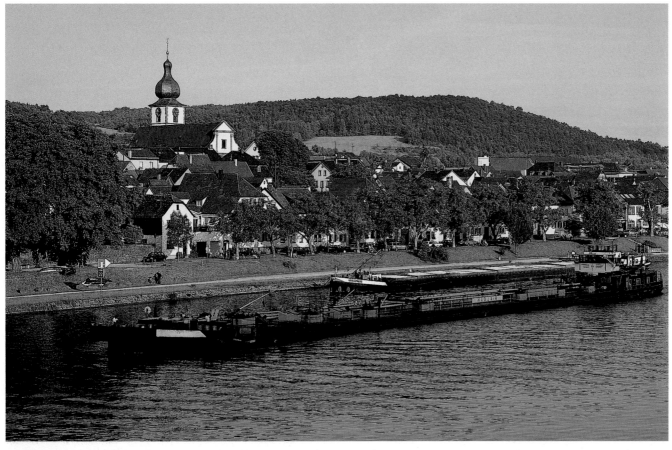

The River Main was only bridged at Marktheidenfeld during the 19th century, greatly boosting the town's importance at the intersection of the Spessart and Fränkisches Weinland.

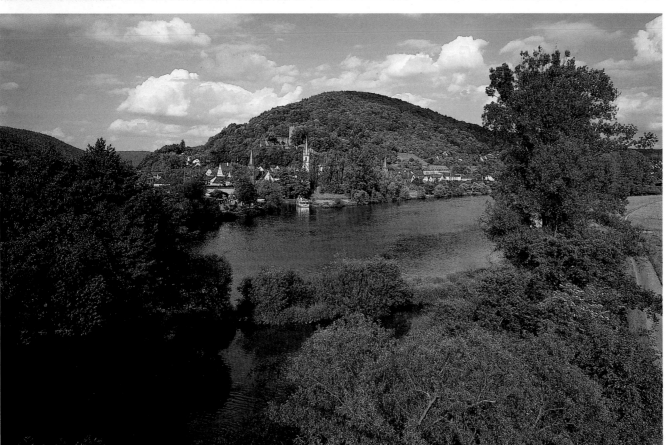

**Left page:**
Another of Franconia's model towns is Lohr am Main with its abundance of half-timbered buildings. The gateway to the Spessart Forest was famous during the 18th century for its glass manufacture, with its mirrors proving particularly popular.

Gemünden evolved at the confluence of the Sinn, Fränkische Saale and Main. The river junction is still 'guarded' today by the 13th- and 14th-century ruins of Scherenburg Castle.

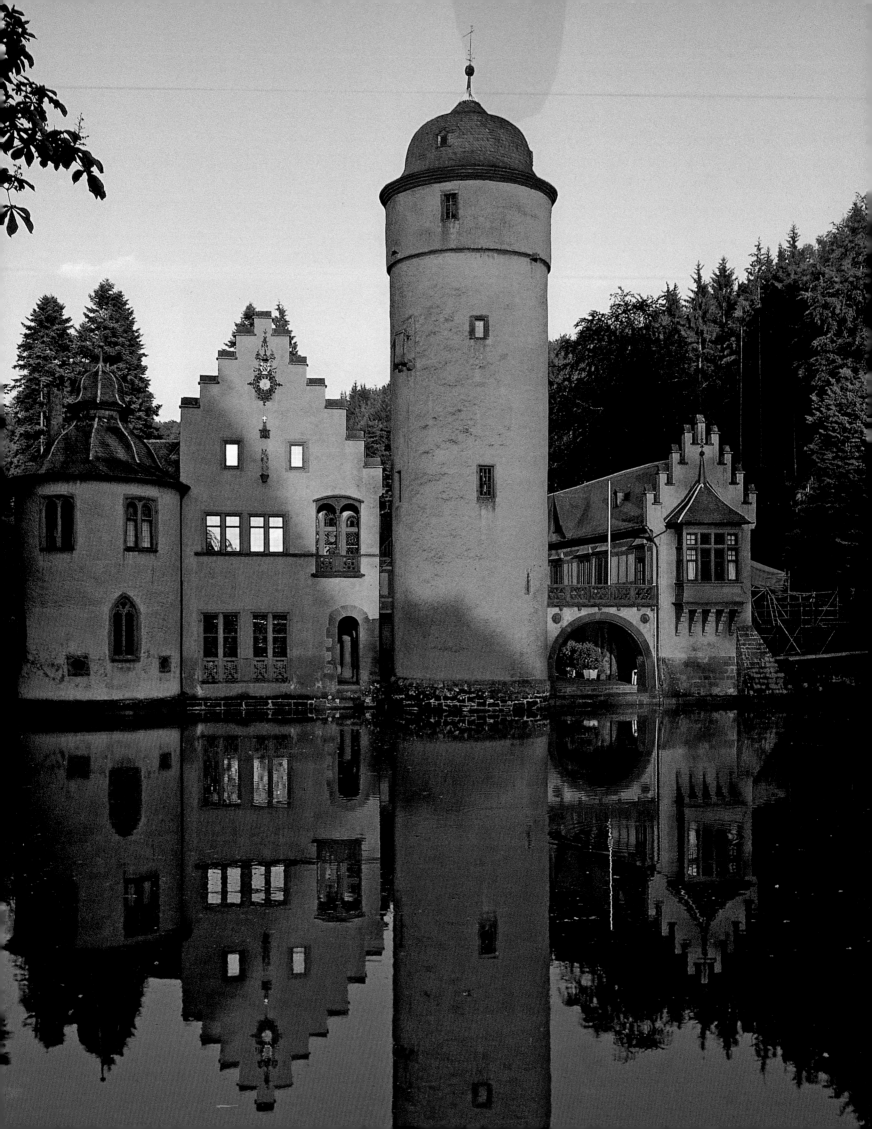

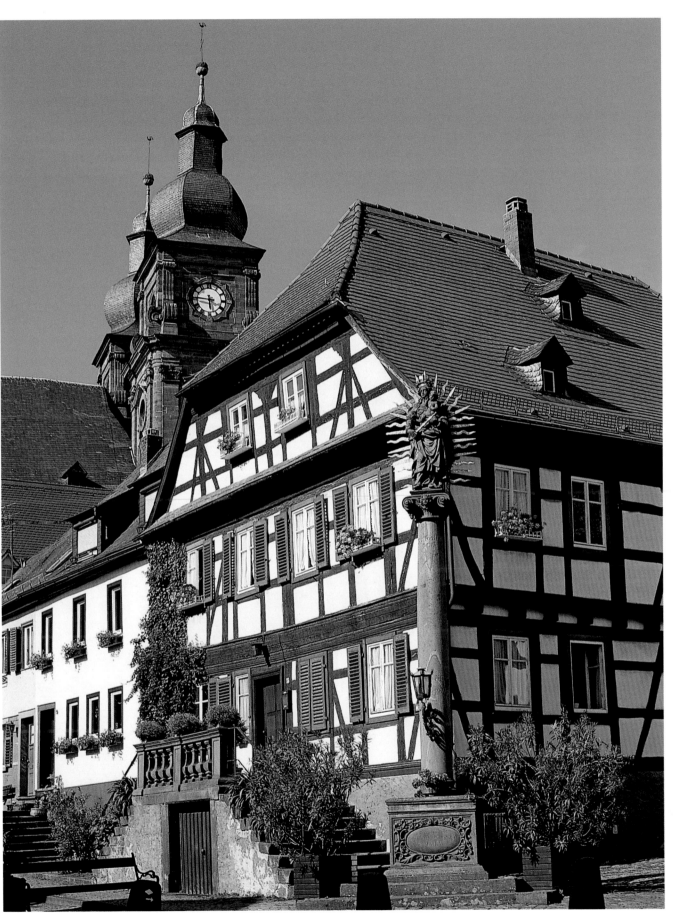

**Left page:**
The epitome of the fairytale
castle in Franconia has to
be Schloss Mespelbrunn,
much of which dates back
to the 16th century and to
its Romantic restoration
in 1904. Until 1665 this
was the ancestral home of
the House of Echter, one
of whose members was
Julius Echter, the highly
influential prince-bishop
of Würzburg.

**Left:**
The market place and
red sandstone Madonna in
Amorbach are framed by
beautiful half-timbered
buildings, with the steeple
of the Gangolfskirche
poking up from behind the
roofs. The main attraction
is, however, the former
baroque abbey church built
by Mainz's court architect
Maximilian von Welsch.

119

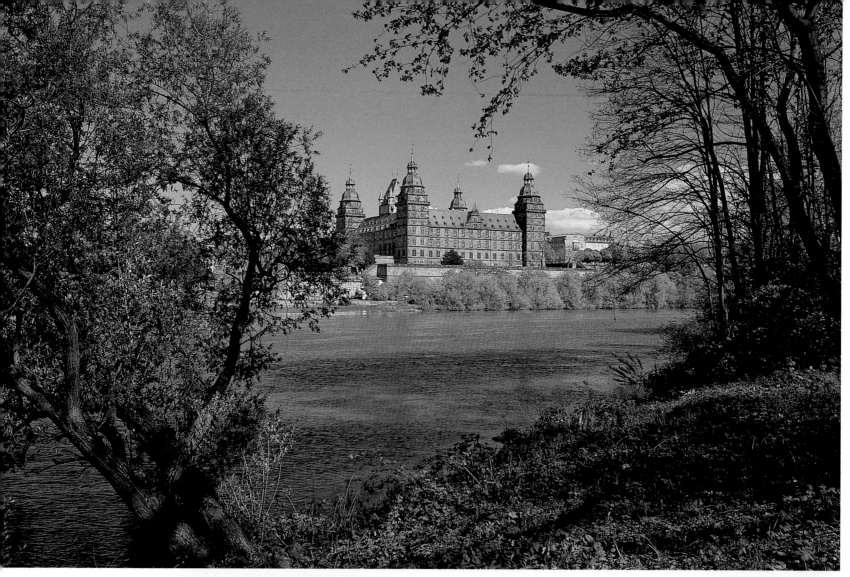

*Above:*
View from the banks of the River Main of Schloss Johanissburg in Aschaffenburg. The square red sandstone palace with its four corner towers is considered to be one of the most beautiful secular buildings in Germany, erected between 1605 and 1614.

*Right:*
The early neoclassical Schloss Schönbusch on the left bank of the Main in Aschaffenburg is surrounded by lush parkland. Once a baroque zoo for the electors of Mainz, it was the first informal landscape garden in South Germany to be laid out in the style of Capability Brown.

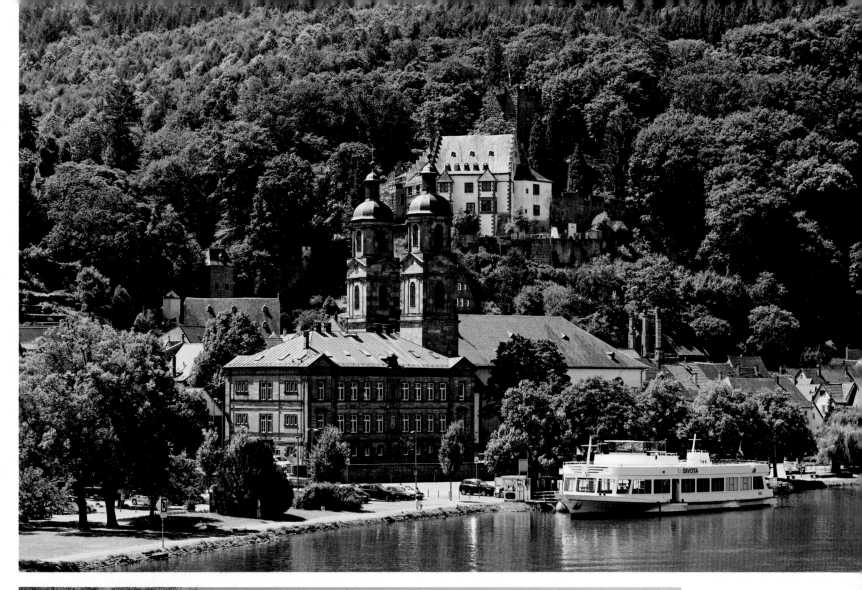

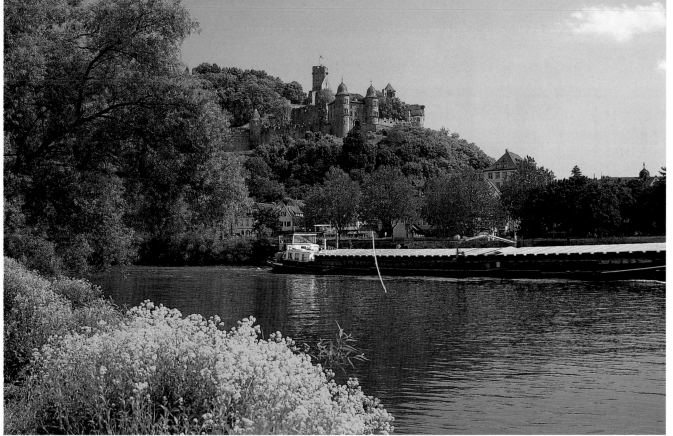

**Above:**
At the southernmost tip of the Mainviereck between the forests of the Oden-wald and Spessart lies Miltenberg, overlooked by Mildenburg Castle. The parish church of St Jakobus with its 19th-century towers fronts the green promenade of the River Main.

**Left:**
View from Kreuzwertheim of Wertheim which strictly speaking is now part of Baden-Württemberg and thus no longer Franconian. Situated between the Main and Tauber rivers, the romantic little town is positively dominated by the gigantic ruins of its medieval castle, destroyed during the Thirty Years' War.

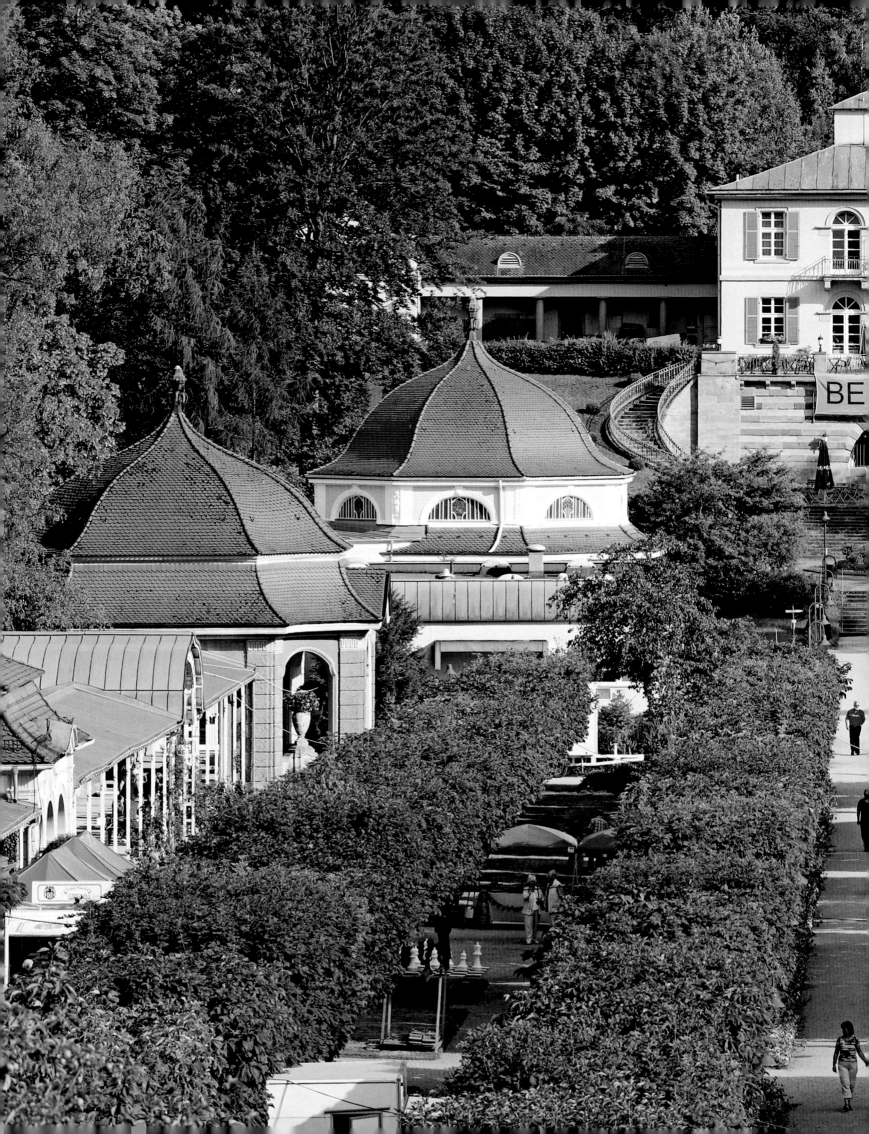

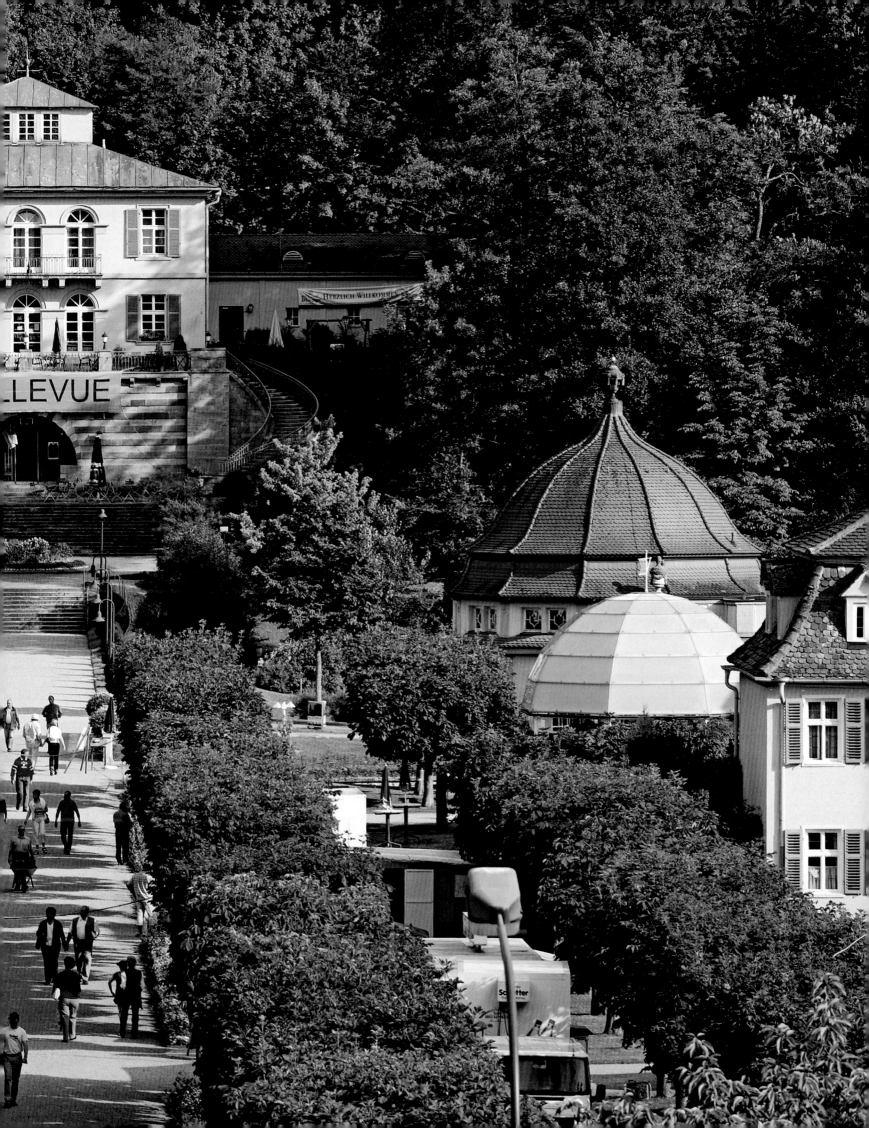

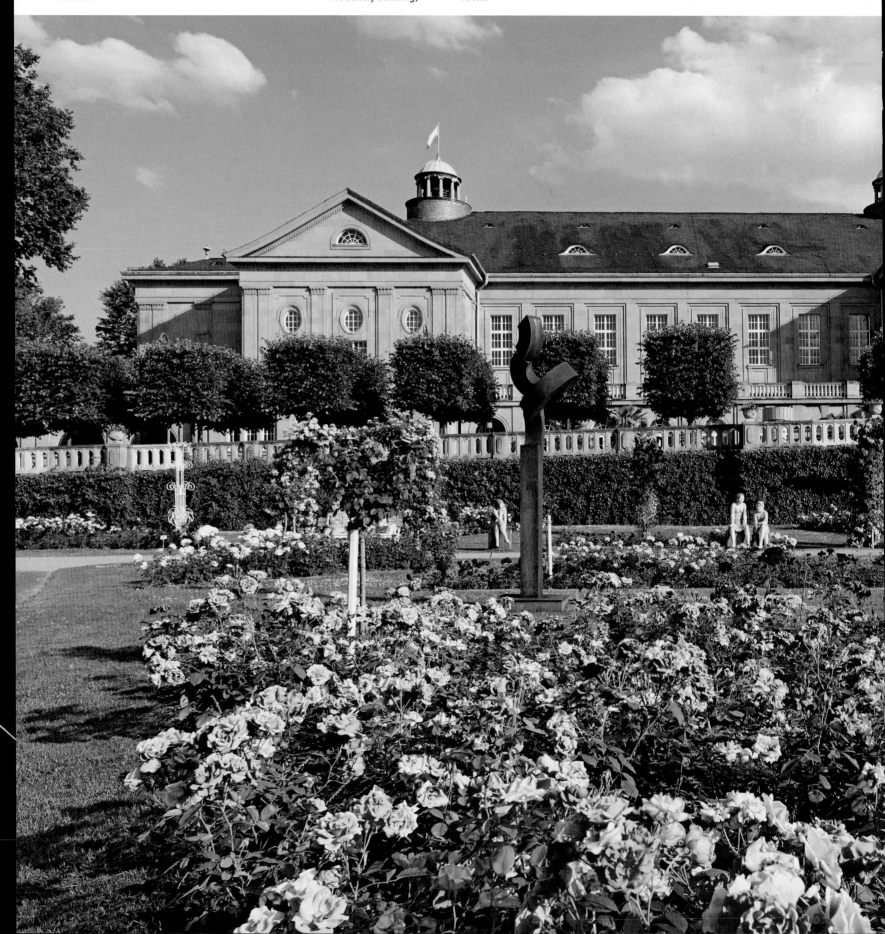

**Page 122/123:**
Today's Hotel Bellevue in the historic spa gardens was the first building King Ludwig I had erected in Bad Brückenau. The plans for the edifice from 1819 were drawn up by the then head of works Bernhard Morelli.

**Below:**
Bad Kissingen, with the rose garden in the foreground and the Regentenbau behind it. The stately building, erected in 1913, contains a sumptuous ballroom and concert hall and also a reading room and games room.

**Top right:**
The pump room in Bad Kissingen in the Rhön was built by Max Littmann to accommodate the Rakoczy and Pandur springs. During the 19th century the spa was extremely popular with the high nobility of Europe.

**Centre right:**
The Luitpoldpark in Bad Kissingen is the perfect place for a relaxing stroll after taking the waters.

**Bottom right:**
The healing springs of Bad Bocklet were given a suitable setting by Balthasar Neumann in 1742. The surrounding park evolved during the 18th century at the instigation of Würzburg's prince-bishops.

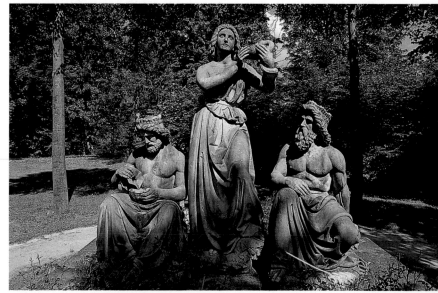

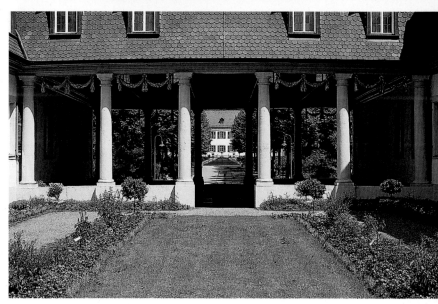

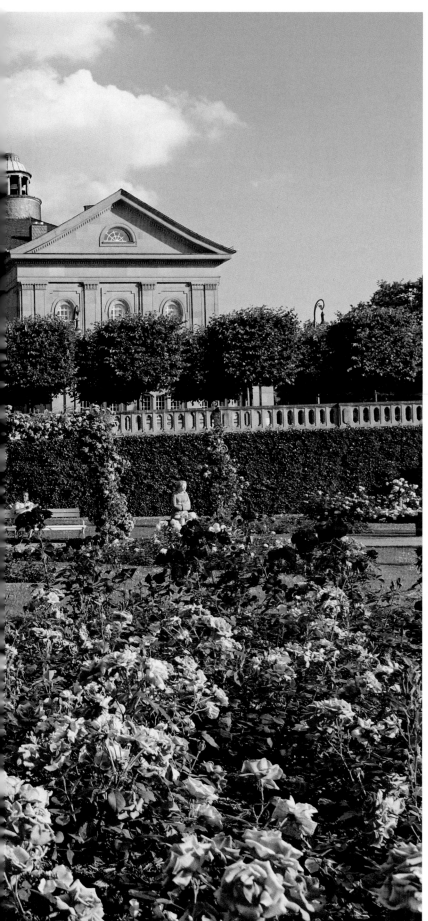

125

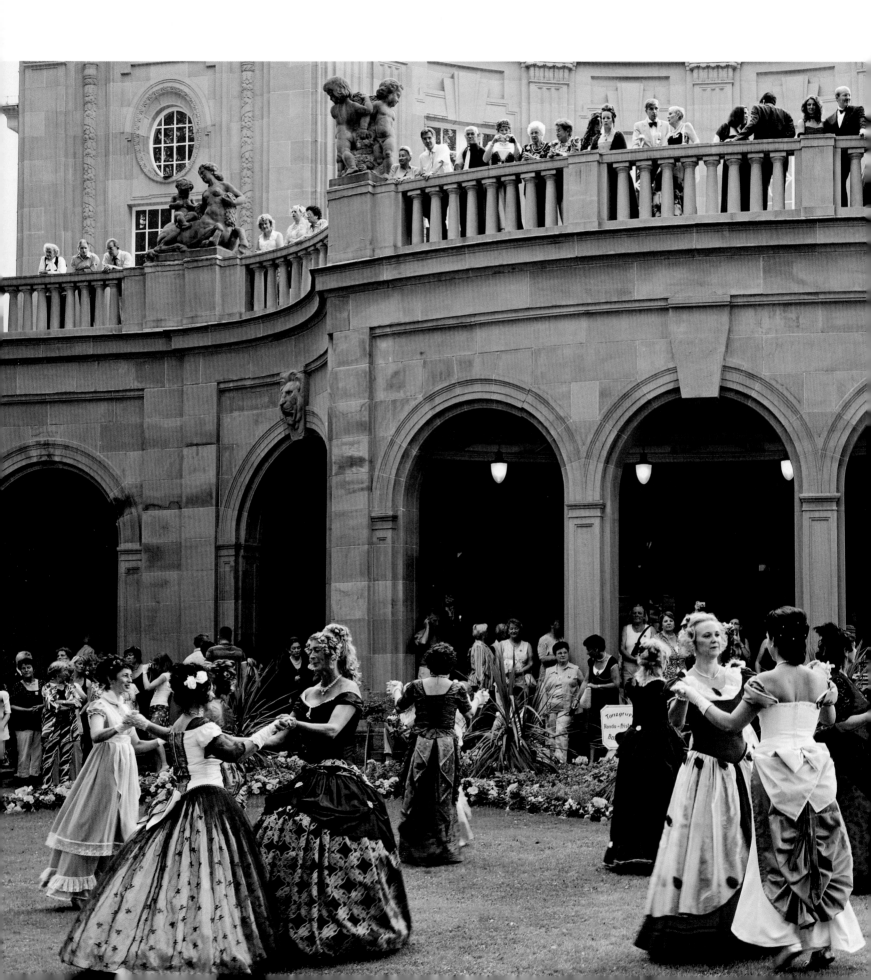

We still don't know for certain why the famous springs in Bad Kissingen were named after the equally well-known Hungarian Prince Rákóczi. This bears only minor relevance to the Rákóczi Festival held here, however, as this dates back not to the spring's origins but to its rediscovery in 1737. Many have come to take its waters, including Empress Auguste Victoria, the imperial Austrian couple, Franz Josef and Elisabeth, Tsar Alexander II of Russia, imperial chancellor Bismarck, poets Josef Victor von Scheffel and Theodor Fontane and composer Gioacchino Rossini.

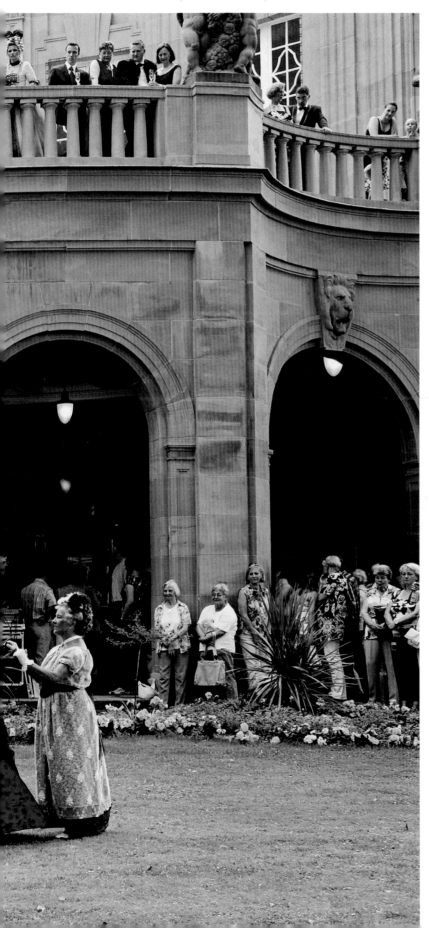

127

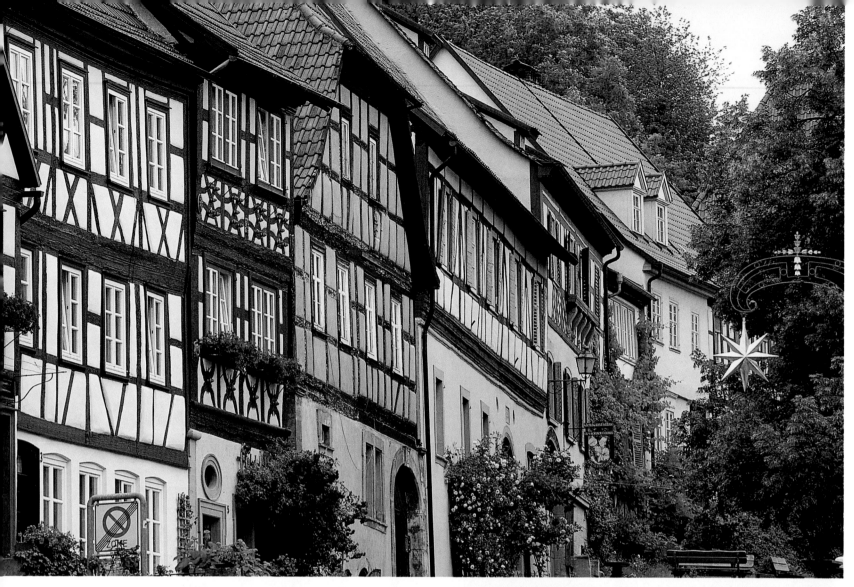

*Above:*
Charming half-timbered houses encircle the old salt market in Königsberg in Bayern. The town's most famous inhabitant was Regiomontanus (1436–1476), the astronomer and mathematician who set up the first observatory in Nuremberg.

*Right:*
Pelargoniums adorn the front steps of a house in Königsberg. The attractive little town in the Hassberge sprang up around the court of a Carolingian king.

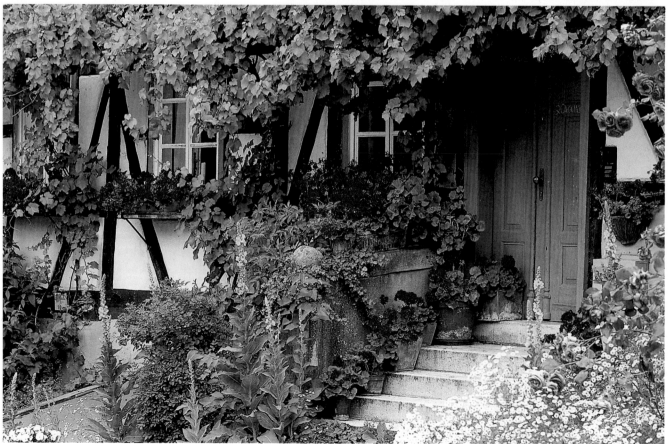

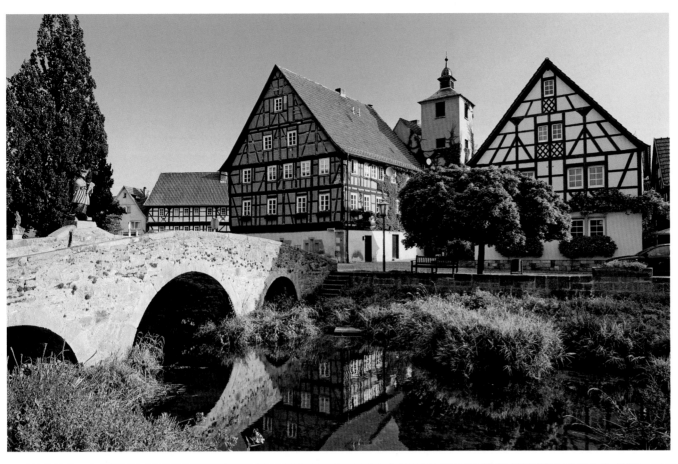

**Left:**
*What Nordheim vor der Rhön lacks in size, it makes up for in atmosphere. Its pretty half-timbered houses glitter in the waters of the River Streu, with the steeple of its fortified church in the background.*

**Below:**
*A wooden walkway takes you safely across the unique Schwarzes Moor biotope in the Rhön. A haven for rare animals and plants, the moor is the largest in the area and one of the few in Europe which has not been affected by peat farming.*

**Right:**
Even if rigorous forest clearance has turned the Bavarian Rhön into an area of wide open spaces in many places, there are still some areas of fairytale woodland to be found.

**Below:**
The valley of the Fränkische Saale is not just perfect for hiking and cycling. Lazily canoeing along the river itself also has its charms, with plenty of lush scenery to explore along the way.

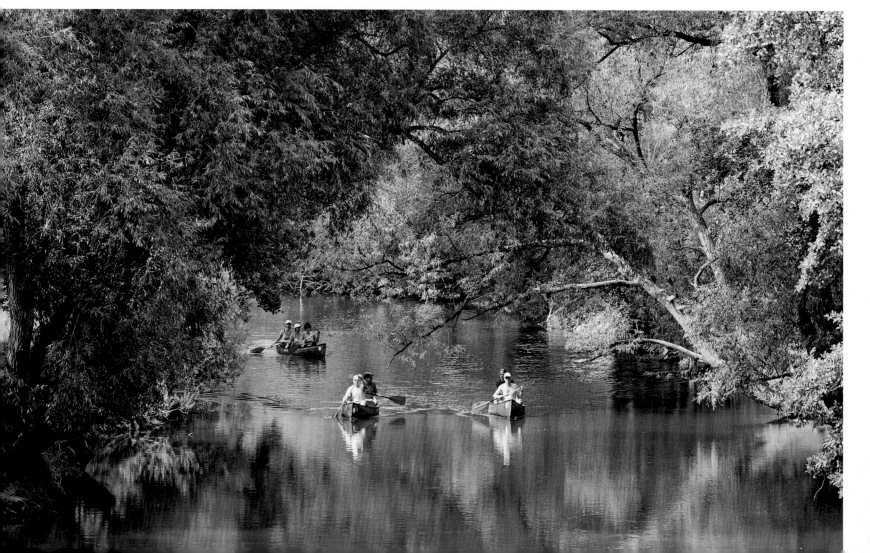

**Above:**
The Rothsee is not far from Bischofsheim on the Hochrhönstrasse. The shady pool, surrounded by high trees, is popular with anglers.

**Left:**
The Oberelsbacher Graben rises on the Lange Rhön River and spills into the idyllic Nixenteich, surrounded by mossy basalt boulders, near Oberelsbach.

The Kreuzberg ski resort now has four lifts, over ten pistes, a ski jump and two toboggan runs. There is also an extensive network of cross-country ski runs here.

**Above:**
*Out with the huskies in the white Schwarze Berge in the Rhön. The mountains south of Wildflecken are up to 839 metres (2,753 feet) high and usually covered in snow in the winter.*

**Left:**
*Gemündener Hütte in the Kreuzberg skiing area promises "A cool beer, a good spread and some peace and quiet". What more could the tired skier wish for …*

# Index

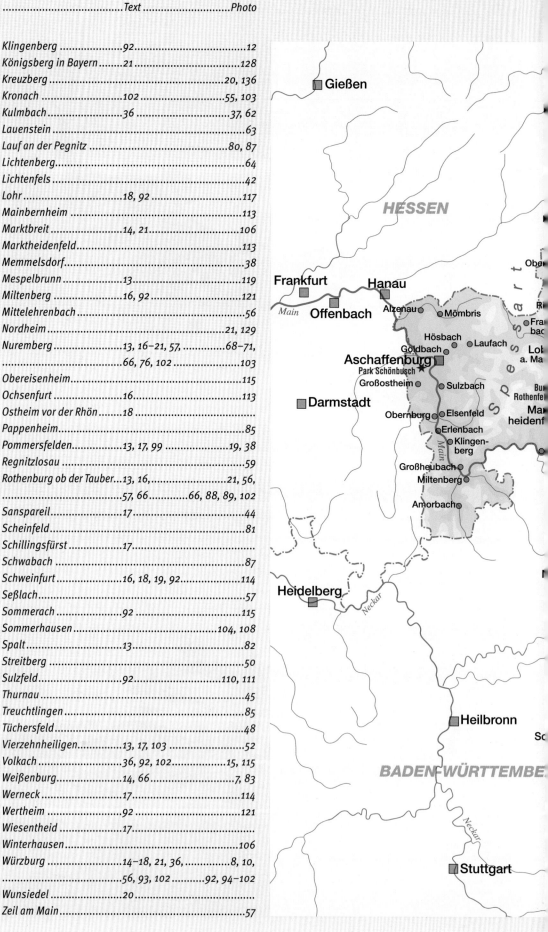

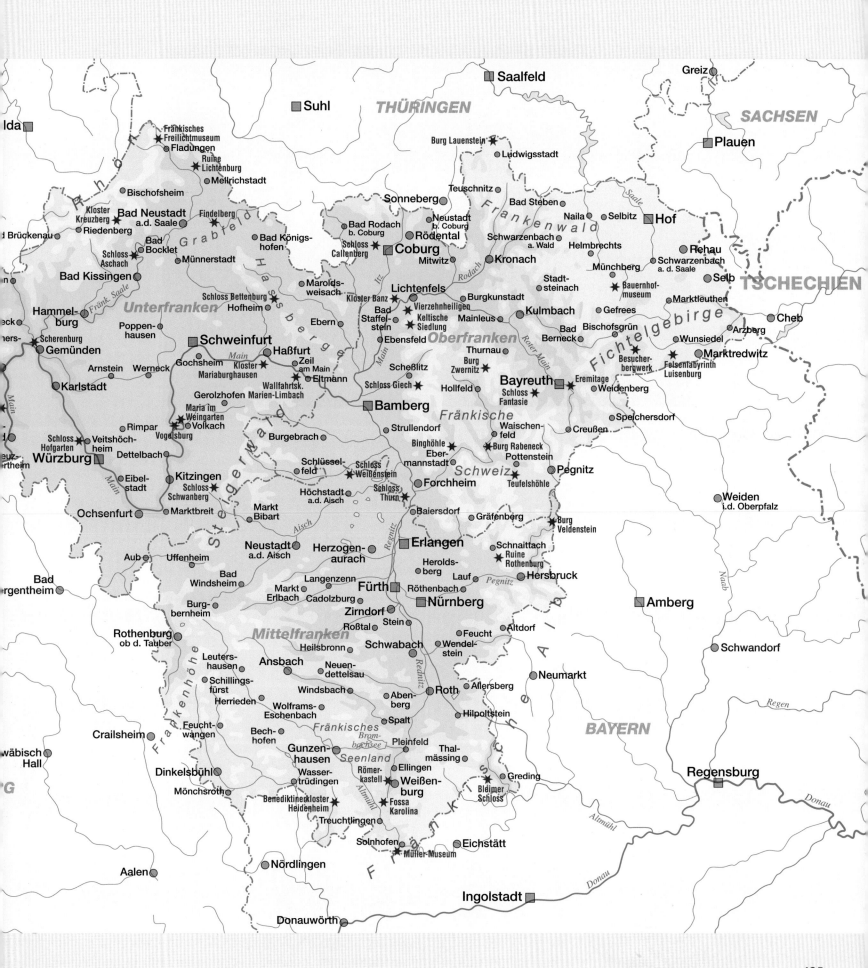

Greiz

■ Saalfeld

■ Suhl          THÜRINGEN                                                                SACHSEN

Ida                                                                                                          ■ Plauen

                    ★ Fränkisches
                       Freilichtmuseum
                     ★ Fladungen                              Burg Lauenstein ★
                    ★ Ruine                                                    ● Ludwigsstadt
                       Lichtenburg
              ● Mellrichstadt                              ● Teuschnitz                          Frankenwald              ● Rehau
          ● Bischofsheim                         ● Sonneberg                        Bad Steben ●                              Saale
     ● Kloster          ● Bad Neustadt    ● Findelberg                      Neustadt        Naila ● ● Selbitz    ■ Hof
       Kreuzberg          a.d. Saale    ★                    ● Bad Rodach    b. Coburg    ● Schwarzenbach                ● Schwarzenbach
    Brückenau  ● Riedenberg         Grabfeld        ● Bad Königs-  b. Coburg    Schloss    ● Rödental    a. Wald    ● Helmbrechts    a. d. Saale
             ● Bad                              hofen          Callenberg ■ Coburg                                       ● Selb
     ● Schloss  Bocklet  ● Münnerstadt                            ● Mitwitz ● Kronach    ● Münchberg
       Aschach                                                                                    Stadt-                    ● Marktleuthen
    ● Bad Kissingen                      ● Marolds-  Kloster Banz  ● Lichtenfels  ● Burgkunstadt  steinach ●    ★ Bauernhof-    ● Cheb
                                           weisach  ★                                                         museum
  Hammel-        Fränk. Saale   ● Schloss Bettenburg  Bad ● ★ Vierzehnheiligen    ● Kulmbach  ● Gefrees    Fichtelgebirge
    burg      Unterfranken        ● Hofheim  Staffel-  ★ Keltische  ● Mainleus    Bischofsgrün ●           ● Wunsiedel
  ● Scherenburg    Poppen-        ● Ebern  stein  Siedlung              Bad ●  Berneck ●                ★ Marktredwitz
  ● Gemünden    hausen ●              ● Ebensfeld  Oberfranken          ● Thurnau              ★ Besucher-    ● Felsenlabyrinth
     ● Arnstein  ● Werneck  Gochsheim ● ● Haßfurt  ★  Scheßlitz ●      ● Burg                  bergwerk    Luisenburg
     ● Karlstadt              ★ Kloster  ● Zeil  Main              Zwernitz  Bayreuth    ● Eremitage    ● Weidenberg
                           Mariaburghausen  am Main  ● Schloss Giech ★  ● Hollfeld  Schloss ★
  Main           ● Gerolzhofen  Marien-Limbach  ● Wallfahrtsk.                    Fantasie
              ● Maria im                              ■ Bamberg    Fränkische    ● Speichersdorf
  ● Rimpar   Weingarten ★  ● Volkach                ● Strullendorf  ● Waischen-
  Schloss ★ ★ Veitshöch-  Vogelsburg                  ● Binghöhle ★ feld
  Hofgarten    heim  ● Burgebrach          Eber-  ★ ● Burg Rabeneck  ● Creußen
  Würzburg ■  ● Dettelbach              ● Schlüssel-  mannstadt ●  Pottenstein
     ● Eibel-  ● Kitzingen              feld  ● Schloss  Schweiz  ● Pegnitz
  thertheim    stadt  Schloss ★          Weißenstein
                     Schwanberg        ● Höchstadt  Schloss    ● Forchheim    ● Weiden
  ● Ochsenfurt  ● Marktbreit            a.d. Aisch  Thurn ★                    i.d. Oberpfalz
                                   Aisch      ● Baiersdorf  ● Gräfenberg
                  ● Markt                                          ● Burg
                  Bibart                              Regnitz  Veldenstein
  Bad        ● Aub  ● Uffenheim  ● Neustadt  ● Herzogen-  ■ Erlangen  ● Schnaittach
  rgentheim               a.d. Aisch  aurach            Herolds-  ★ Ruine  Naab
                                          ● berg  ● Lauf  Rothenburg  ● Hersbruck
             ● Bad                                  Pegnitz
             Windsheim  ● Langenzenn  ■ Fürth  ● Röthenbach
  Rothenburg   ● Markt                ● Cadolzburg  ■ Nürnberg        ■ Amberg
    ob d. Tauber  Erlbach                ● Zirndorf
             ● Burg-                ● Roßtal  ● Stein            ● Altdorf
             bernheim    Mittelfranken  ● Heilsbronn  ● Schwabach  ● Feucht  ● Wendel-    ● Schwandorf
  ● Leuters-        ● Neuen-                  ● Roth  stein
    hausen  ● Ansbach  dettelsau
  ● Schillings-                              ● Allersberg    ● Neumarkt
    fürst  ● Windsbach
  ● Herrieden  ● Wolframs-  ● Abenberg
  ● Crailsheim  Eschenbach        berg  ● Roth  ● Hilpoltstein
  Feucht-                  ● Spalt
  wängen  Bech-  Fränkisches
  wäbisch  hofen  ● Gunzen-  Brom-  ● Pleinfeld    ● Thal-
    Hall           hausen  bachsee  Seenland    mässing
  ● Dinkelsbühl  ● Wasser-  ● Römer-  ● Ellingen    ● Greding    ■ Regensburg
             trüdingen  kastell  ● Weißen-  Bleimer
  ● Mönchsroth           ★ burg  Schloss
             Benediktinerkloster ★  ★ Fossa    Donau
  RG           Heidenheim    Karolina
             ● Treuchtlingen    Altmühl                              Donau
                         ● Solnhofen    ● Eichstätt
                         Müller-Museum
  ● Aalen   ● Nördlingen
                                   ■ Ingolstadt
             ● Donauwörth

                                                                                               135

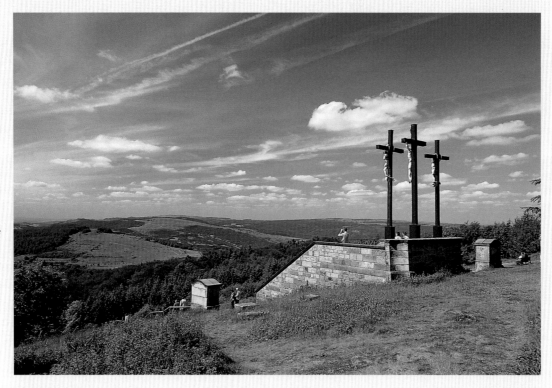

*View out across the broad expanses of the Rhön from the Kreuzberg, the second-highest mountain in the area. Legend has it that St Kilian once erected a cross here, turning the Kreuzberg into an early place of pilgrimage. A chapel was later built here by Julius Echter, around which a Franciscan monastery evolved. The monks began brewing their own strong brand of beer here in 1731 – which still does much to cement the mountain's popularity.*

**Journey through Franconia**

**Design**
www.hoyerdesign.de

**Map**
Fischer Kartografie, Aichach

**Photo credits**
All photos by Martin Siepman with the exception of:
p. 92/93: Jürgen Roth; p. 96, top and p. 98, left: Wikimedia, Krzysztof Golik (Lizenz cc-by-sa 4.0).

**Translation**
Ruth Chitty, Stromberg
www.rapid-com.de

Printed in Italy
Repro by Artilitho snc, Lavis-Trento, Italy
www.artilitho.com
Printed/Bound by Grafiche Stella srl, Verona, Italy
www.grafichestella.it
© 7th edition 2018 Verlagshaus Würzburg GmbH & Co. KG
© Photos: Martin Siepmann
© Text: Ulrike Ratay

ISBN 978-3-8003-4091-0

Details of our programme can be found at
**www.verlagshaus.com**